TO MY BROTHER EDWARD

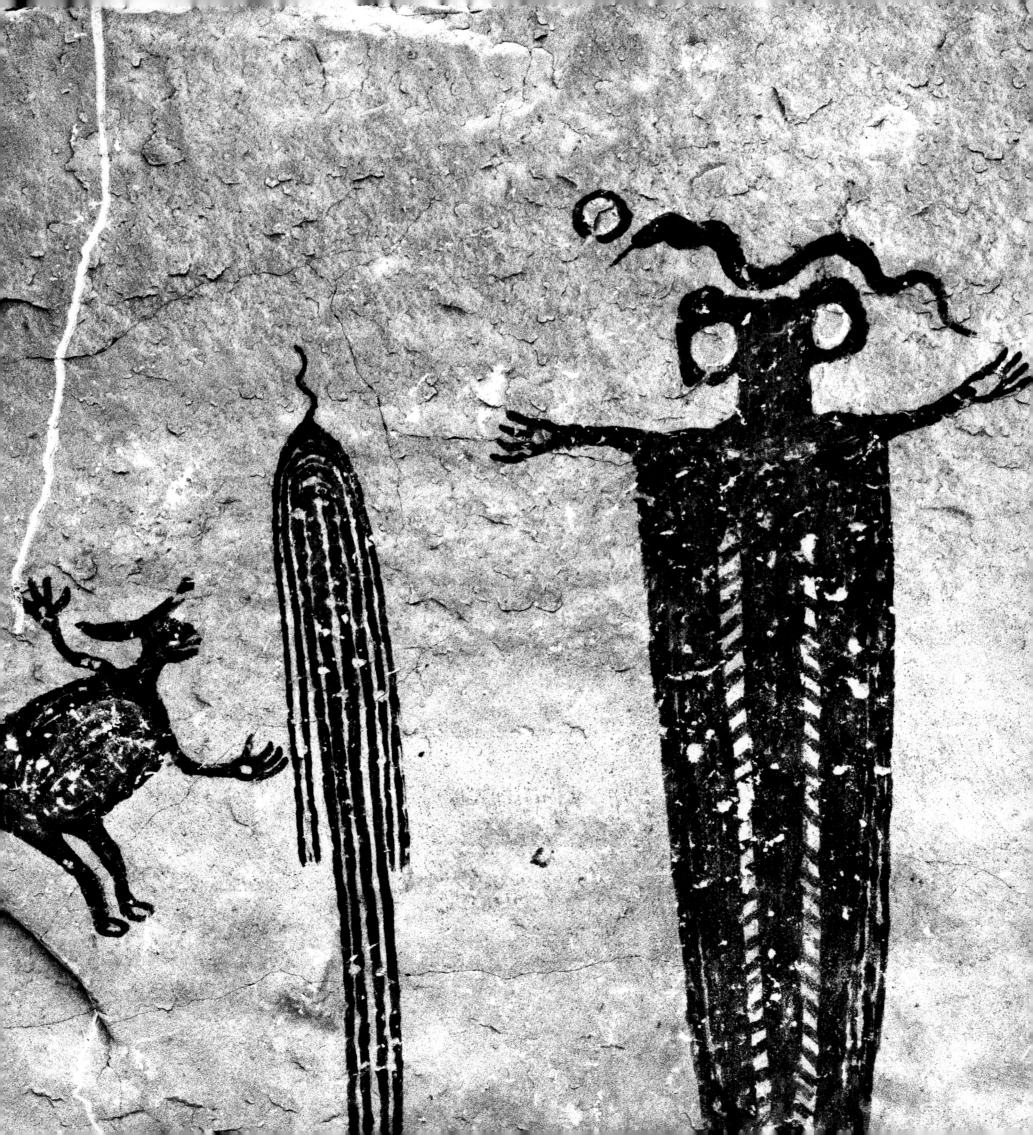

ELAINE LING

TALKING STONES

A PHOTOGRAPHIC SOJOURN

KEHRER

SPEAKING OF STONES

William L. Fox

The Earth is 4.5 billion years old. The oldest terrestrial stones that we have found are zircons from Australia: 4.374 billion years old. They have witnessed nearly everything. For all human intents and purposes, five kinds of stones now exist in the world. First are those we find in a natural state, shaped by the planet's internal heat and pressure, then wind and water on the surface: the smooth round rocks you pick up on the seashore, the cavernously weathered ventifacts of Australia's Kangaroo Island, sandstone arches in the American Southwest. And those zircons.

Second are the rocks that people pile up, stack, and otherwise assemble. Cairns along far trails, Stonehenge, the Pyramids, the temples of Angkor Wat: perhaps everything we build with stone would be the simplest way to outline this category. At times we stack up natural stone to build houses, or carve dwellings into it, as in the formations of Cappadocia. Cutting natural stones and installing them on building surfaces—whether for a granite kitchen counter in a luxury penthouse or the limestone facade of the Getty Museum, complete with embedded fossils—also falls into this compiling category.

The third kind of stones are those we sculpt, from paleolithic hand axes to the Venus of Willendorf, from the prehistoric petrospheres of Costa Rica to Henry Moore's abstract reclining nudes. We fracture gemstones into multifaceted jewels to wear, and grow them to channel light for lasers. Sometimes we shape stones into columns for buildings, or figures mounted on the walls of temples and banks. The ways in which we cut, carve, sculpt, shape, and smooth stones—from crystals visible only with an electron microscope to blocks of marble as huge as houses—are innumerable.

The fourth stones are those upon which we draw and write, inscribing everything from sacred knowledge to accounting records. The 50,000-year-old pictographs and petroglyphs in the rock shelters of northern Australia, the rune stones of Scandinavia, the cornerstones of bank buildings, and gravestones everywhere—we are forever setting important information, beliefs, and knowledge in stone. Often inscribed stones are placed inside the stacked stones of cathedrals, universities, and museums—our most important public buildings.

And then there is the fifth category, stones we have never seen and wish to discover. These are the stones sought by Elaine Ling and other photographers; but, like the fabled particles basic to the construction of the universe, all we see are indirect evidence of such stones. We never see the objects themselves. The closest we can come is to capture images of those stones that are in plain sight, and thus surmise what the missing ones might look like, how they might function.

For decades no one could say definitively how rocks on Death Valley's Racetrack Playa sailed across its cracked surface, leaving behind long scores in the alkali. Not until 2014 did we have time-lapse photographs showing dozens of the stones moving, apparently from the force of strong winds blowing across the mud-slick basin after a rainstorm. This is an analog for stones of the fifth order: unseen geodes travelling through the Earth's crust; carvings yet to be unearthed in burial grounds; the columns of Atlantis.

Ling presents her photographs of stones in revealing juxtapositions, carefully sequencing images in books and exhibitions, or more directly in diptychs. It is difficult, viewing her work, because you wish it would never end, this cataloguing of our oldest medium of memory. Stones astonish us with the variety of their natural forms and of myriad uses to which we have put them. We want to know them all.

FOREWORD

Wade Davis

Whenever one stands in the shadow of architectural wonders such as those so elegantly, indeed lovingly, portrayed in this book several questions come to mind. Who ordered such monumental constructions, and what power did they wield over those who actually did the work? What motivated civilizations to divert the full measure of their wealth and human capital from satisfying the daily needs of their people to supporting the elaboration of massive structures of purely symbolic and ceremonial significance? And given the limits of their technologies, how did they possibly engineer and build works of such scale and grandeur?

To an extraordinary extent archaeology has allowed us to have a firm handle on the first of these questions. At Petra one can still sense the passage of caravans that carried frankincense and myrrh to fire altars throughout the Roman world. We can read etched into the sandstone words in Aramaic, the language of the Nabataeans, and recognize in rock monoliths symbolic representations of Dushara, their paramount masculine god.

In Cambodia satellite imagery has shown that the vast temple complexes of Angkor extended over 390 square miles. The ancient capital of the Khmer Empire, built in the 12th century, was the largest city ever constructed in the pre-industrial world. Every structure was positioned in alignment with celestial phenomena. Every causeway and city gate, each deity revealed in stone, are elements of a single cosmic model of the universe, the infinite realm of the gods made manifest on earth through the labour and suffering of men.

Machu Picchu was never a "lost city" as described by Hiram Bingham, but rather an integral part of the Incan Empire, clearly linked to the network of roads that reached back to Cusco and extended for 25,000 miles, bringing together the longest empire ever forged in the Americas. Situated on a strategic spur high above the Urubamba River, Machu Picchu was perfectly positioned to guard the approaches to the Sacred Valley while at the same time dominating the eastern lowlands of Antisuyo, the source of coca, medicinal plants and shamanic inspiration. It was a ritual centre established as the royal estate of Pachacuti, the first of the three great Incan rulers who forged an empire that endured for less than a century. Studies of the canals and waterways leave little doubt that Machu Picchu was built from a single architectural plan that was itself conceived within the framework of Incan cosmology, and rooted in ancient Andean notions of sacred geography.

To answer the second question, that of motivation, we need only to consider the human condition. The world has always been a place of grace and corruption, the sordid and the sublime, where those who control wealth and power dictate the conditions of those who have little. Death is the great equalizer, and how a culture comes to terms with the inexorable separation implied by death to a great extent determines its religious ideology. As a species we have universally conceived of the existence of worlds beyond this one, realms of the gods where death is defeated and life is eternal. Controlling the gates to heaven has always been the essence of power. Ancient monumental architecture expresses religious conviction, even as it lays claim to immortality, reminding the living that all this talk of an afterlife and worlds beyond this one is more than just wishful thinking.

Oddly enough it is the third of these questions that proves to be the most challenging, especially for those of us looking back through three centuries of astonishing technological innovations. How could the inhabitants of ancient Britain five thousand years ago possibly have quarried and erected the massive monoliths of Stonehenge? How did the Polynesians of Easter Island, without benefit of

metal tools or the wheel, cleft from the face of Rana Raraku and transport across Rapa Nui, gigantic statues of ancestral gods, moai that stood thirty feet high and weighed as much as 80 tons? The massive ramparts of the Incan fortress of Sacsayhuaman just above Cusco were constructed from multi-angled stones, all weighing fifty to 200 tons, fit together like pieces in a jigsaw puzzle. Many of these were dragged overland, from a quarry twelve miles southeast of the Incan capital. The largest measures twenty-five feet high, ten feet across and is believed to weigh 361 tons.

The Spanish who saw Sacsayhuaman in its glory, when it housed five thousand imperial troops, when its water towers stood and the lodgings and religious sanctuaries had yet to be pillaged, could not believe that the fortress was the work of men. Nothing created in the history of Europe could compare. The Church declared the stonework to be the product of the demons, an assertion no more fantastic than many more recent attempts to explain the enigma of Inca masonry. The ill-fated explorer Colonel P.H. Fawcett was the first to express the idea of a secret plant capable of dissolving rock. A slew of writers have argued for an extraterrestrial origin, a suggestion not only silly but demeaning, implying as it does that the ancestors of the highland Indians were incapable of executing what was in fact their greatest technical achievement.

The actual explanation is far simpler and more elegant than fantasy would allow, and it suggests how much of the artistry celebrated in this exquisite book came into being. To quarry the stone, Inca masons sought natural weaknesses in the rock, small fissures that could be widened by planting a wooden wedge and soaking it with water. Once a block of stone broke free, it could be worked with harder rocks, by a series of abrasive blows that in time would transform its surface. This is precisely how the people of Easter Island carved moai from volcanic tuff, using chisels made of basalt. Experiments in Peru have shown that, even without iron tools, a shapeless lump of andesite can be turned into a smooth cube a foot in dimension in just two hours. To work a larger stone with complex angles would involve dusting the edges with chalk or coloured powder, setting the rock in place, removing it to see what needed to be ground off, and then setting it in place once again. Excavations have shown that this, in fact, is what the Inca masons did. Load-bearing stones fit with exquisite precision across the entire surface of the stones. The vertical joins, by contrast, are tight on the exposed face but ragged behind and filled with mortar. Clearly, there was no magic technique. Only time, immense levies of workers and an attitude toward stone that most westerners find impossible to comprehend.

For the people of the Andes, matter is fluid. Bones are not death but life crystallized, and thus potent sources of energy, like a stone charged by lightning or a plant brought into being by the sun. Water is vapour, a miasma of disease and mystery, but in its purest state it is ice; the shape of snowfields on the flanks of mountains, the glaciers that are the highest and most sacred destination of the pilgrims. When an Inca mason placed his hand on rock, he did not feel cold granite, he sensed life, the power and the resonance of the earth within the stone. Its transformation to a perfect ashlar or a block of polygonal masonry was service to the Inca and thus a gesture to the gods, and for such a task, time had no meaning. This attitude, once harnessed by an imperial system capable of recruiting workers by the thousands, made almost anything possible.

If stones were dynamic, it was only because they were part of the land, of Pachamama. For the people of the Andes, the earth is alive, and every wrinkle on the landscape, every hill and outcrop, each mountain stream is imbued with ritual significance. A mountain is an ancestor, a protective being, and all those living in the shadow of a high peak share in its benevolence or wrath. Rivers are the open veins of the earth, the Milky Way their heavenly counterpart. Rainbows are double-headed serpents that emerge from hallowed springs, arch across the sky, and bury themselves again in the

earth. Shooting stars are bolts of silver. Behind them lie all the heavens, including the dark patches of cosmic dust, negative constellations that are as meaningful to the people as the clusters of stars that form animals in the sky. Lightning is concentrated light in its purest form. A person killed by lightning is buried on the spot and instantly becomes a sacred being.

Surely what draws us to these ancient works of art and architecture so beautifully illustrated in this book is what they reveal about yearning and devotion, commitment and connection, the sacred and the stone. The earliest known work of art is a simple cross hatching carved into rock by the hand of a Neanderthal. Around the same time, some 40,000 years ago, our Paleolithic ancestors reached deep into the earth, moving through narrow passages that opened into chambers illuminated by the flicker of tallow lamps, to draw with stark realism the animals they revered, singly or in herds, using the contour of the stone to animate forms so dramatically that entire caves come alive even today with creatures long since lost to extinction. To this day contemporary artists chip away at marble not to create forms but to liberate what lies within, just as Michelangelo released David to the world. This is the power of stone, at once fluid and static, eternal and fleeting, the perfect template for the human imagination and spirit.

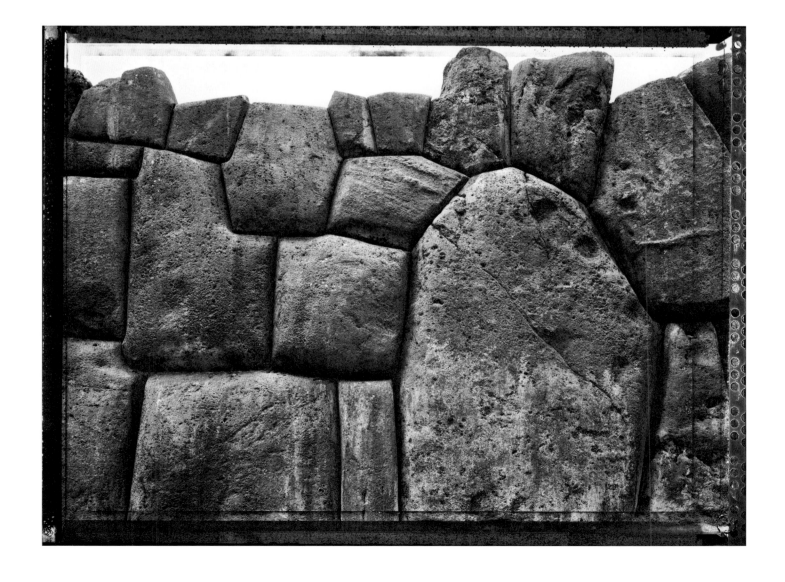

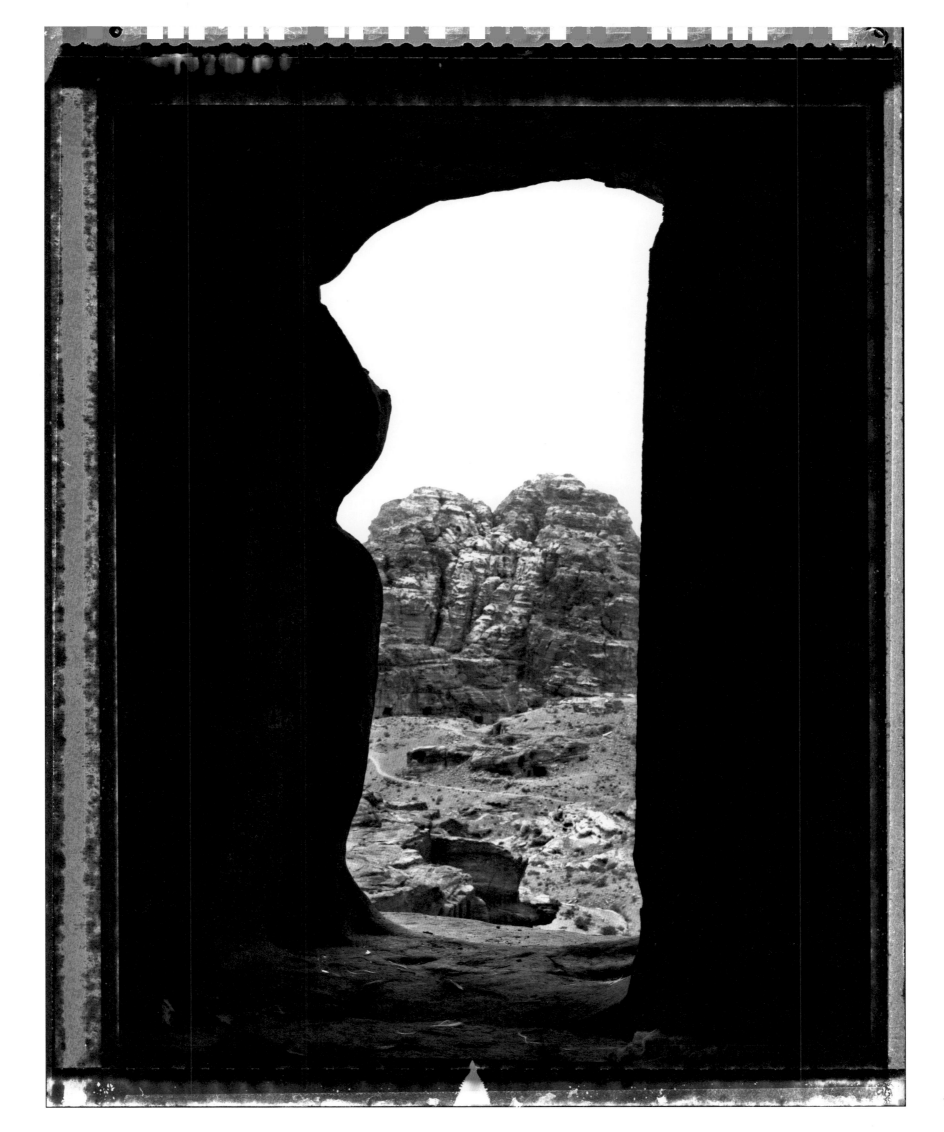

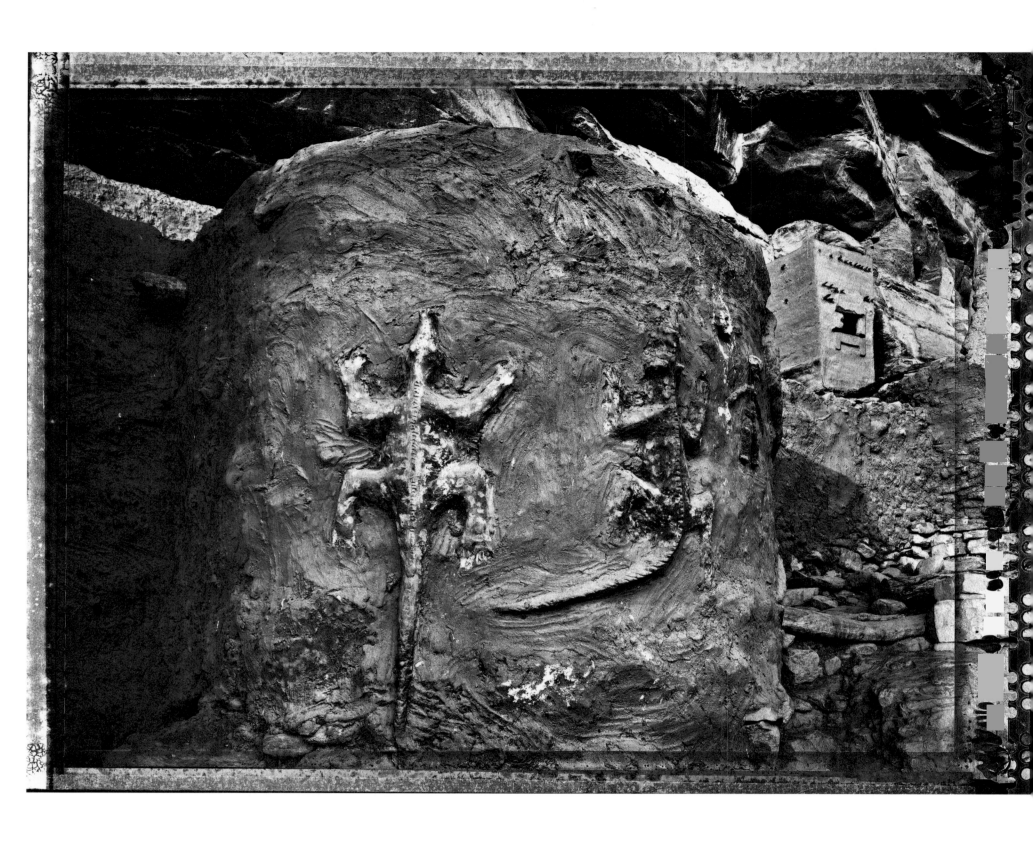

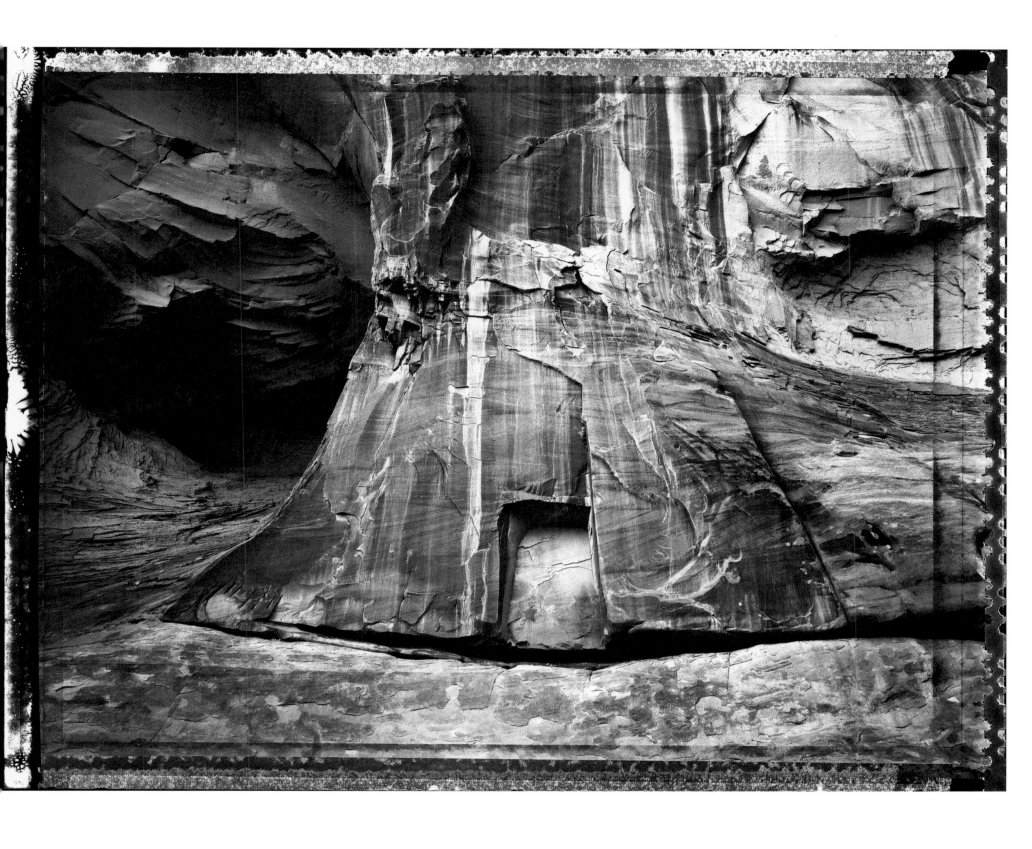

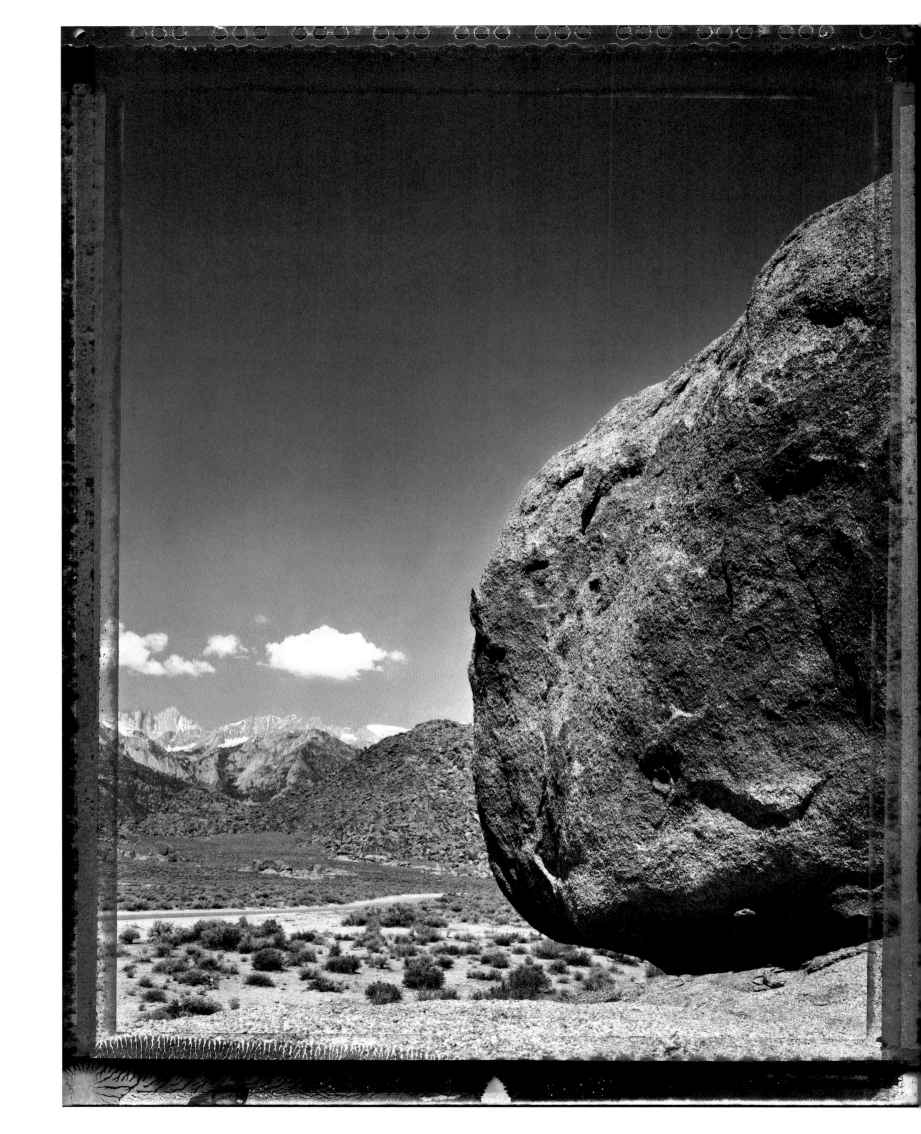

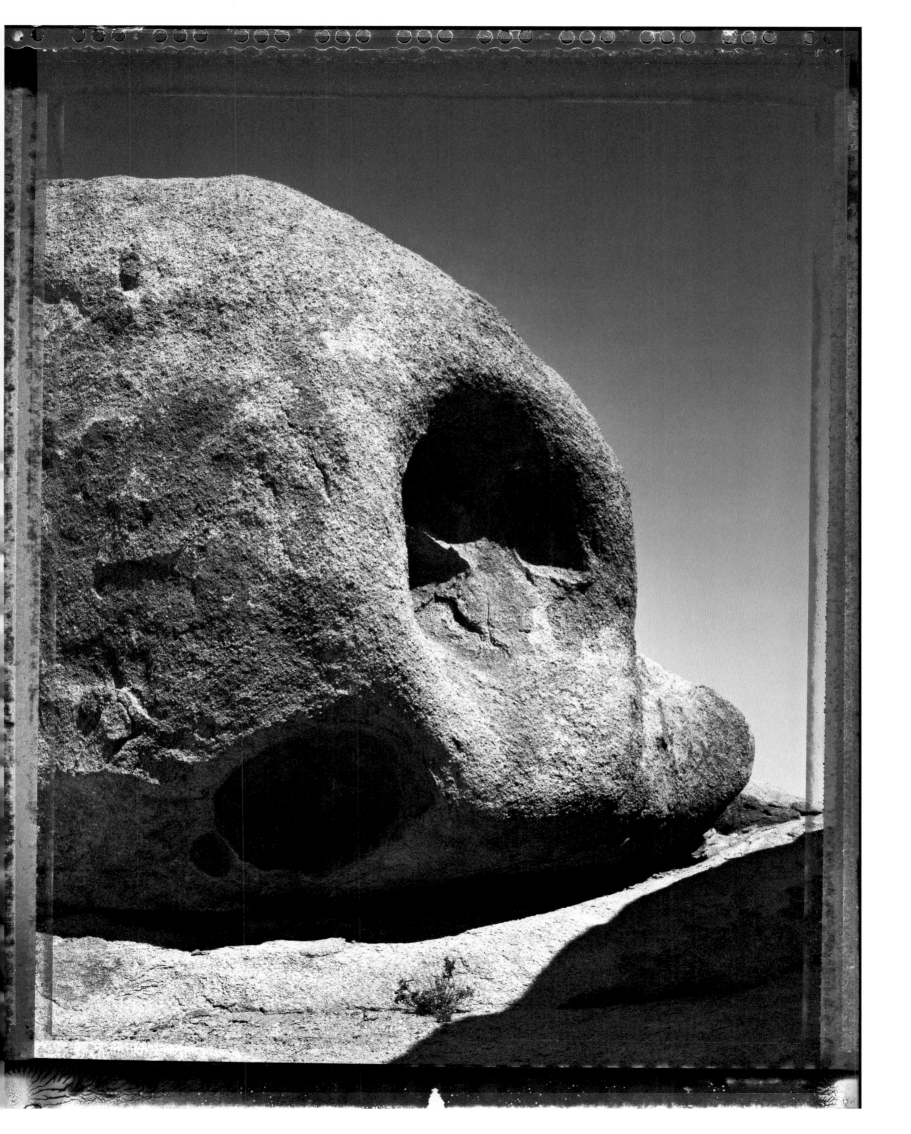

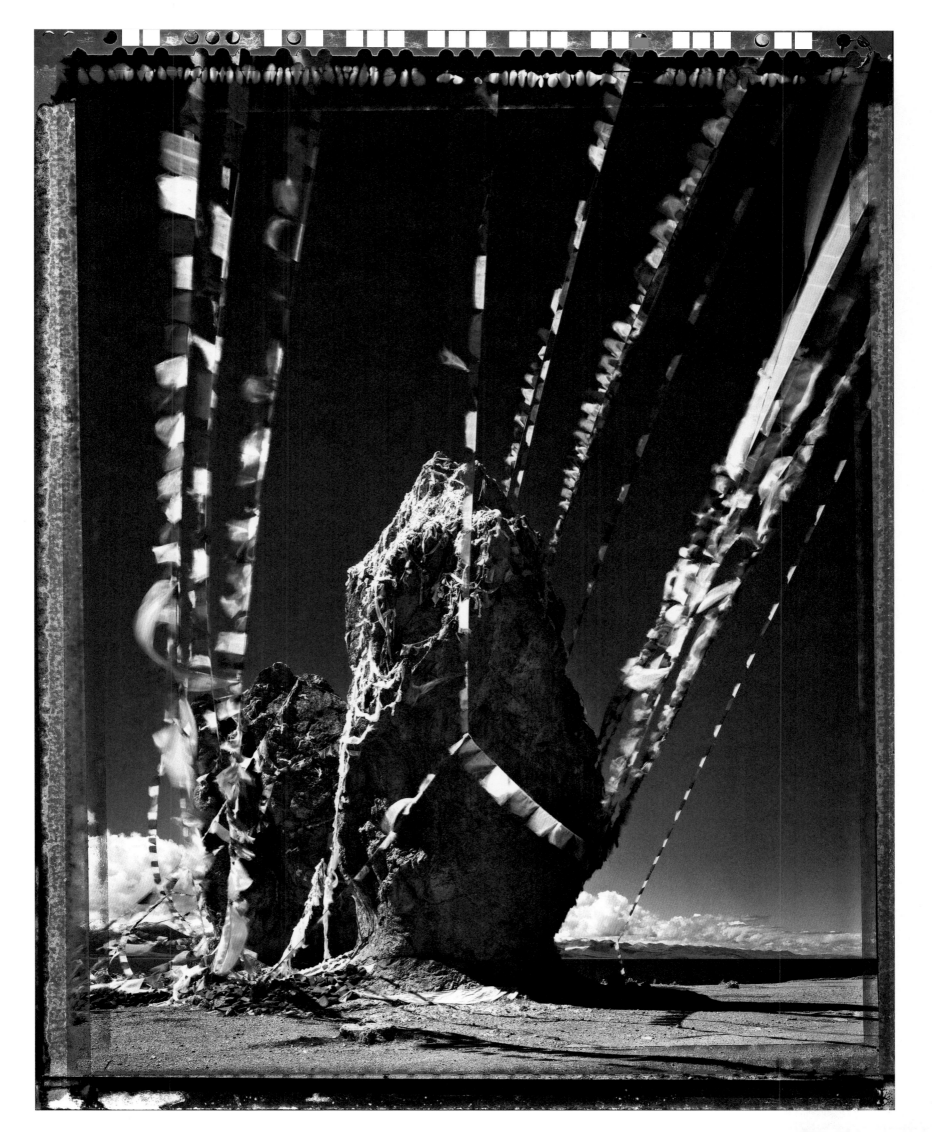

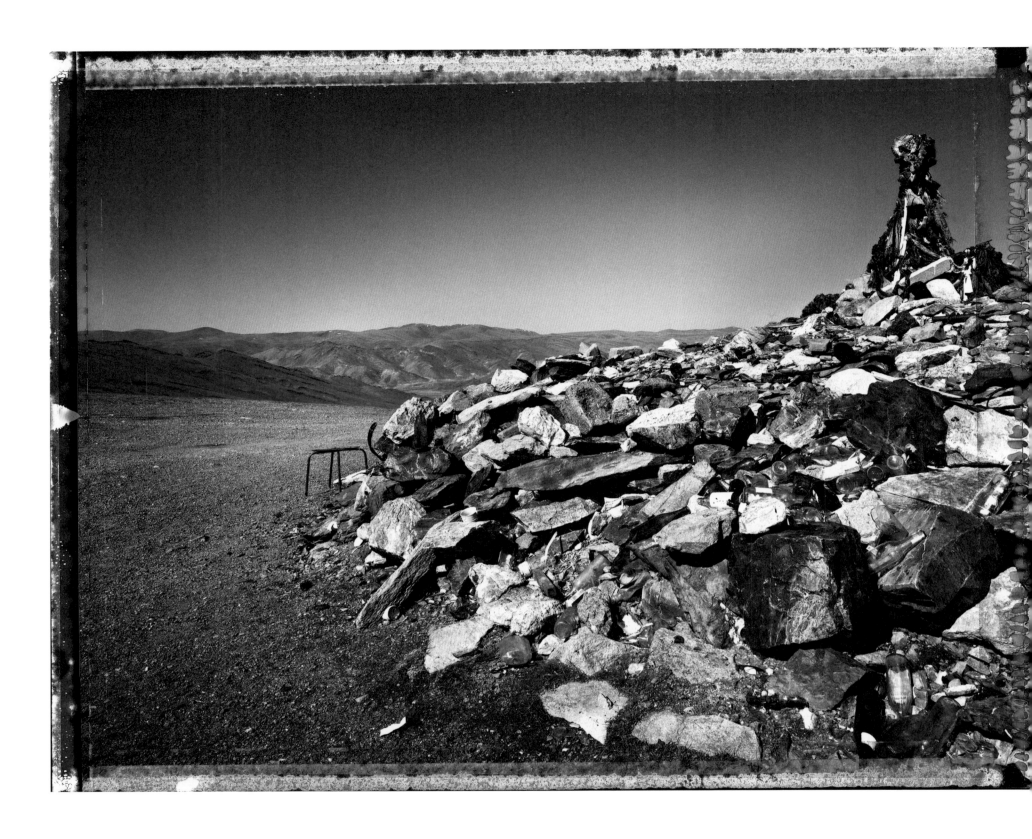

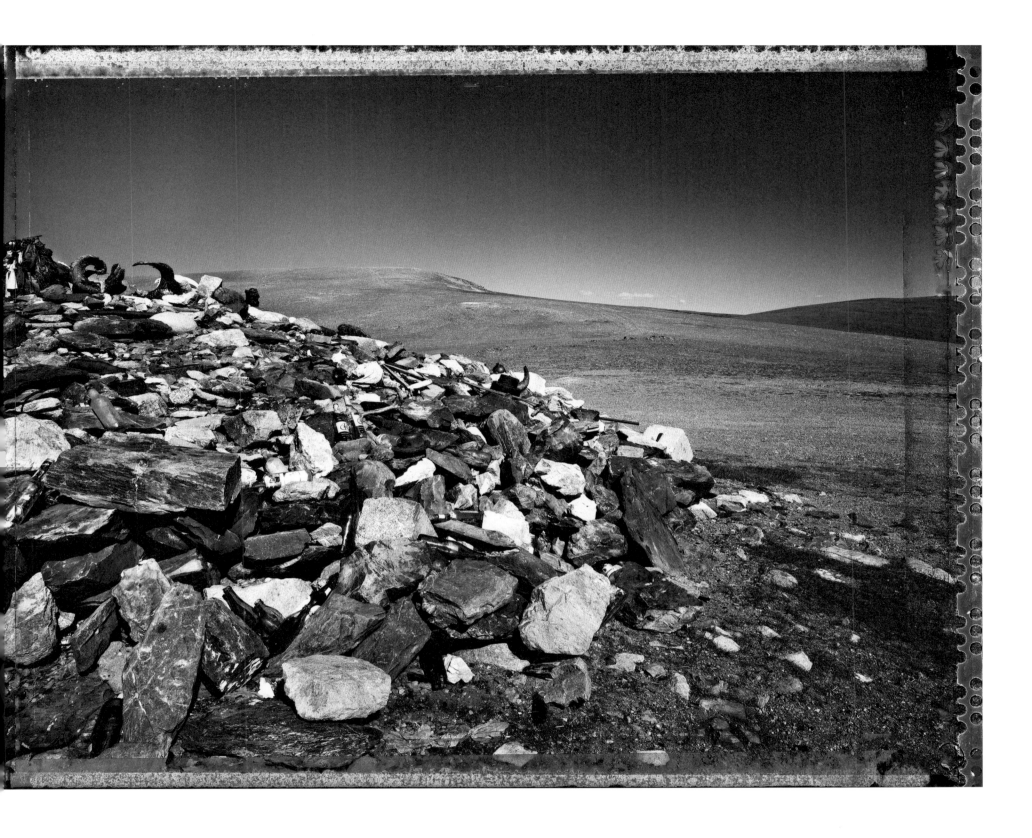

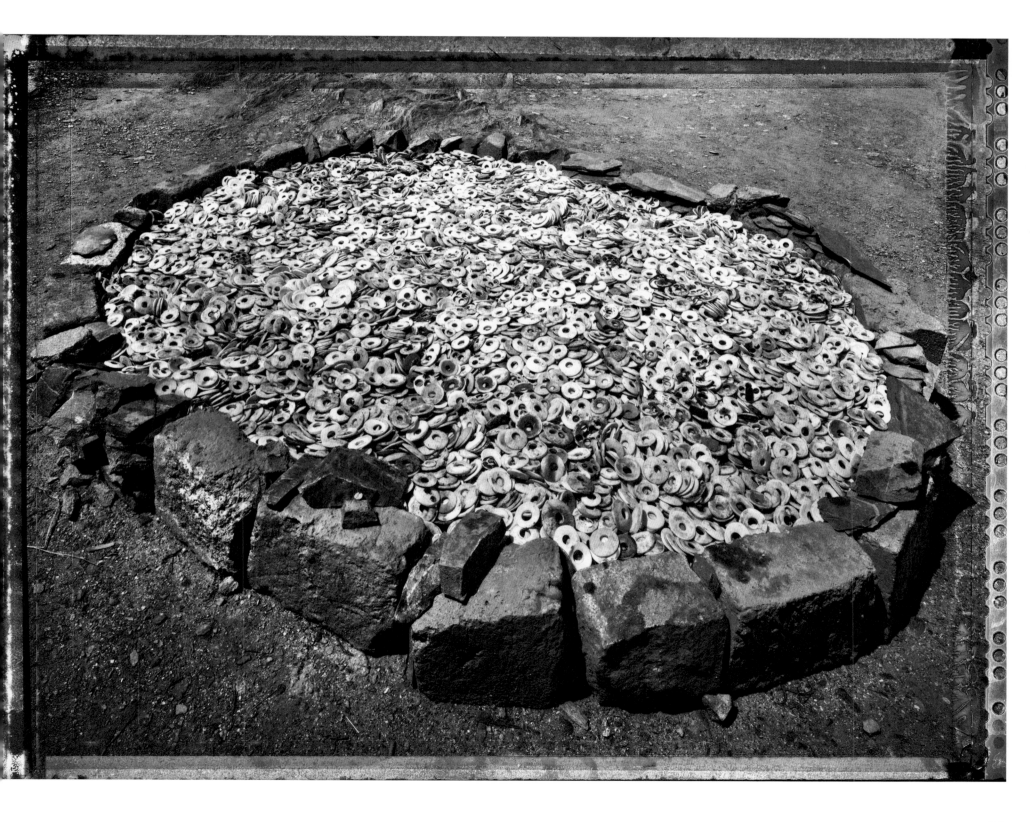

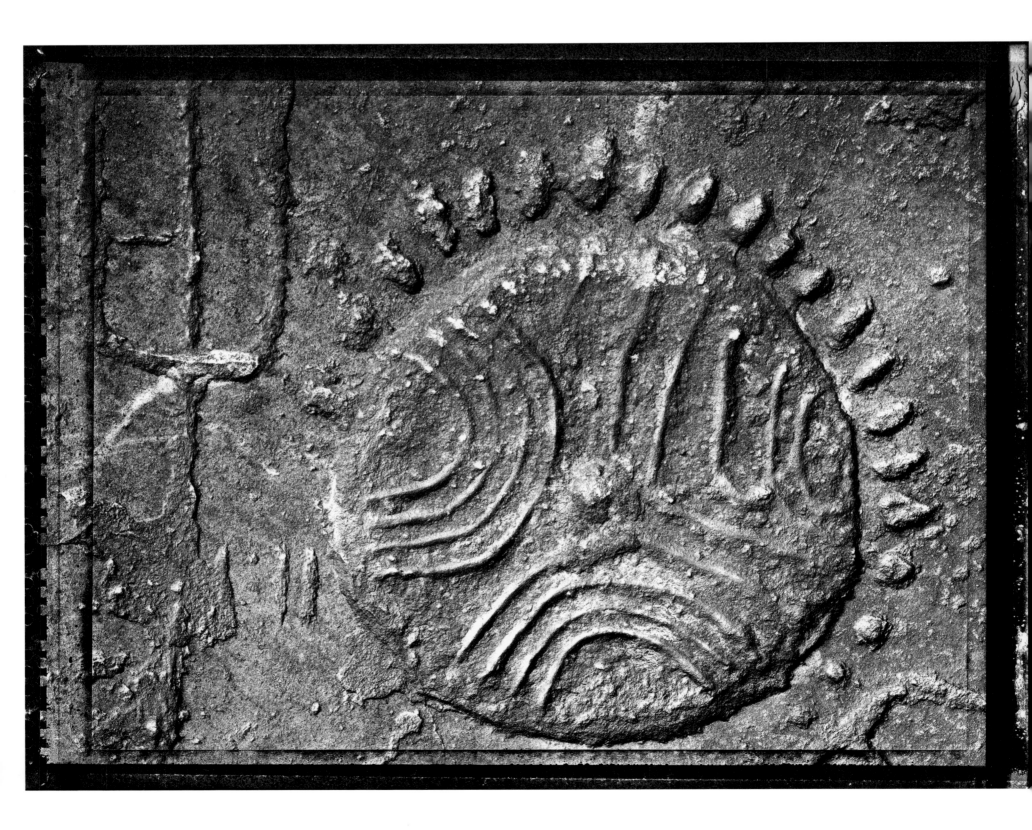

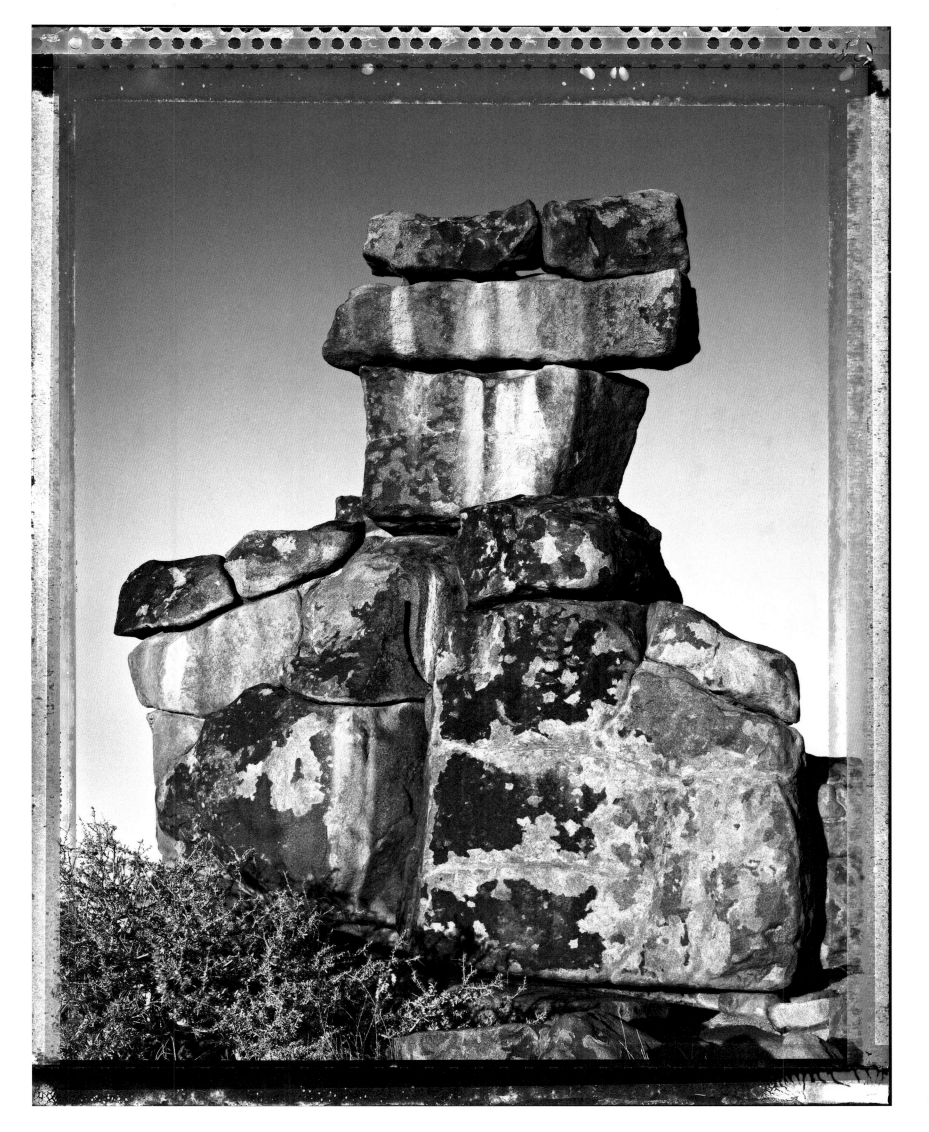

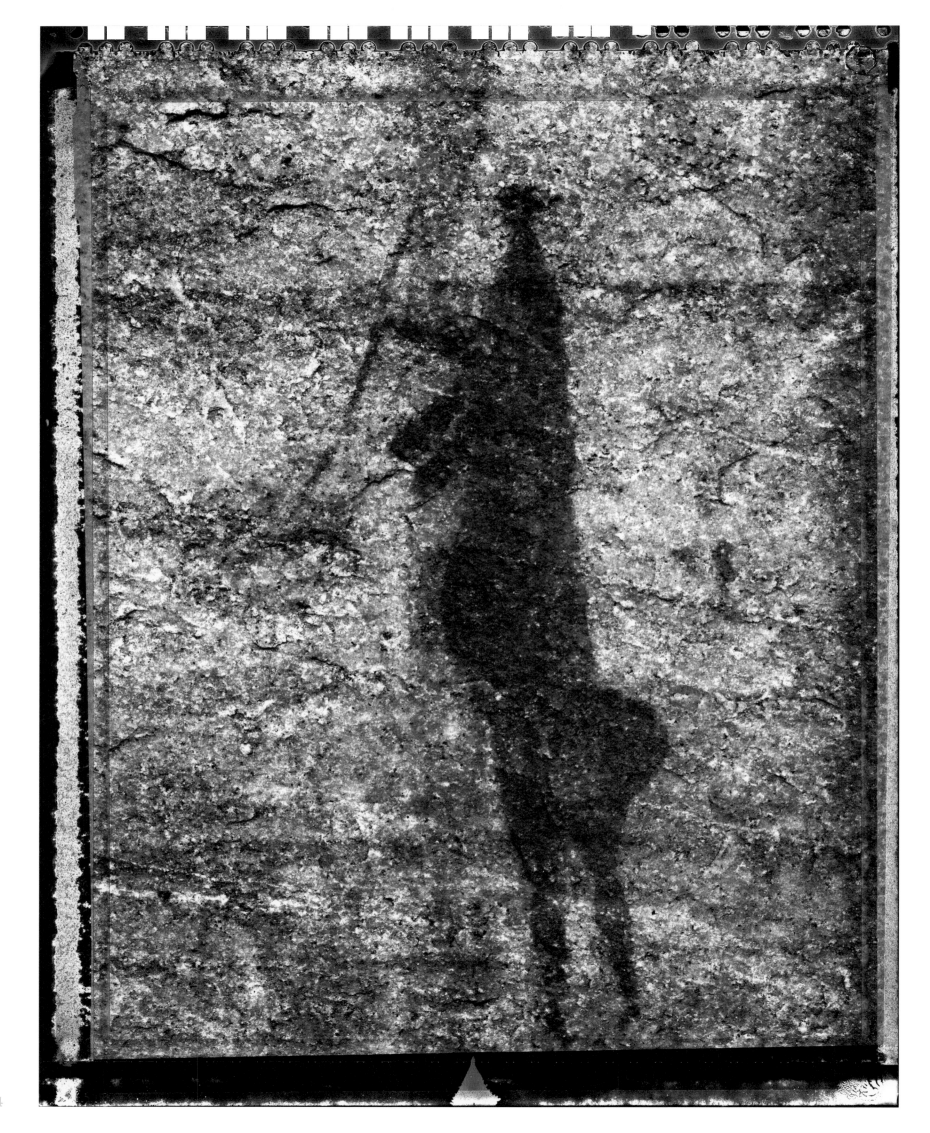

24

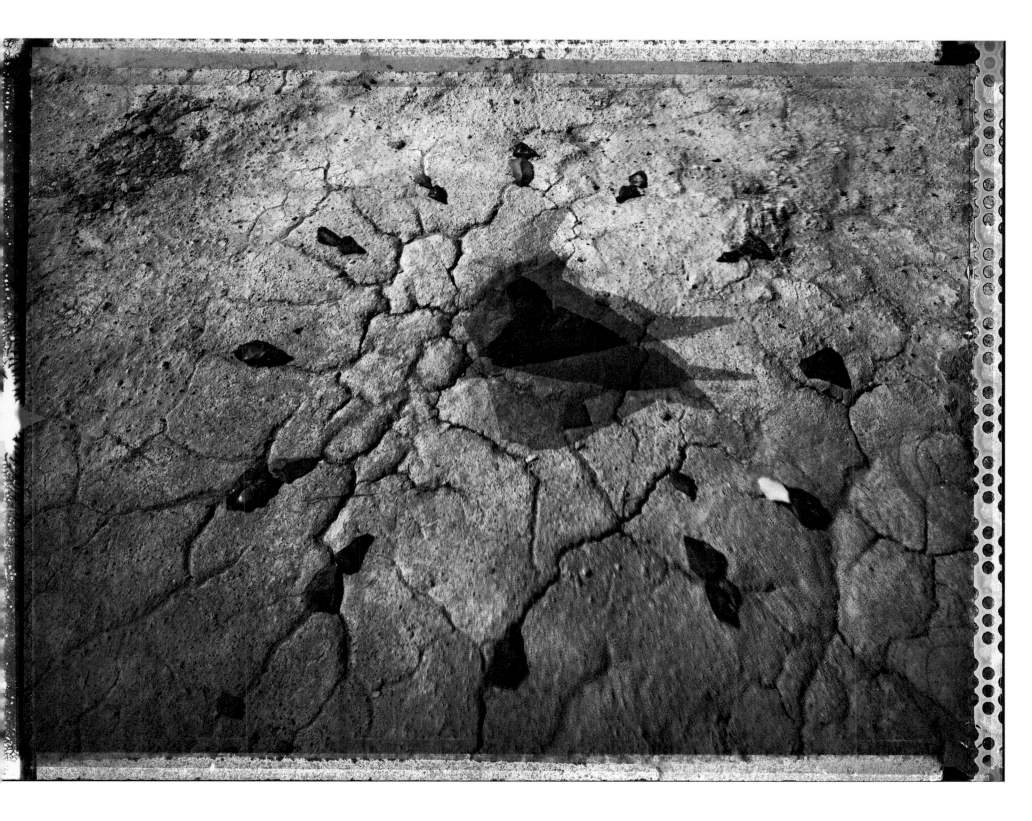

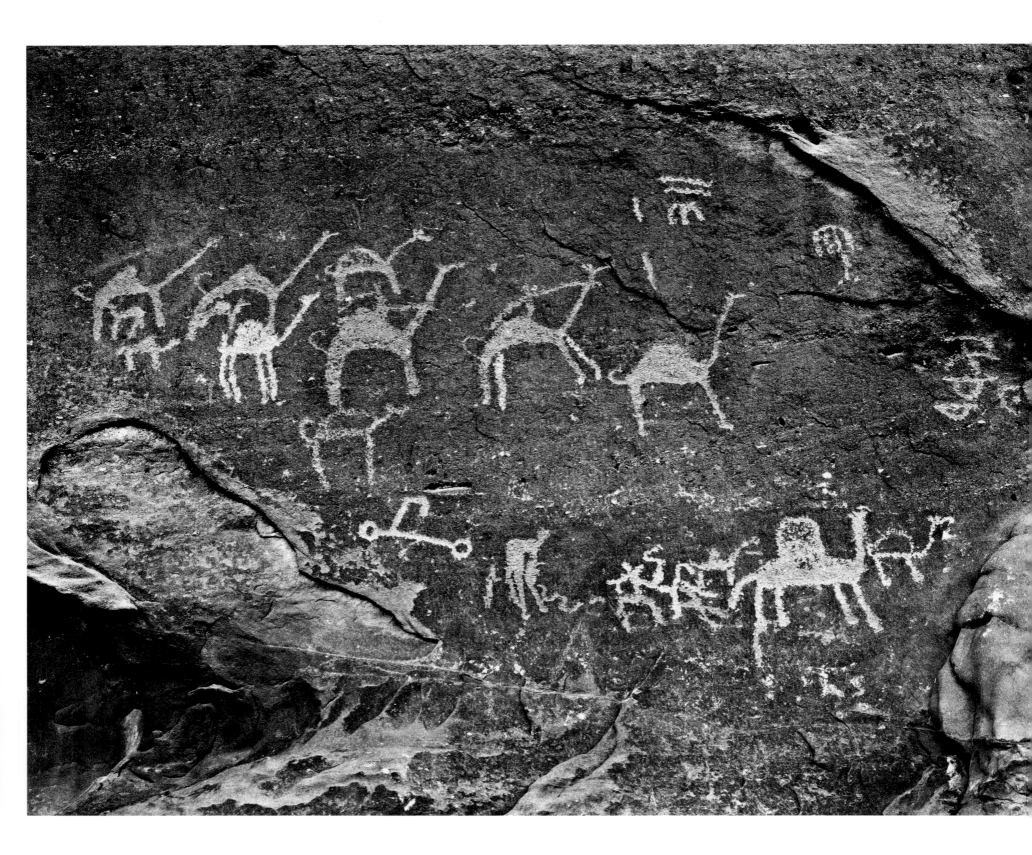

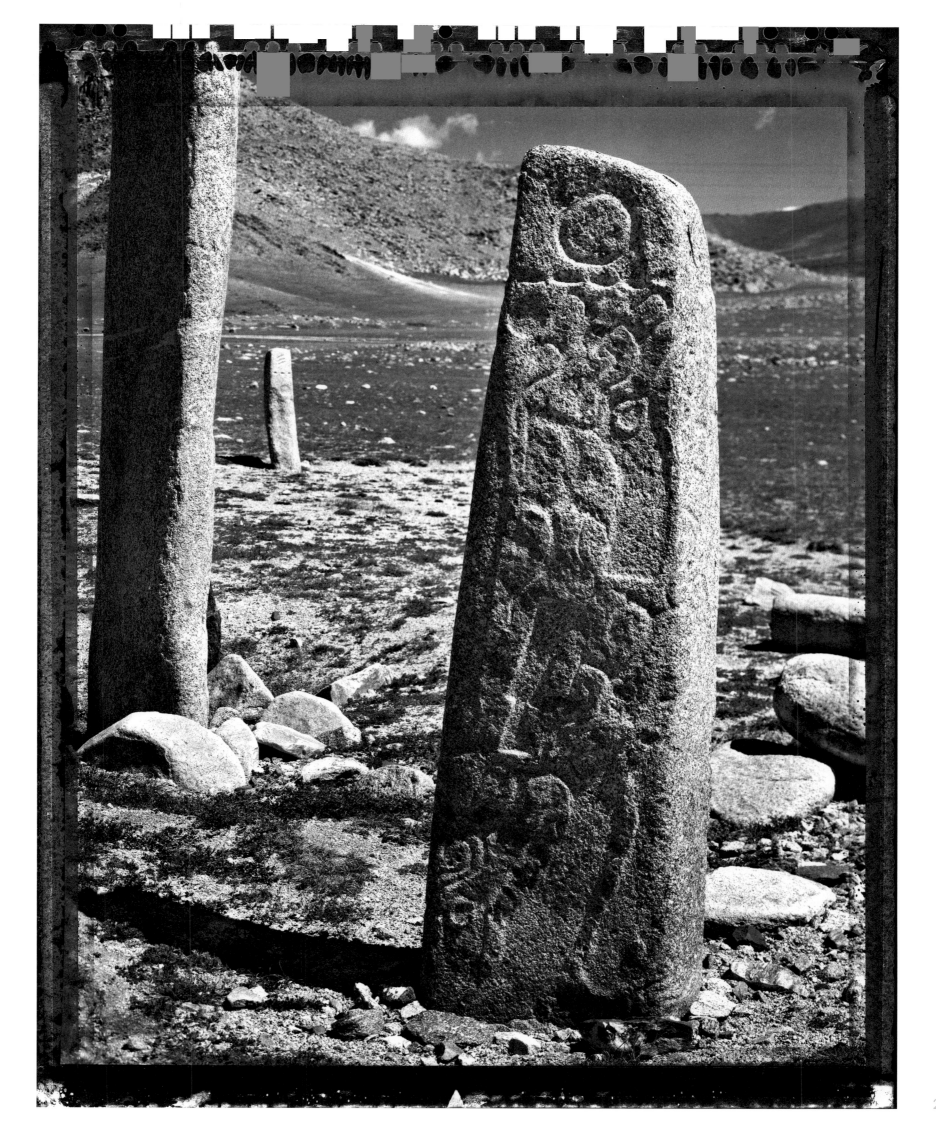

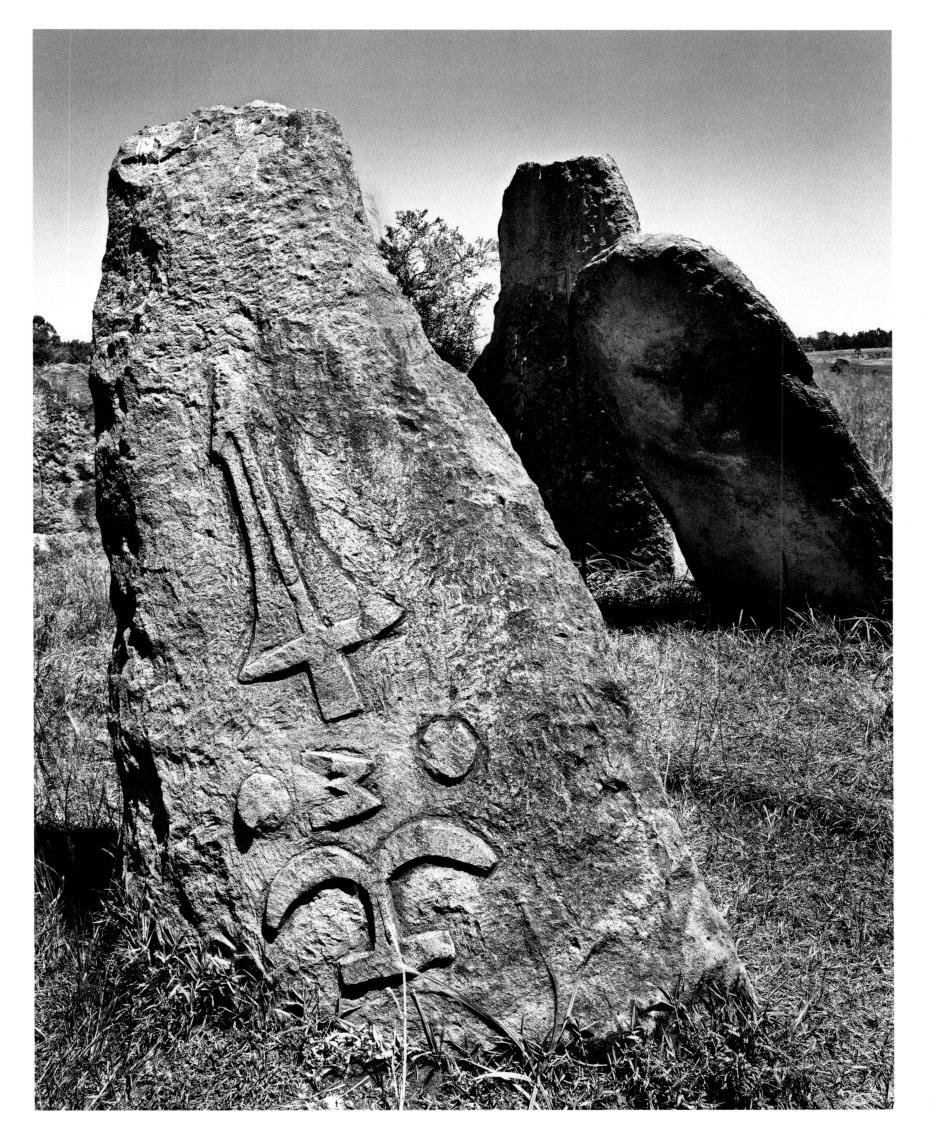

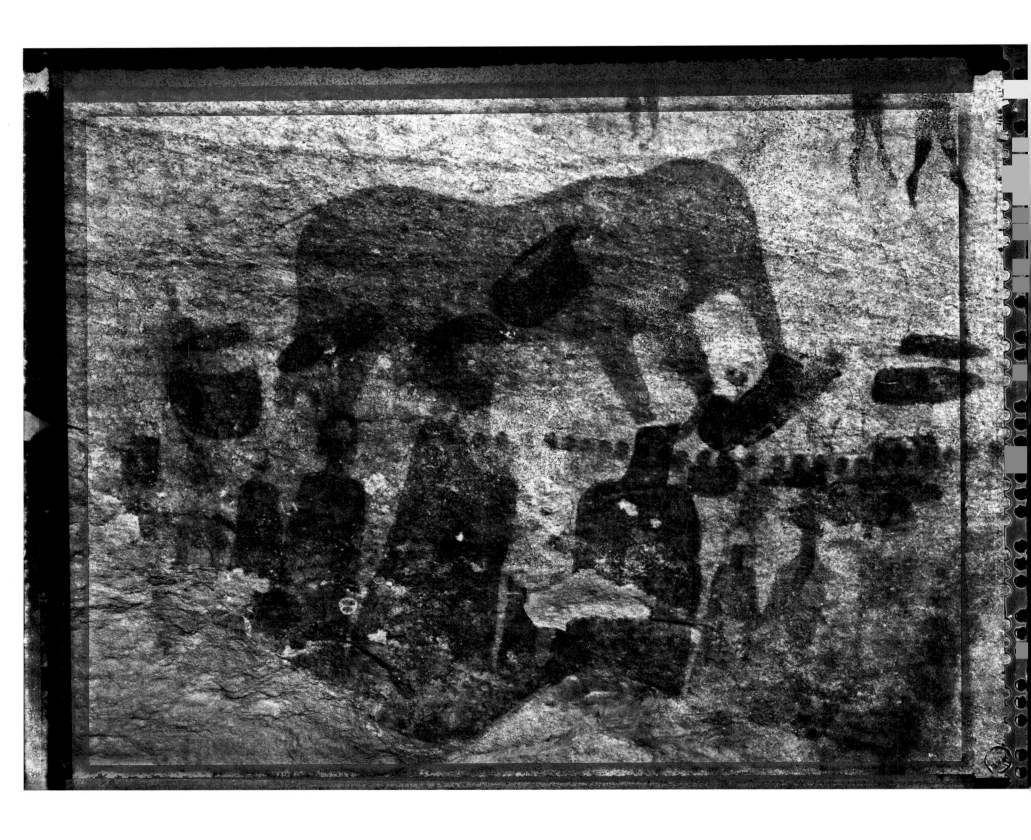

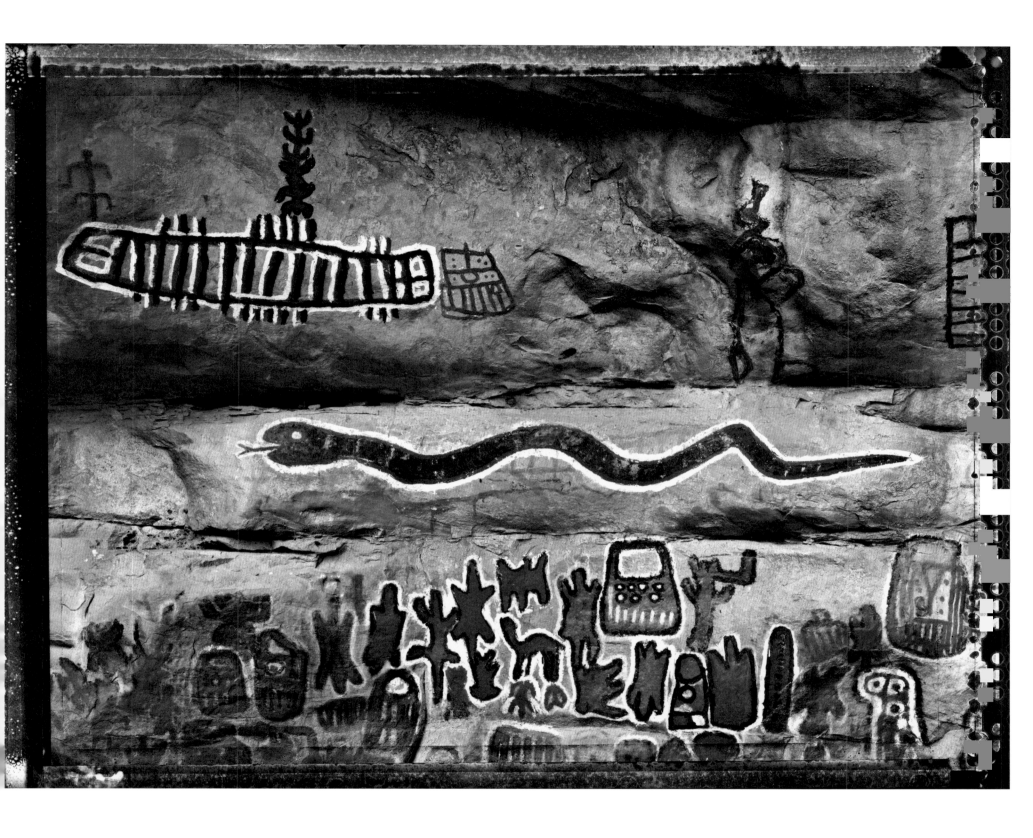

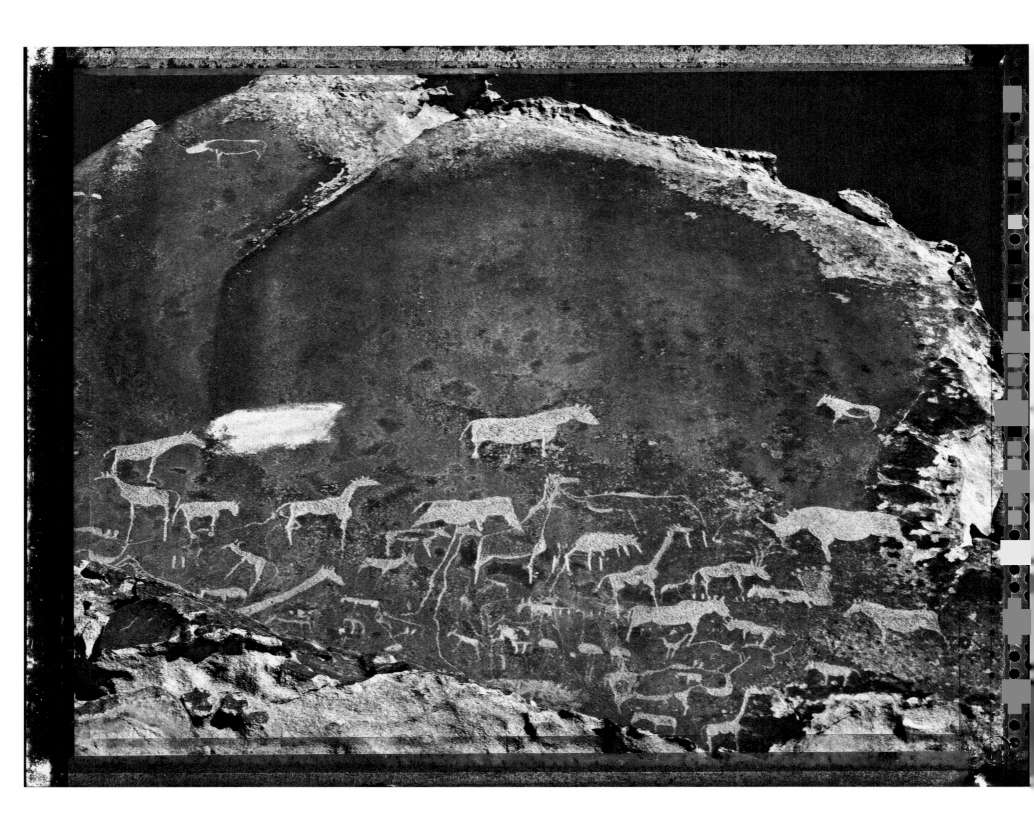

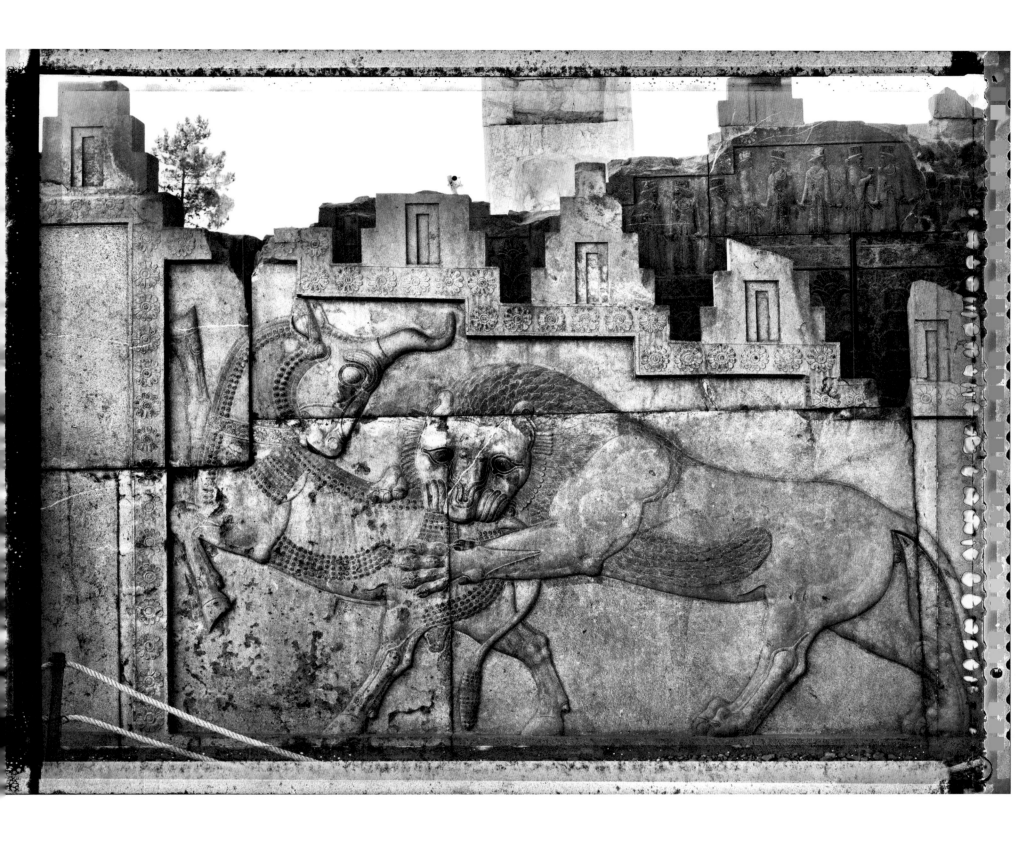

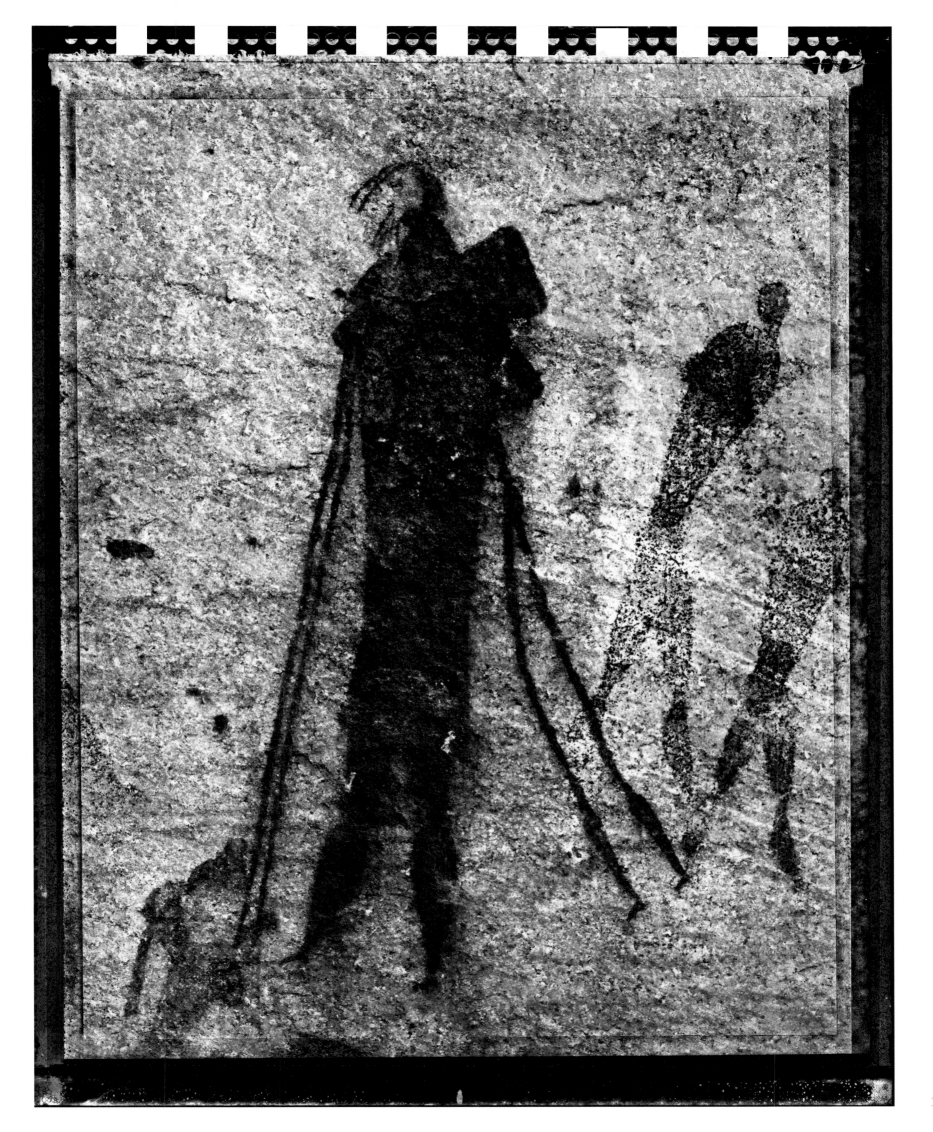

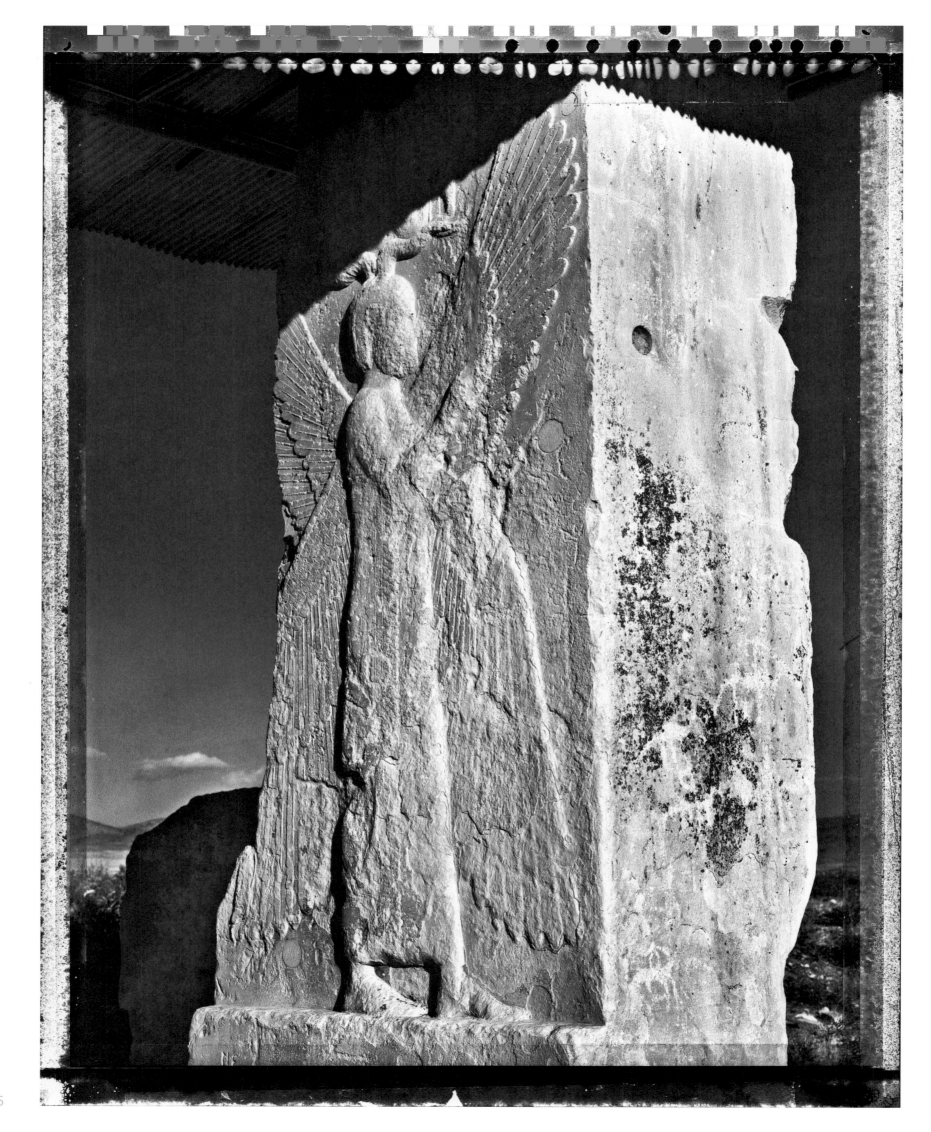

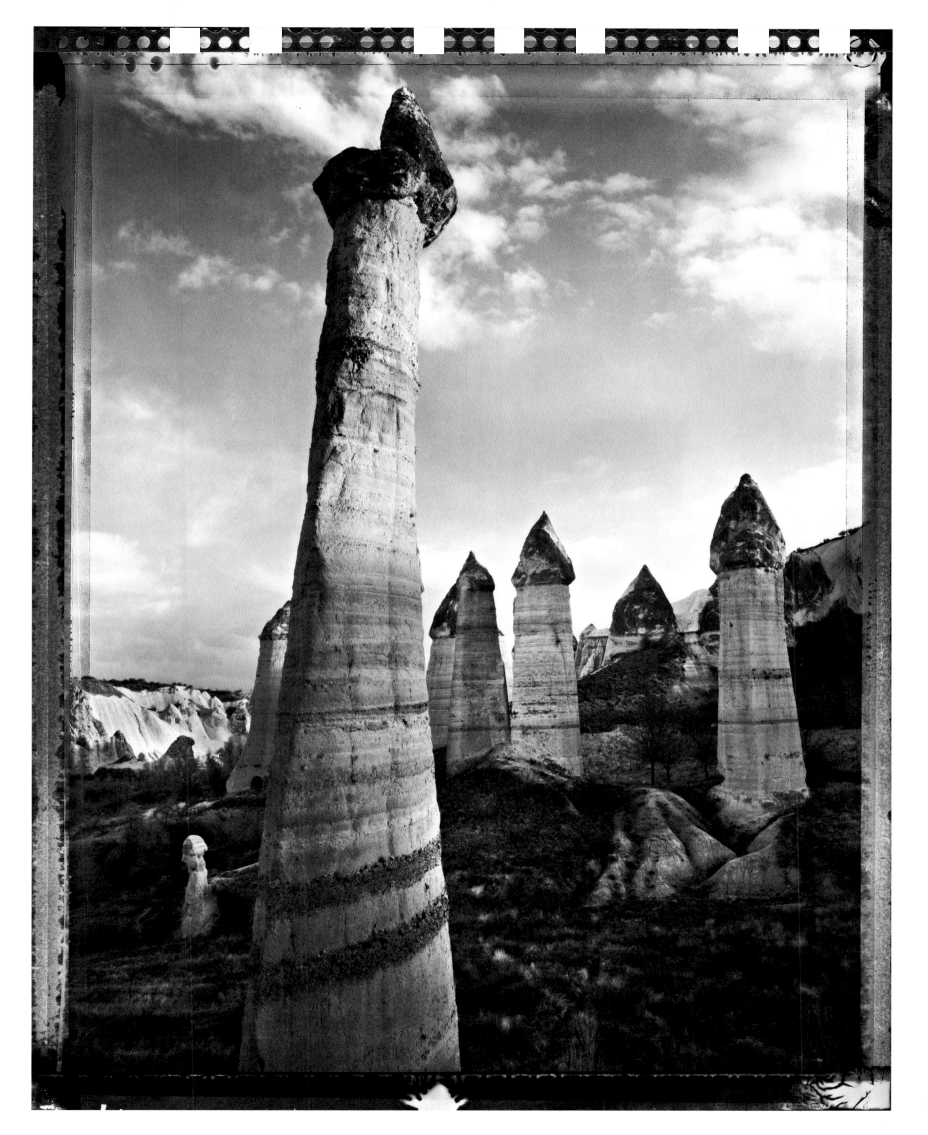

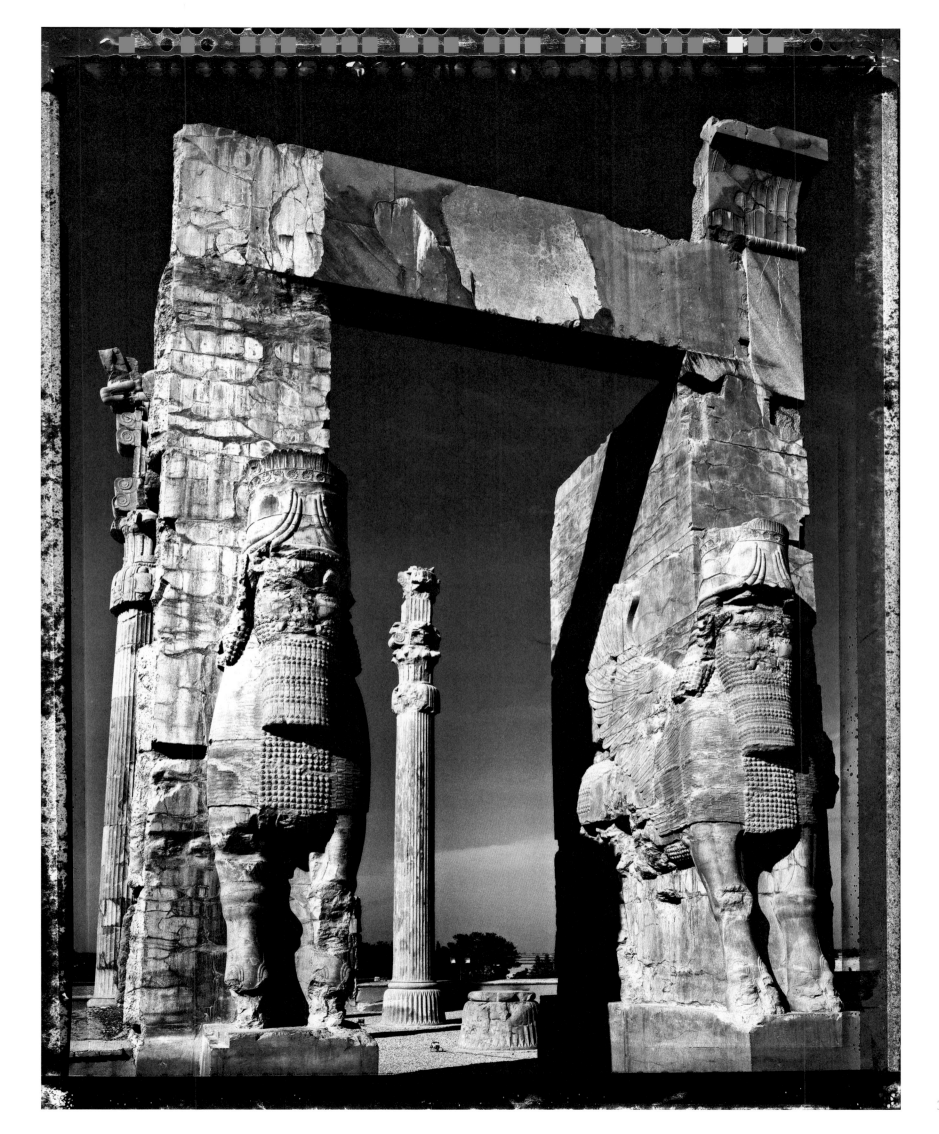

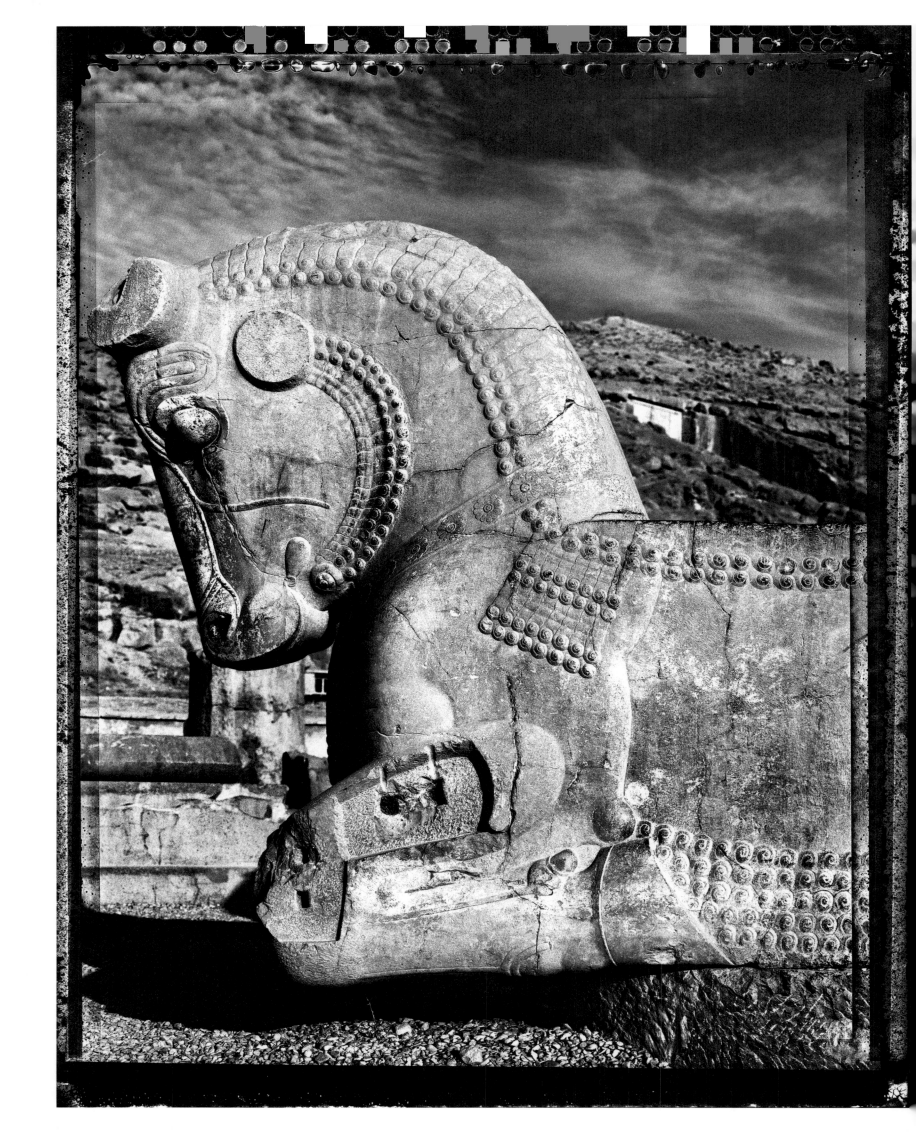

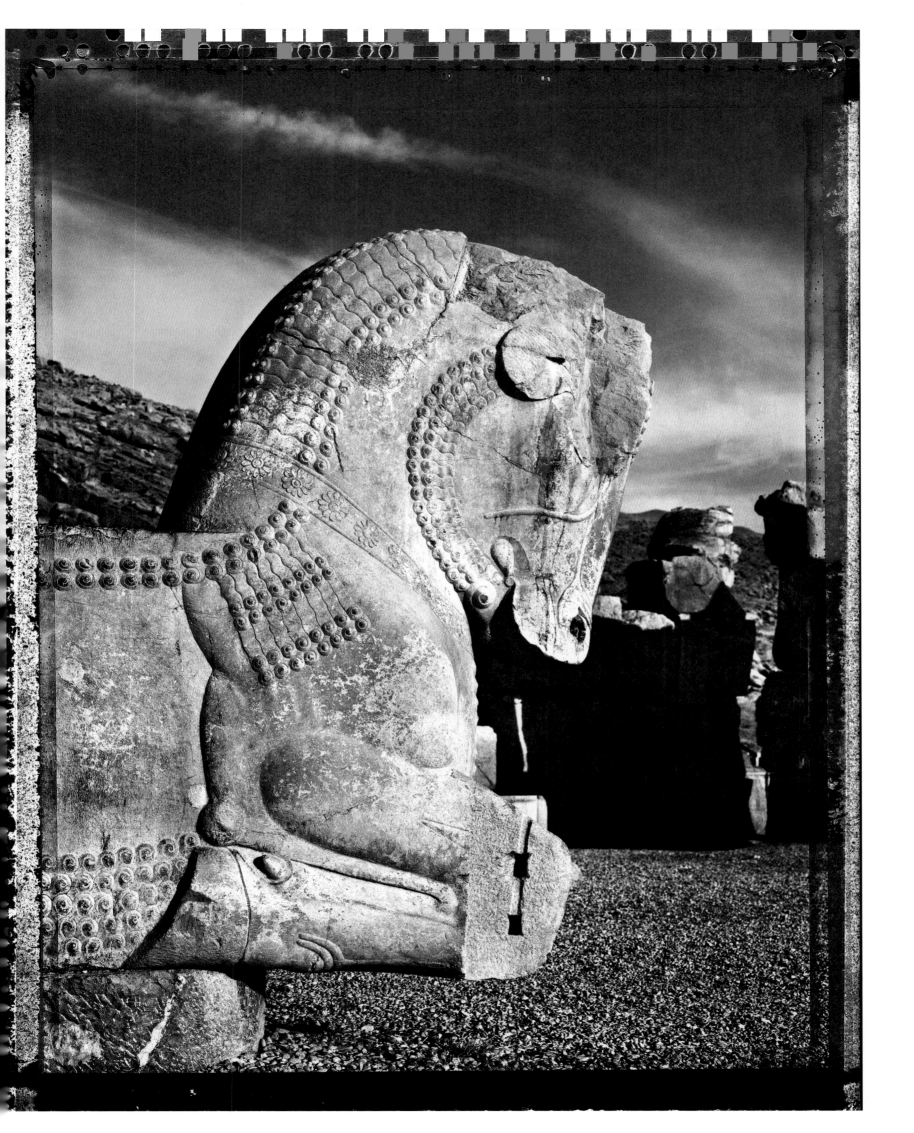

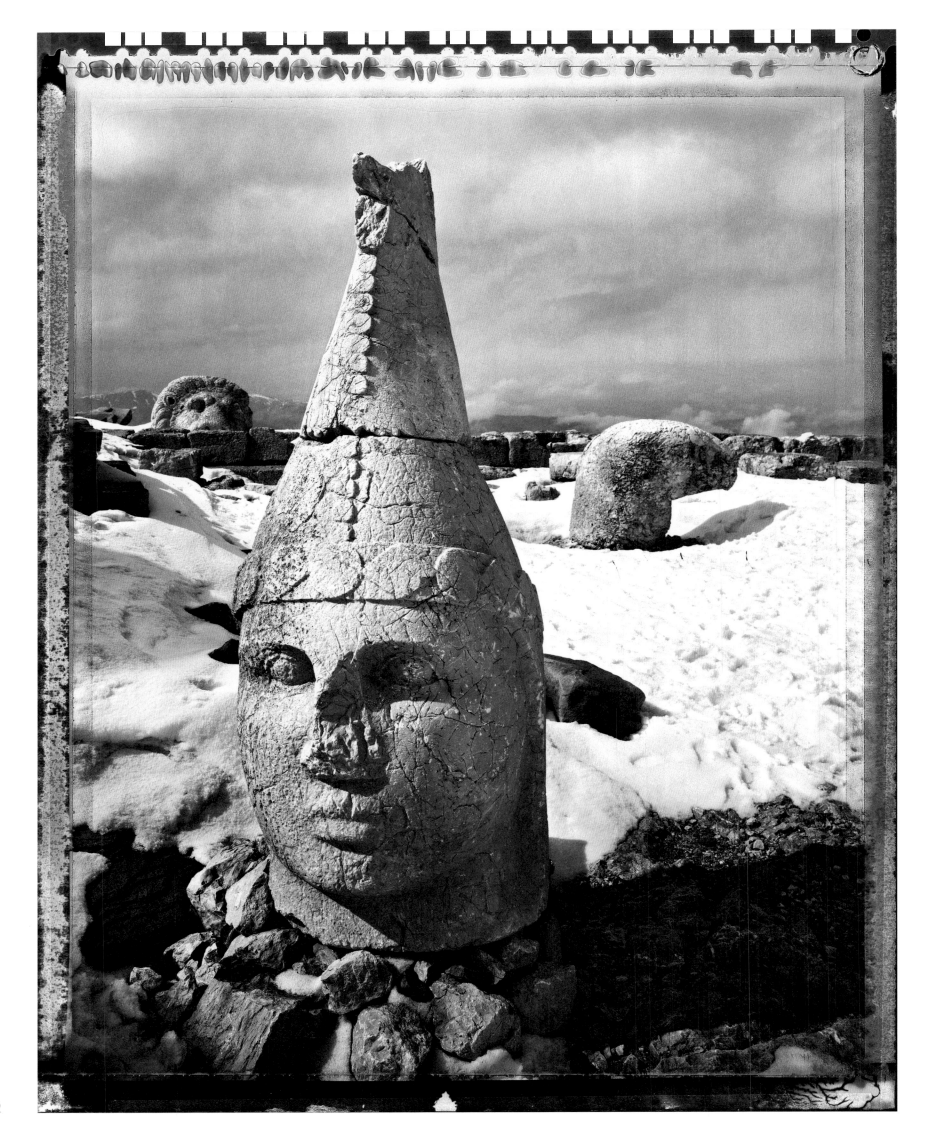

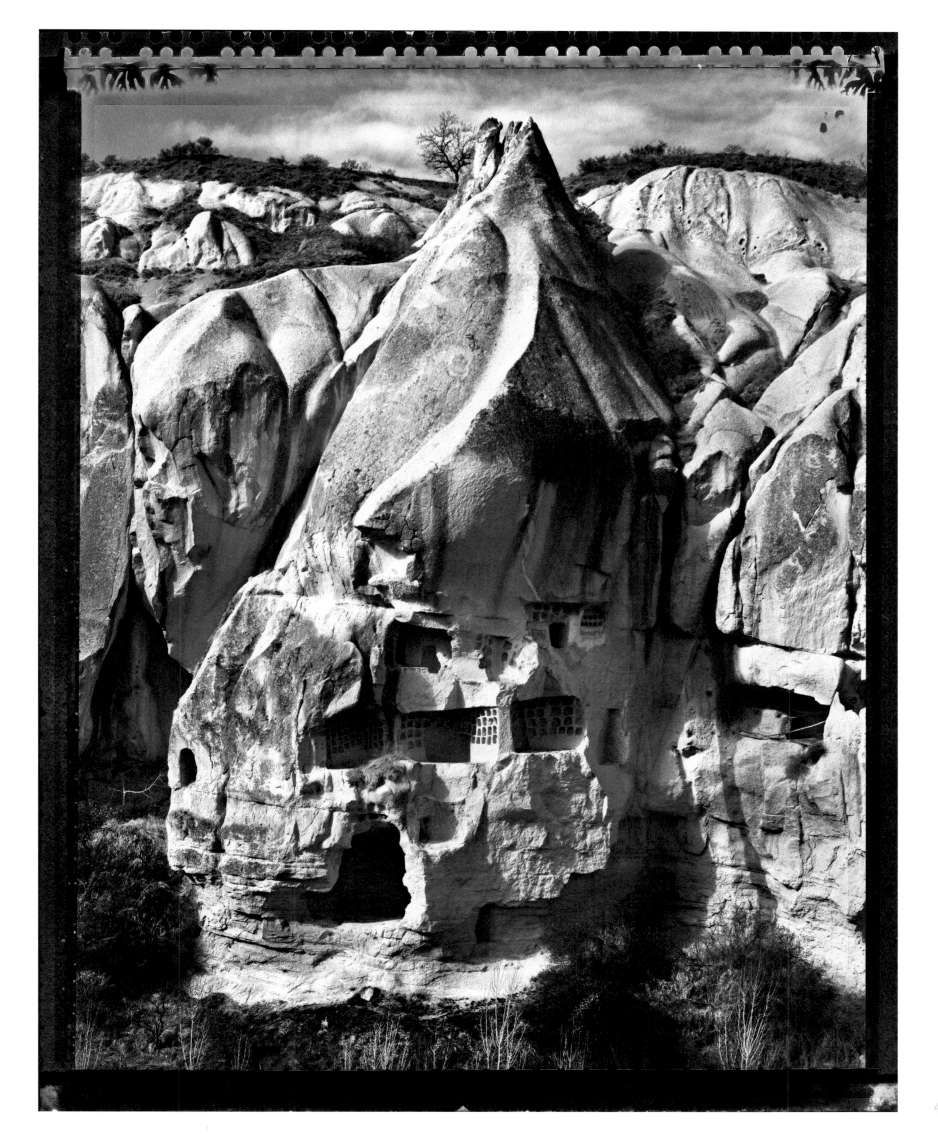

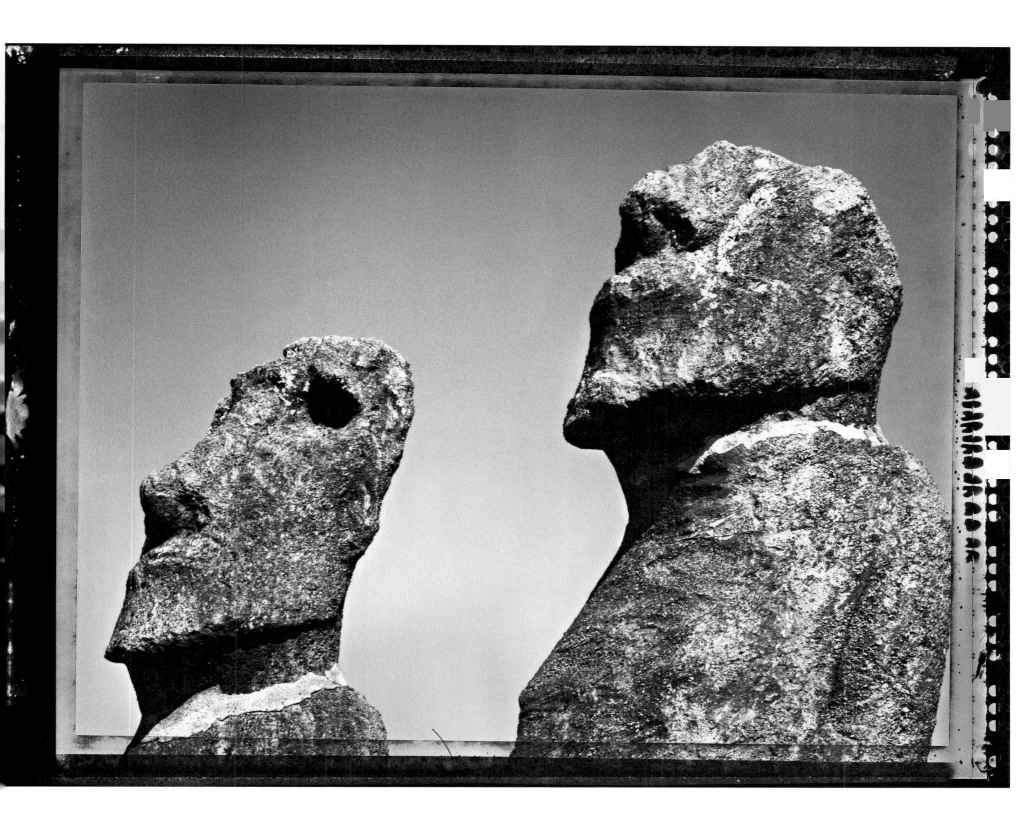

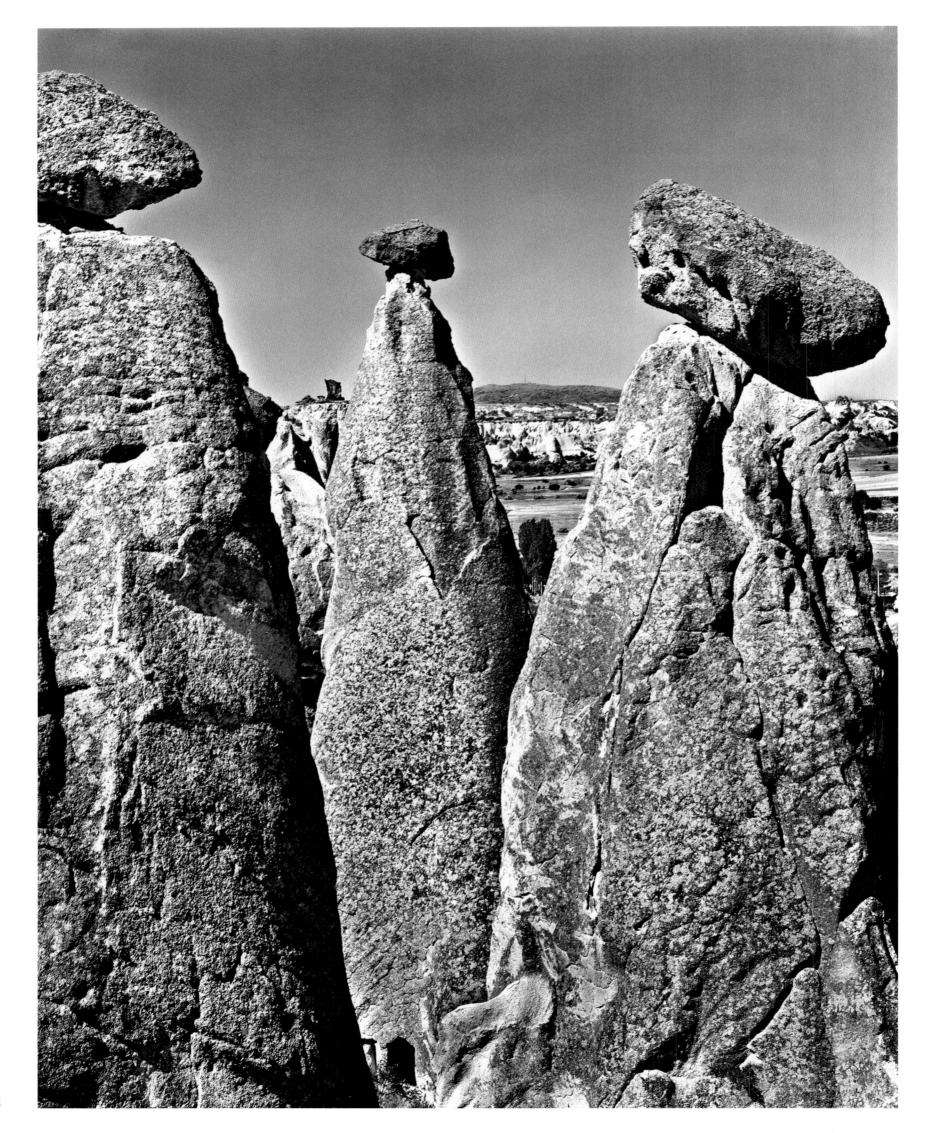

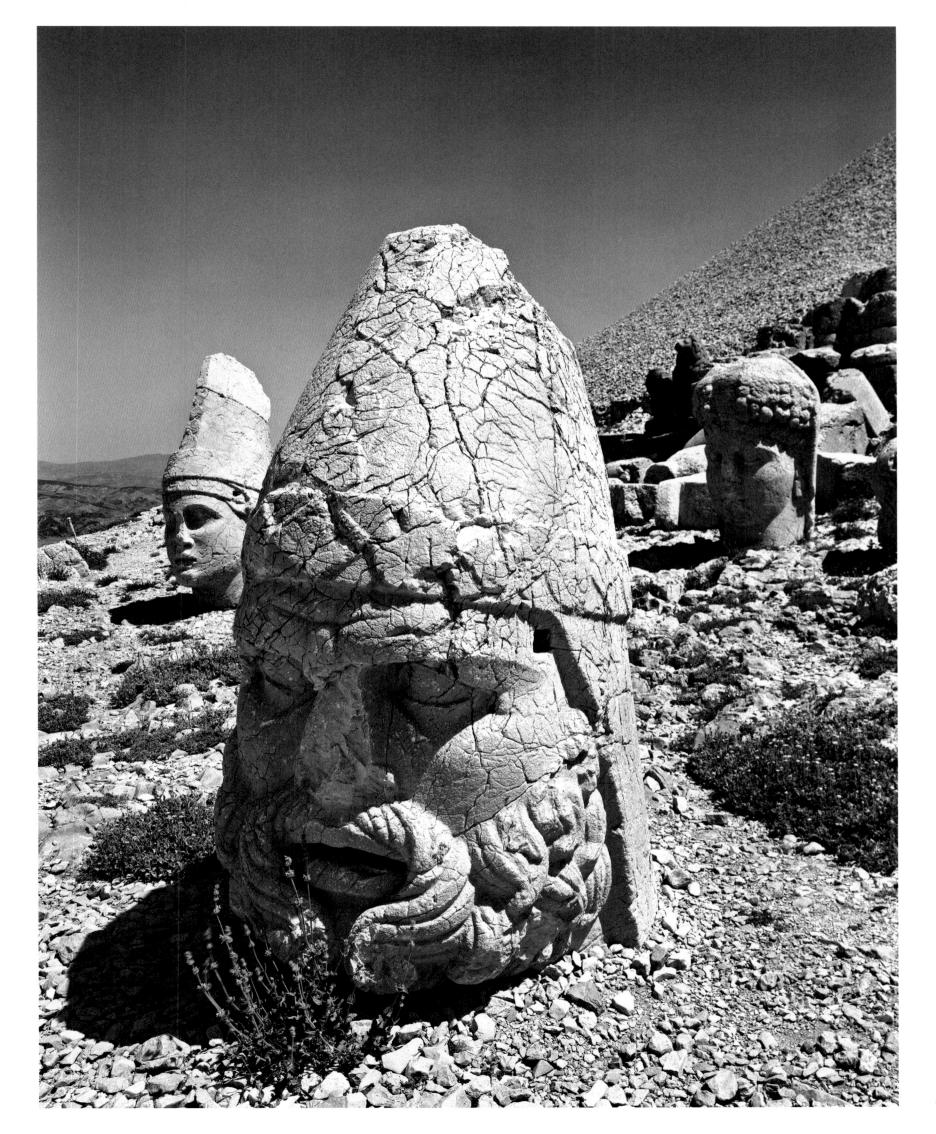

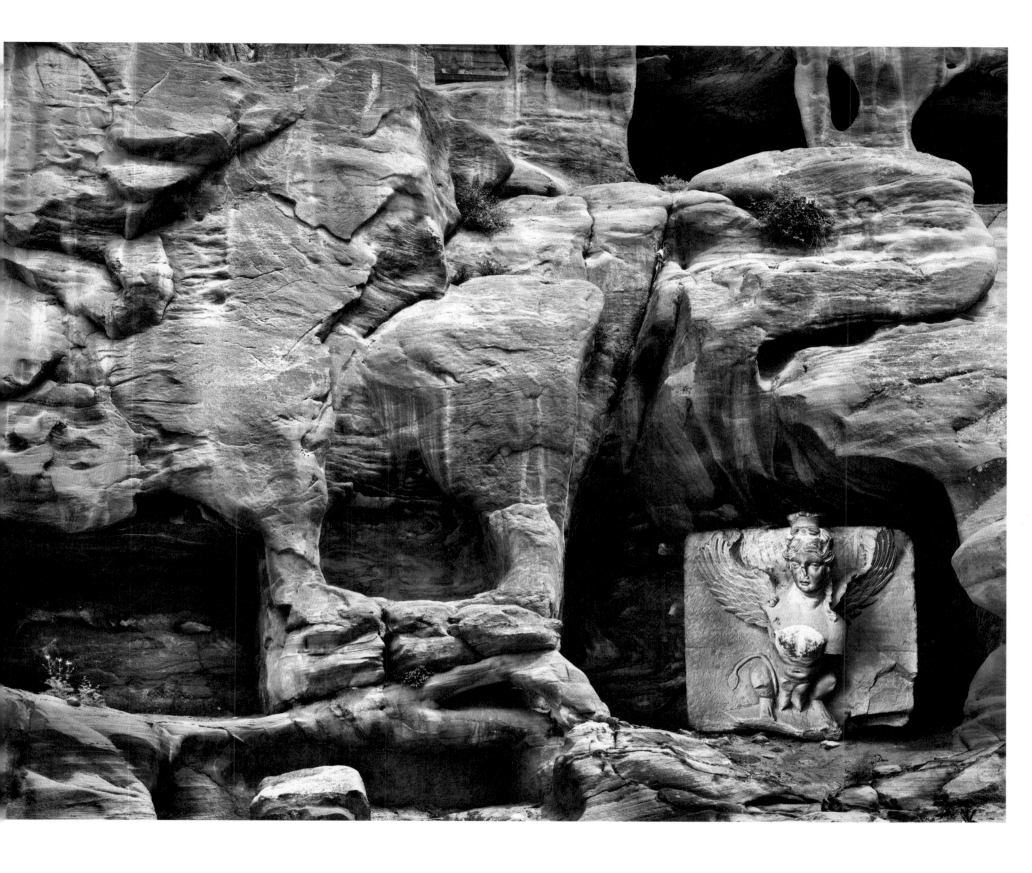

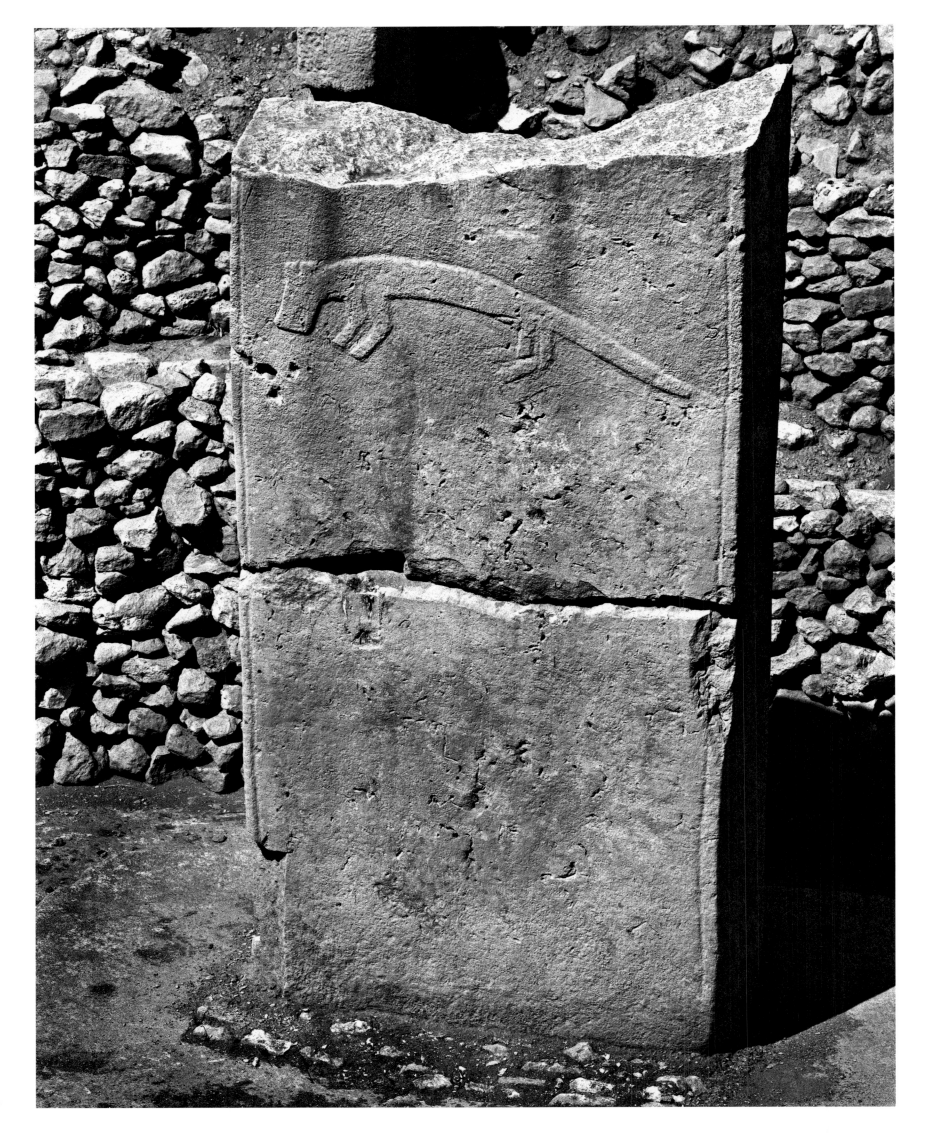

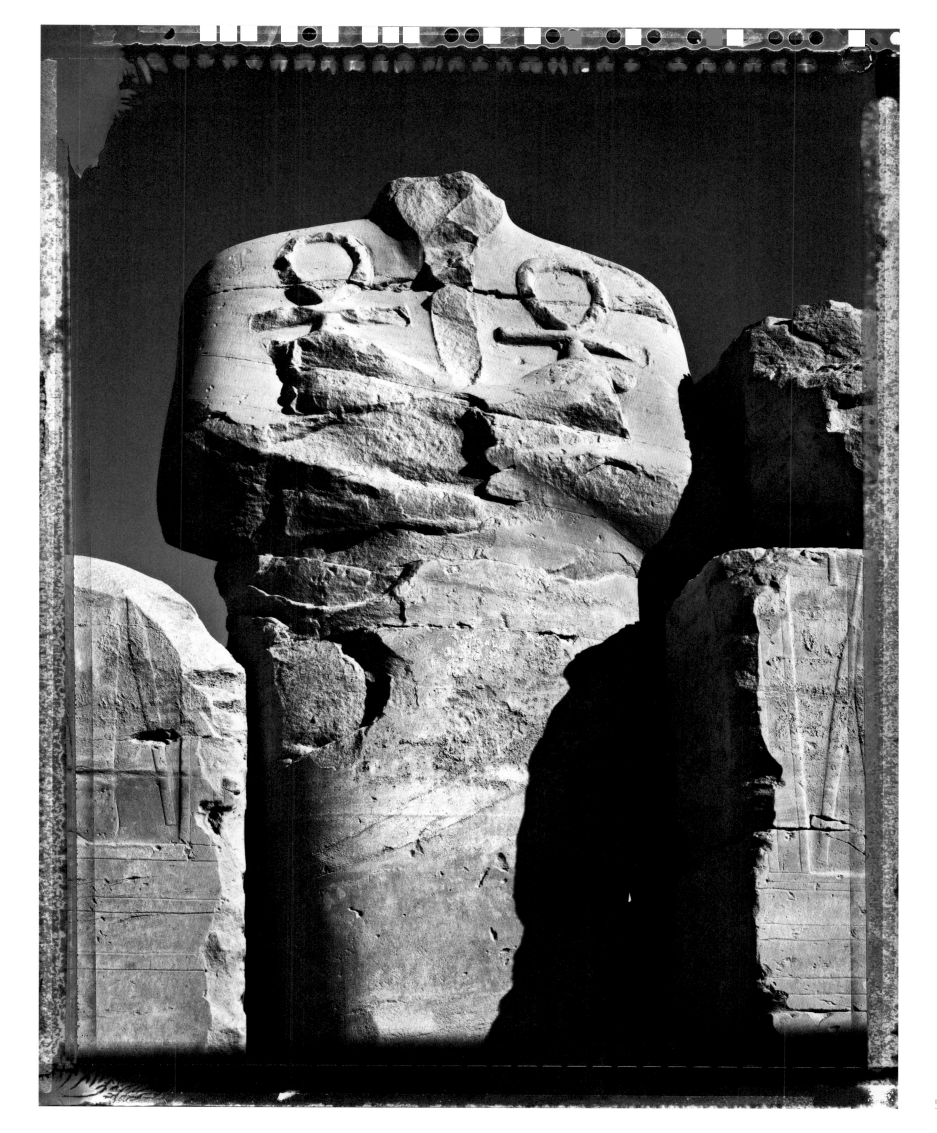

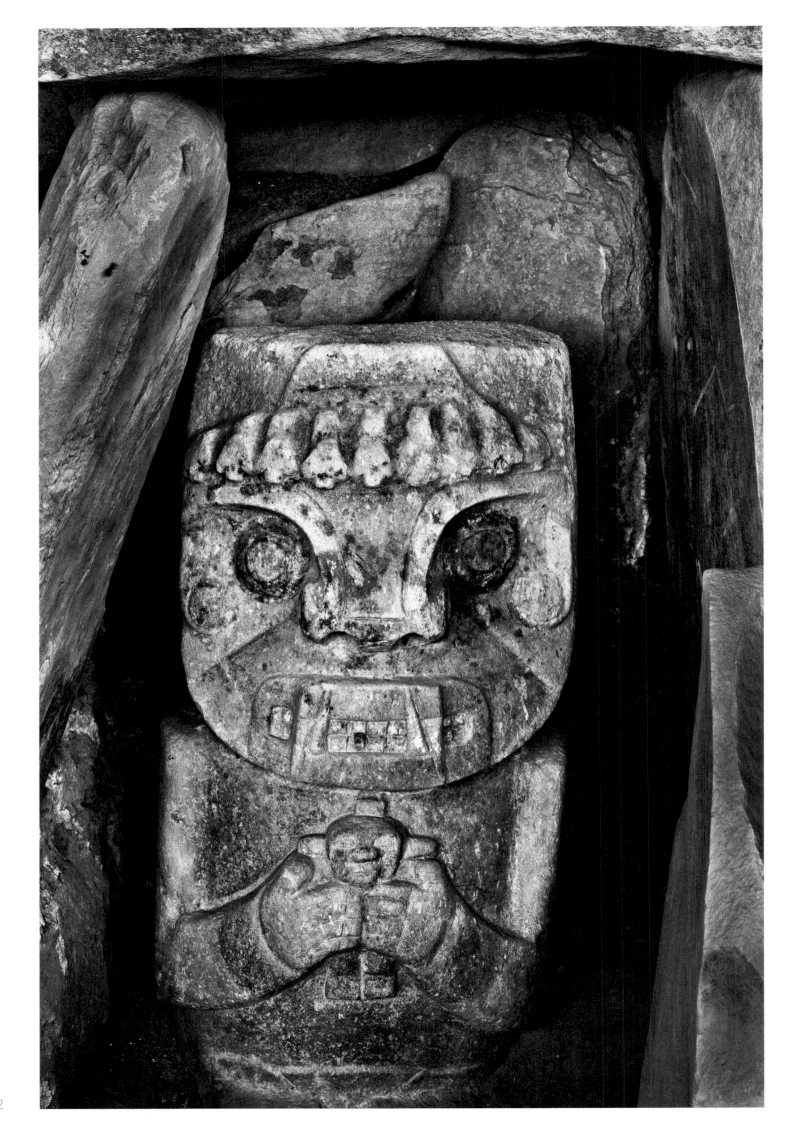

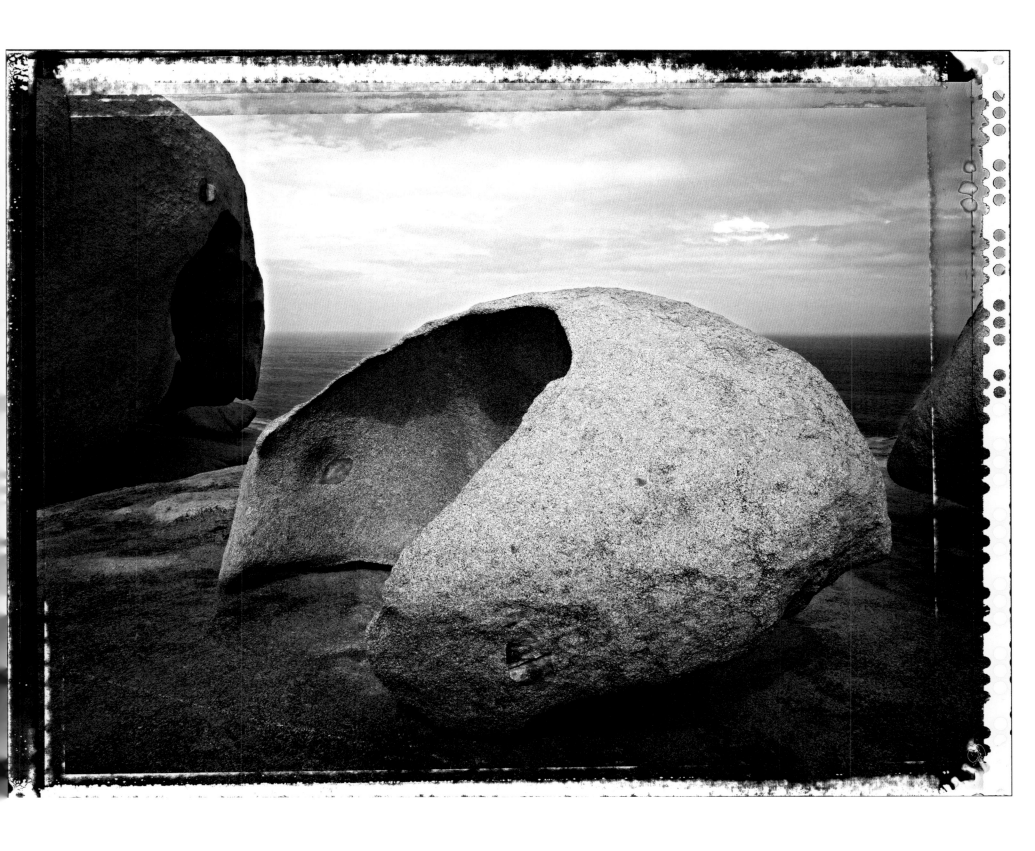

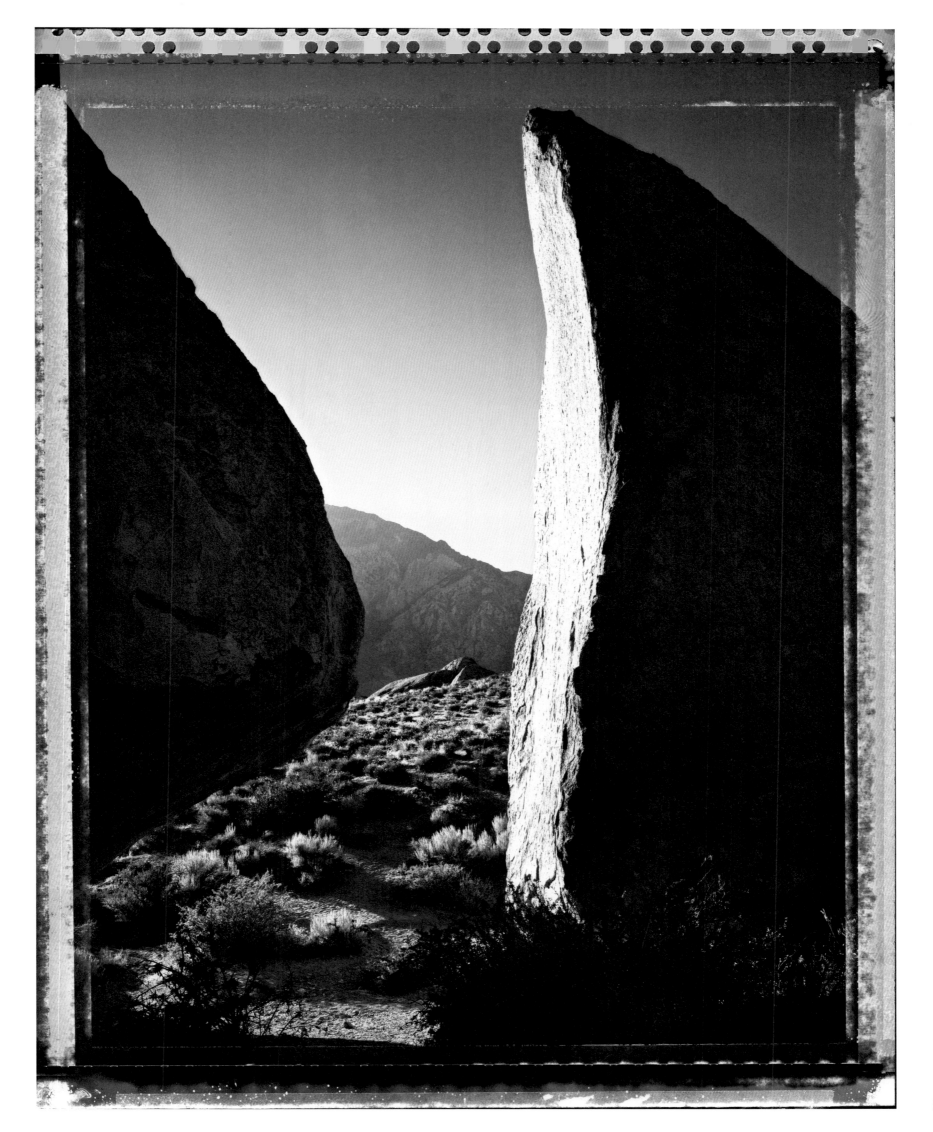

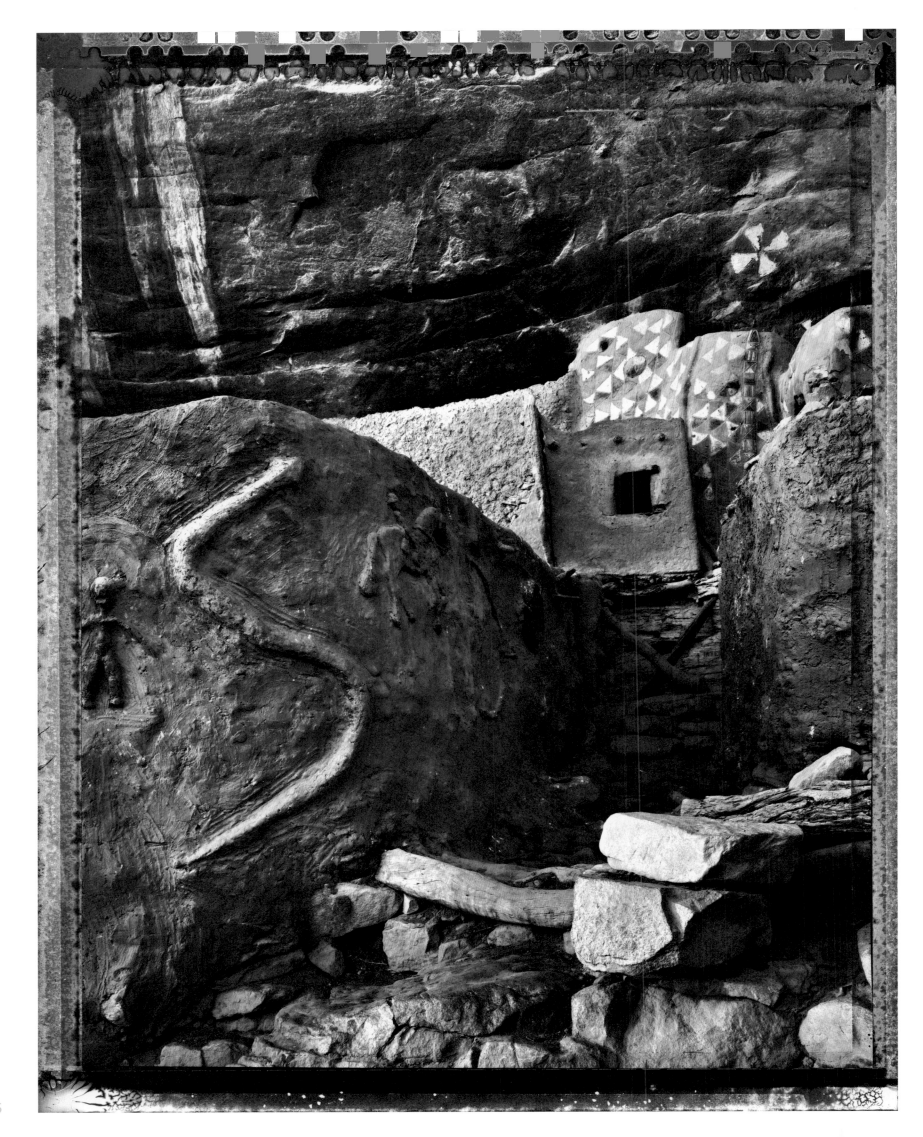

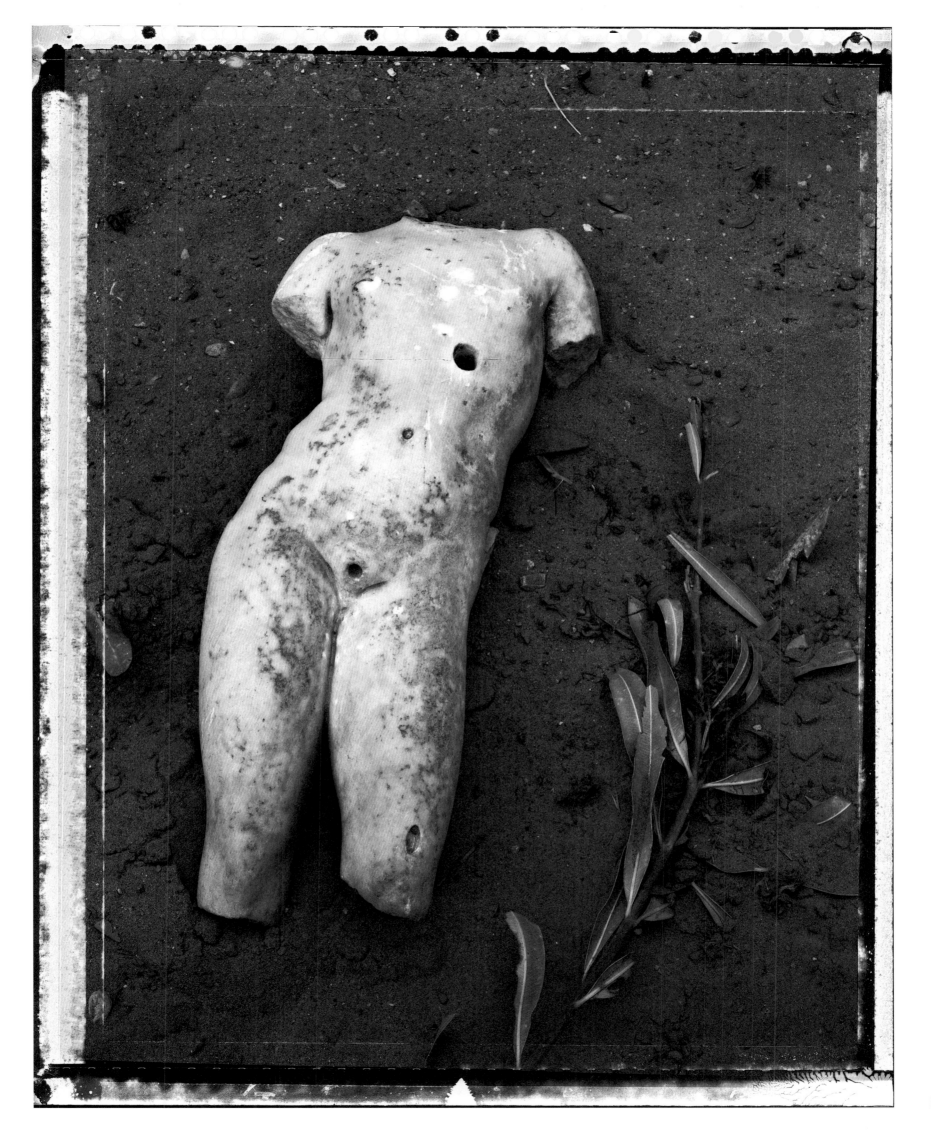

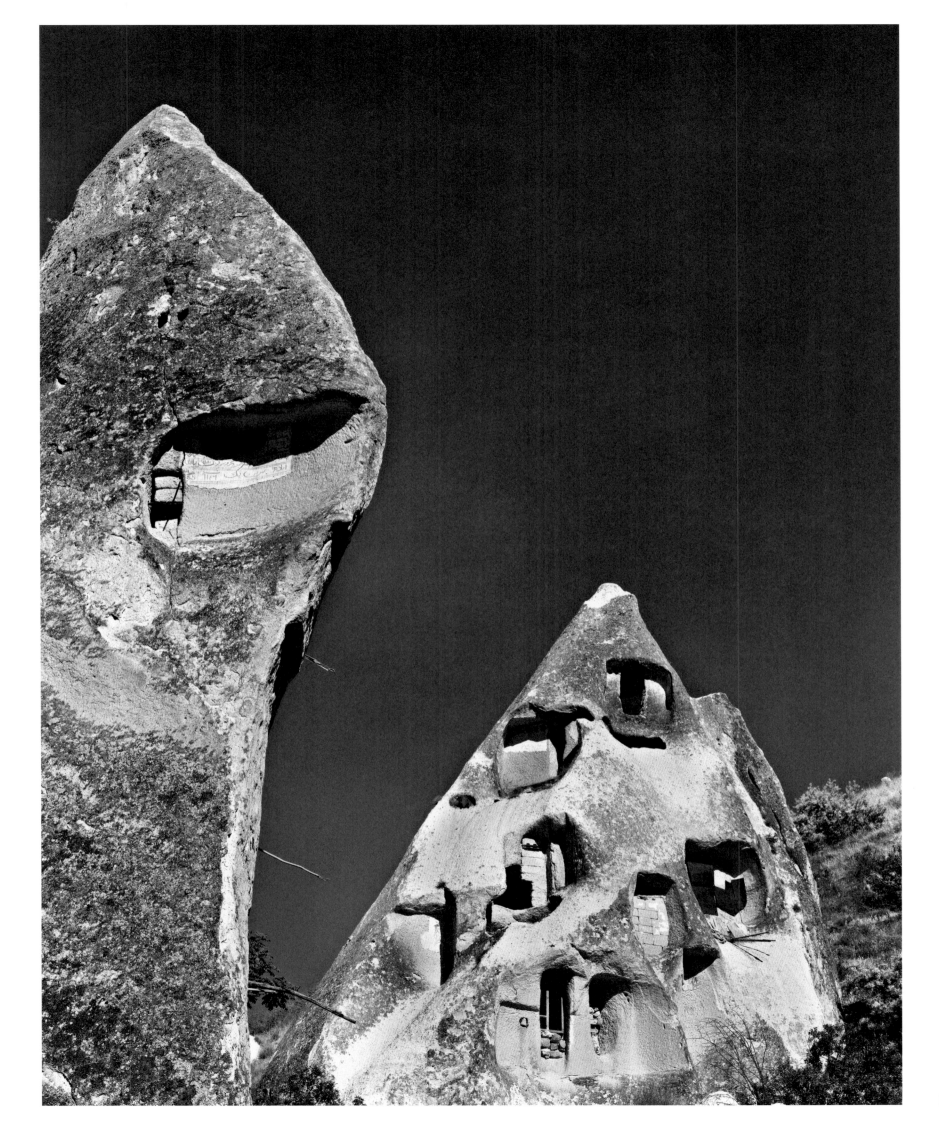

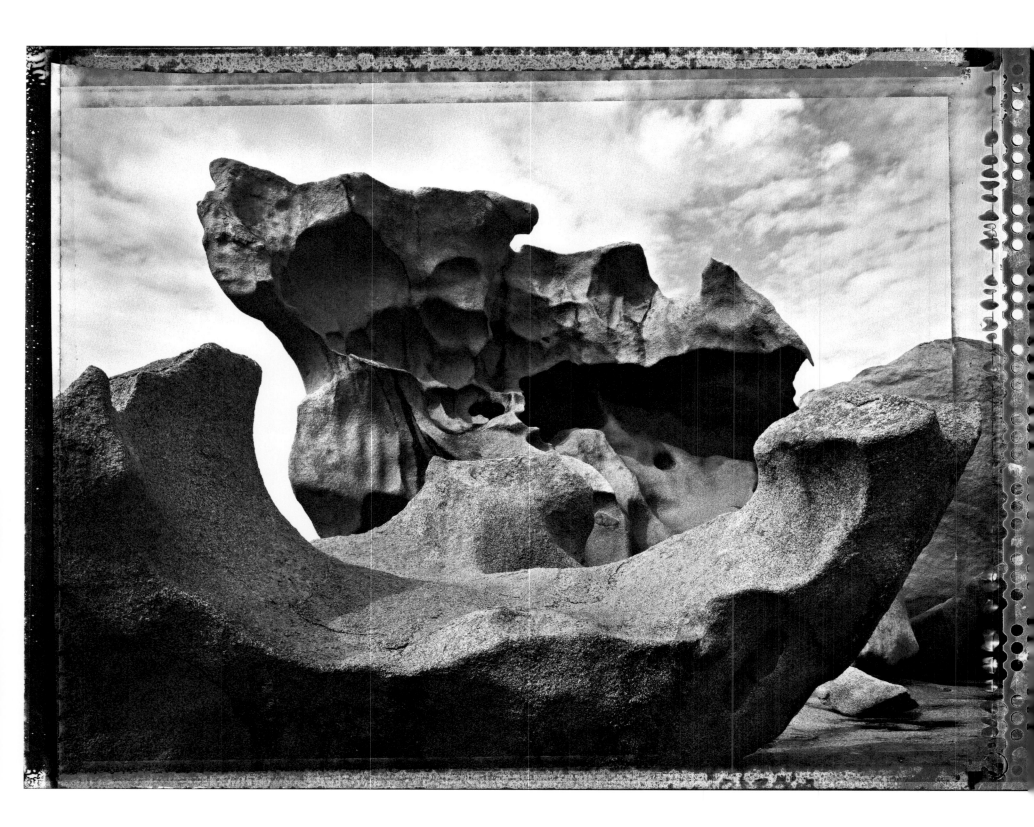

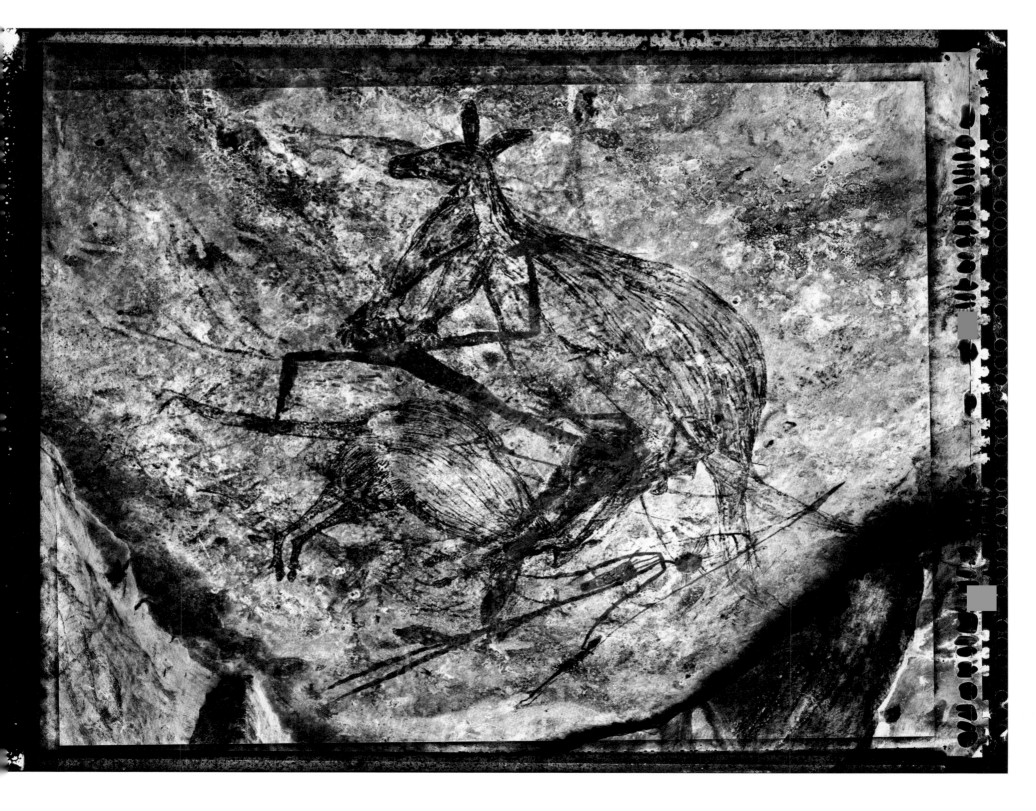

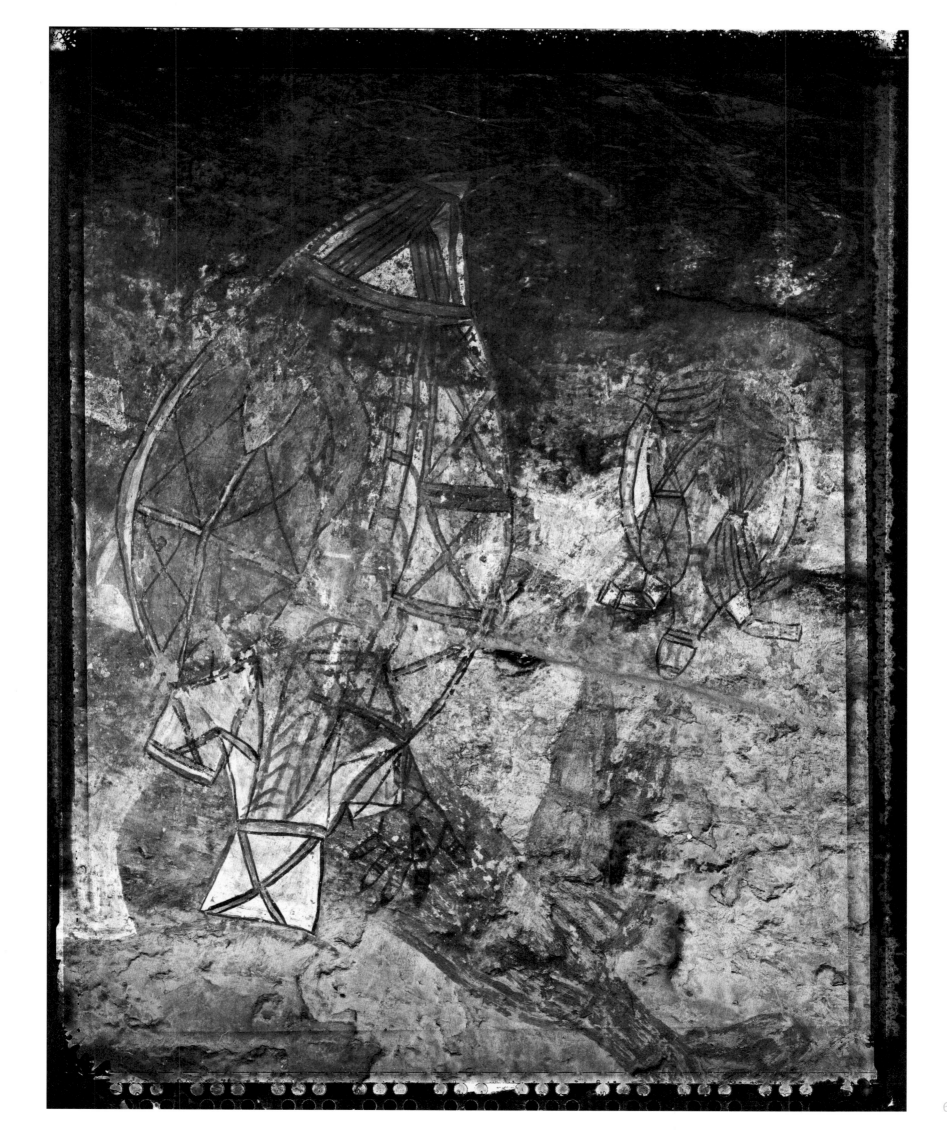

63

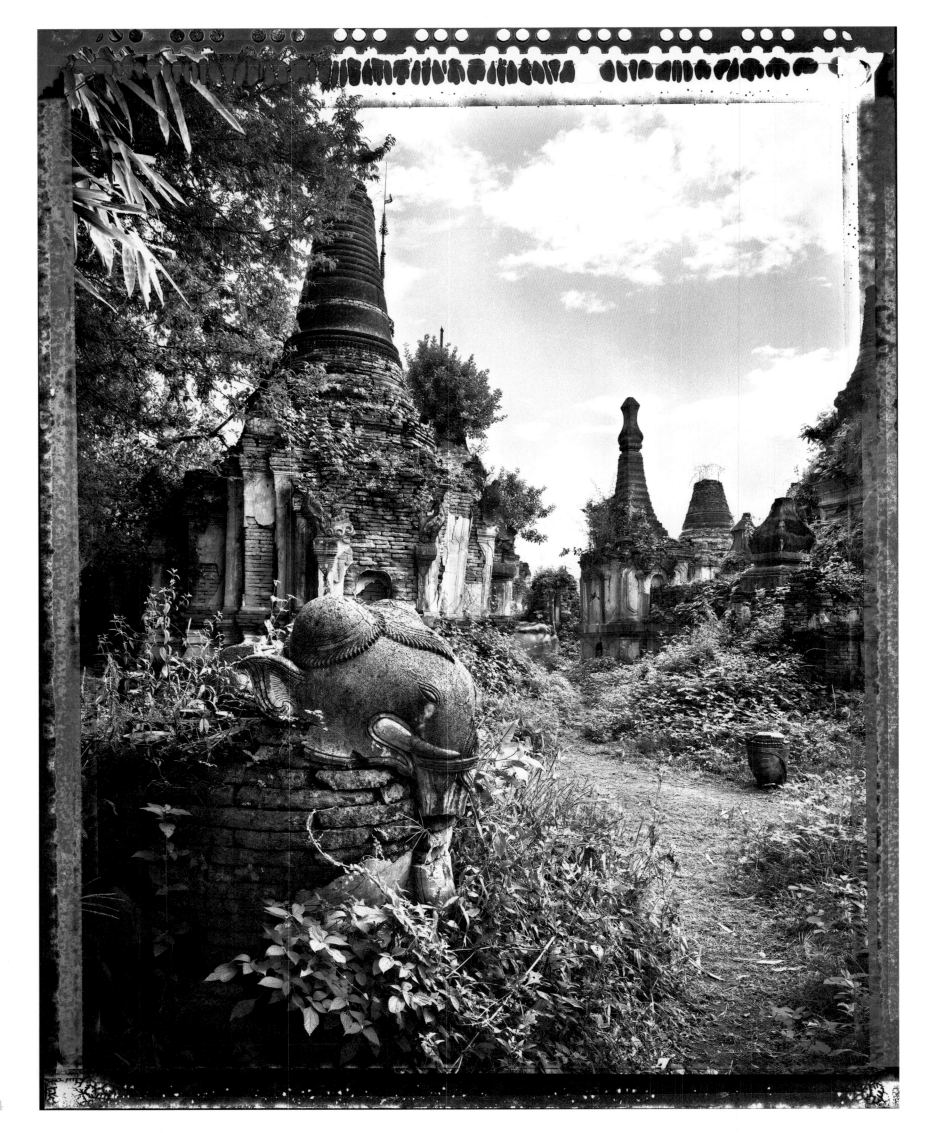

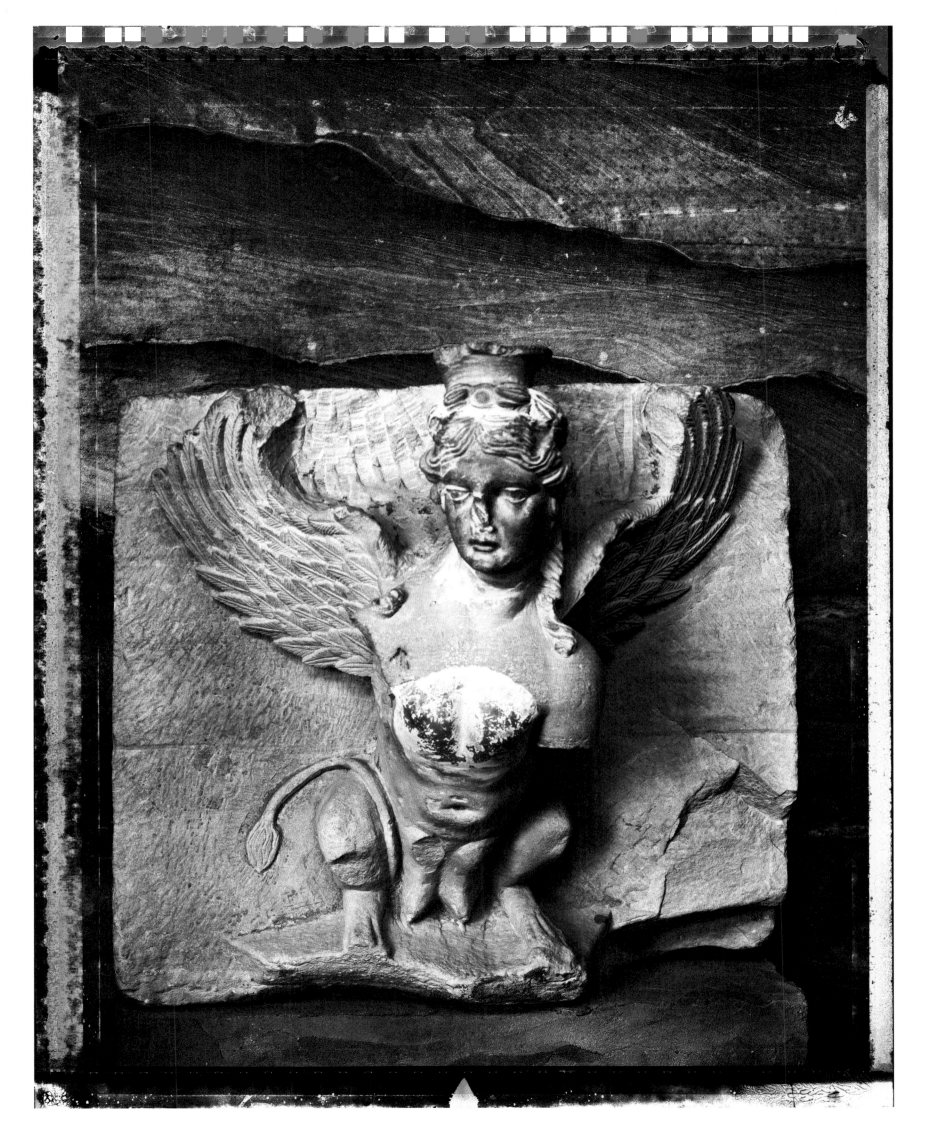

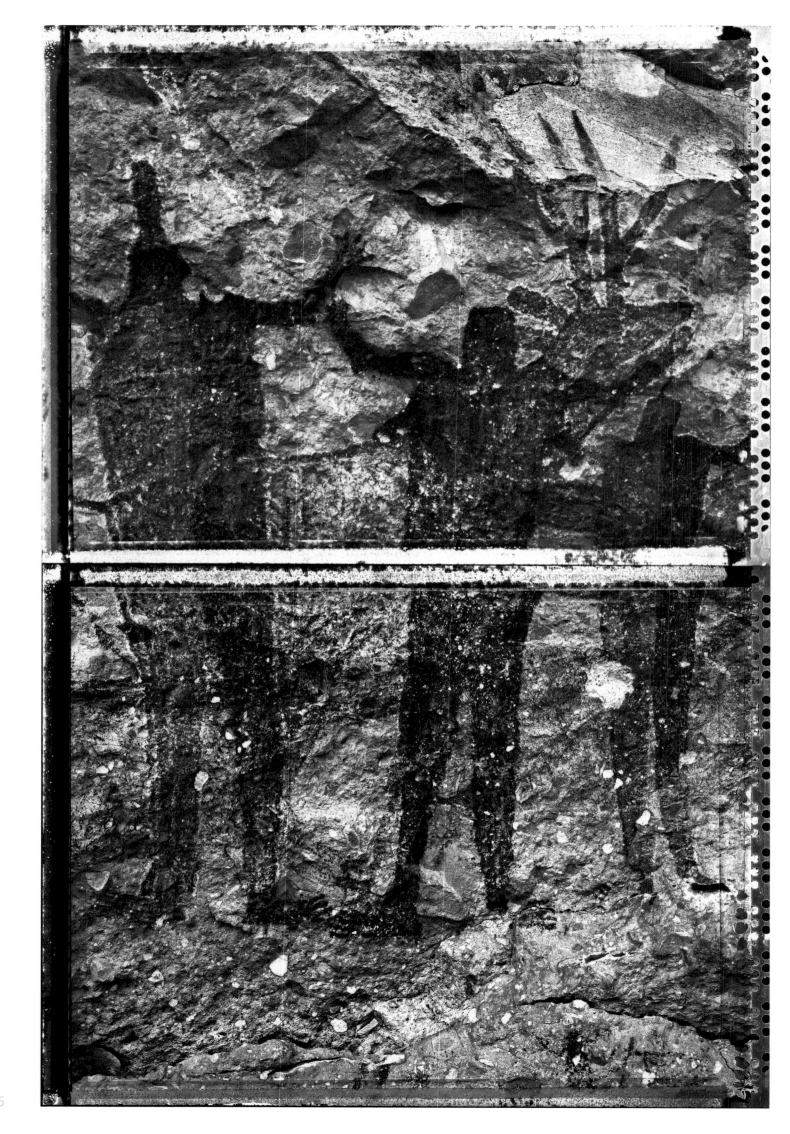

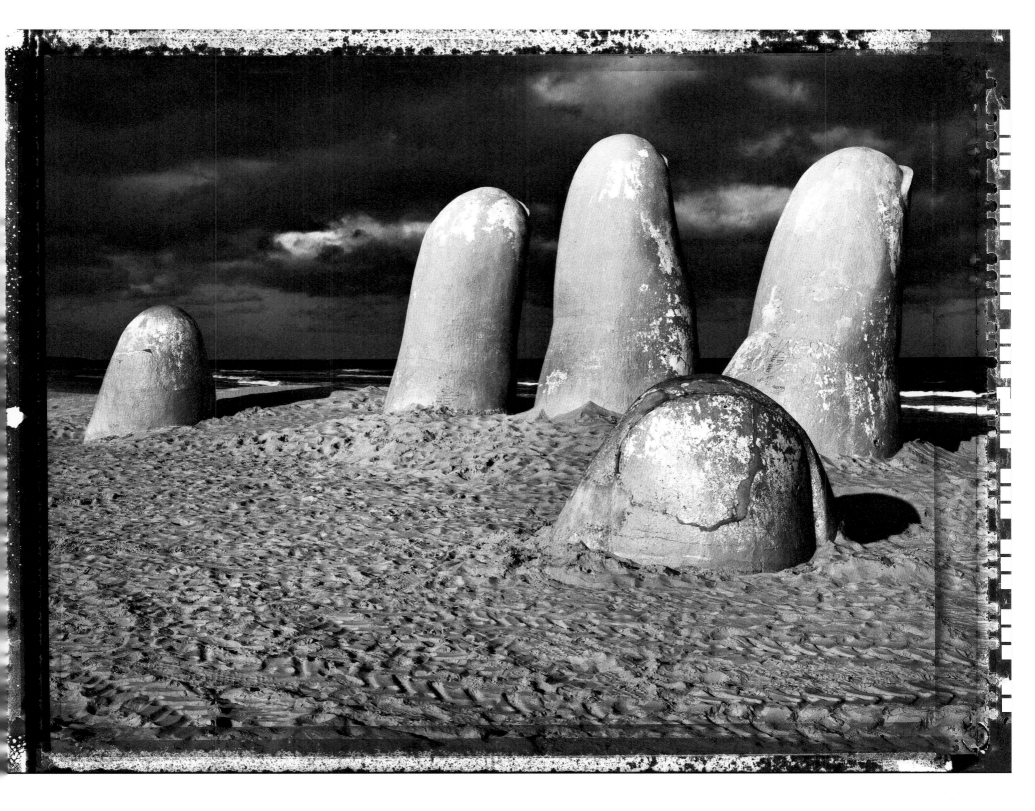

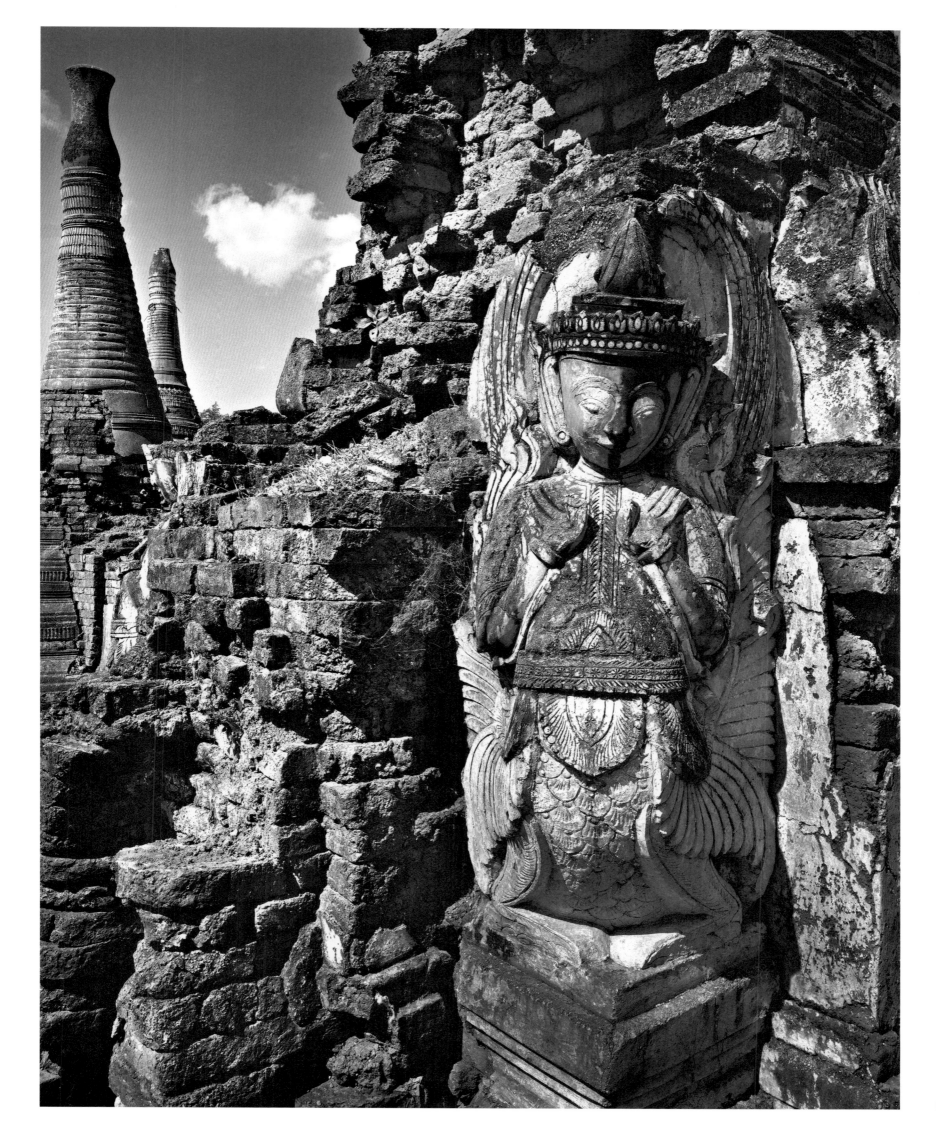

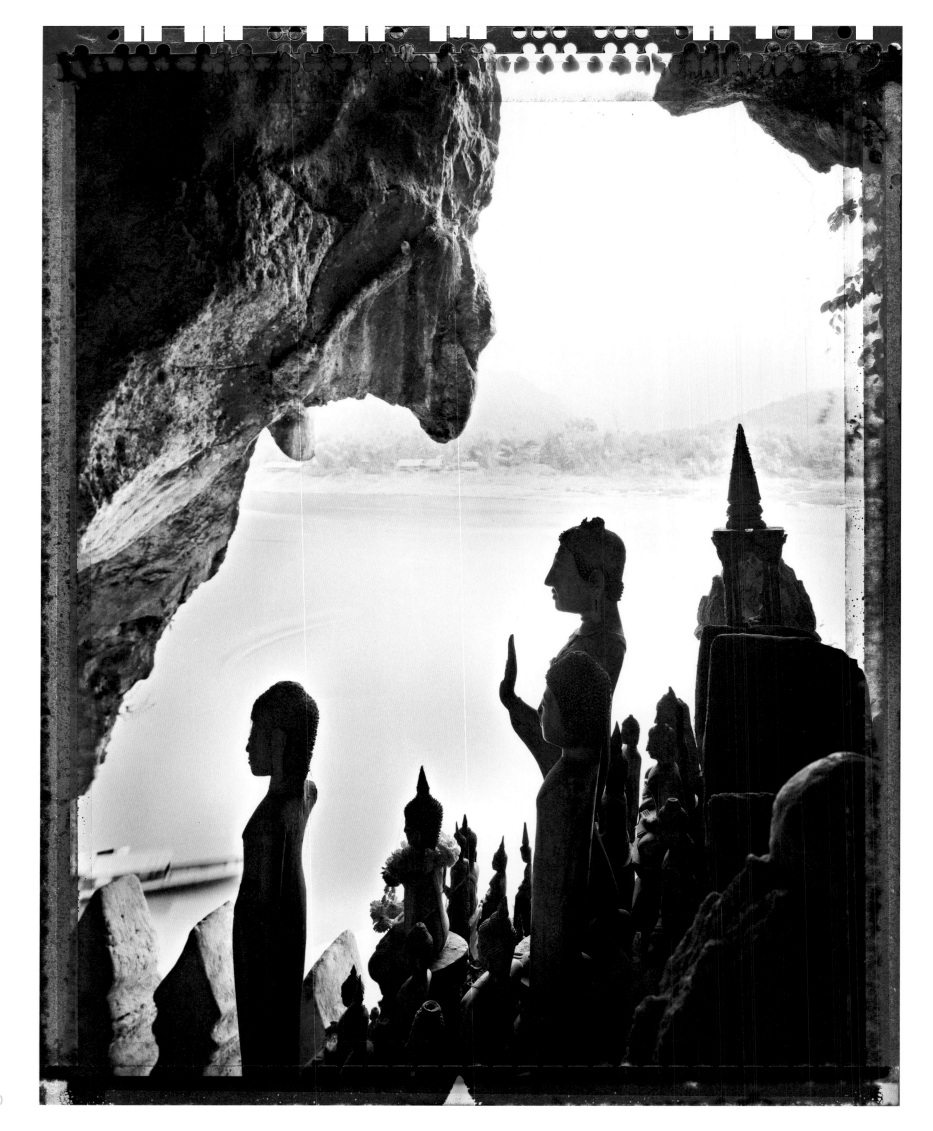

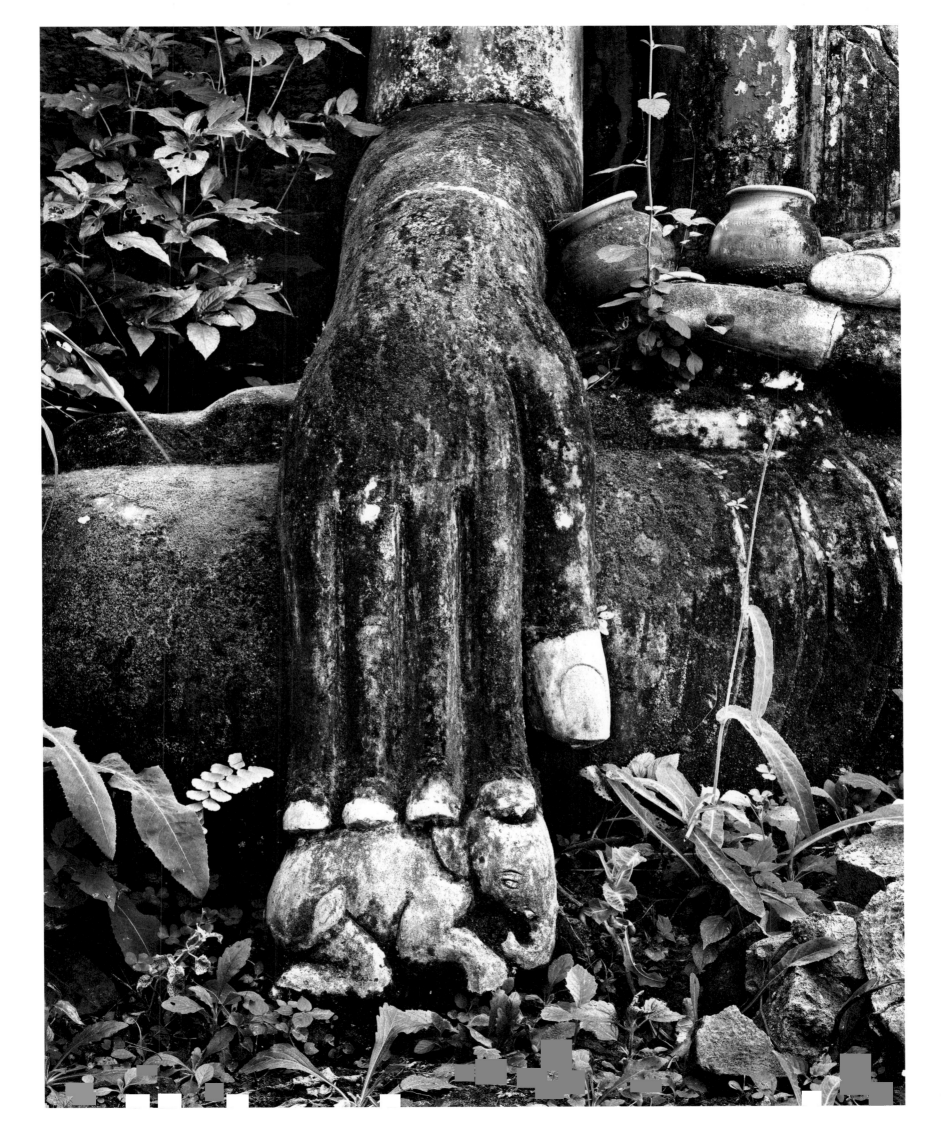

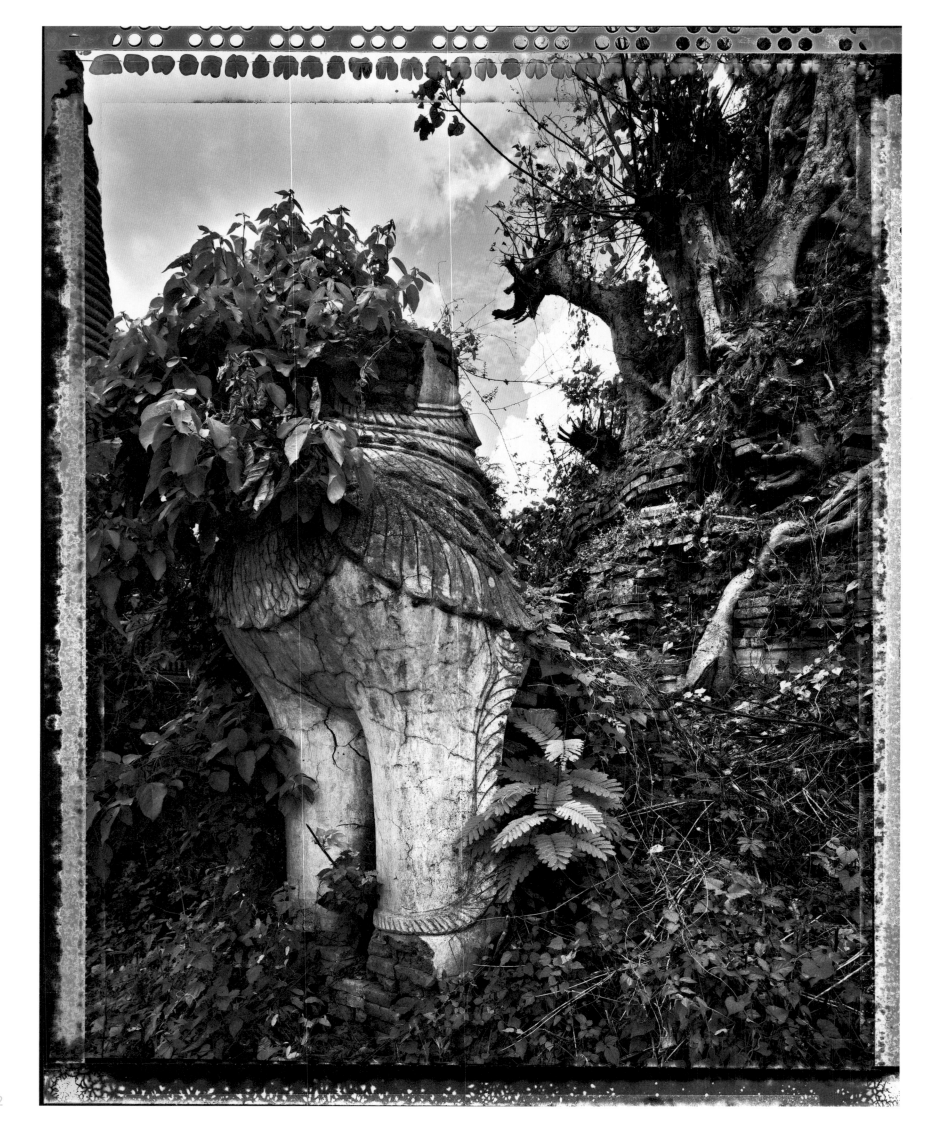

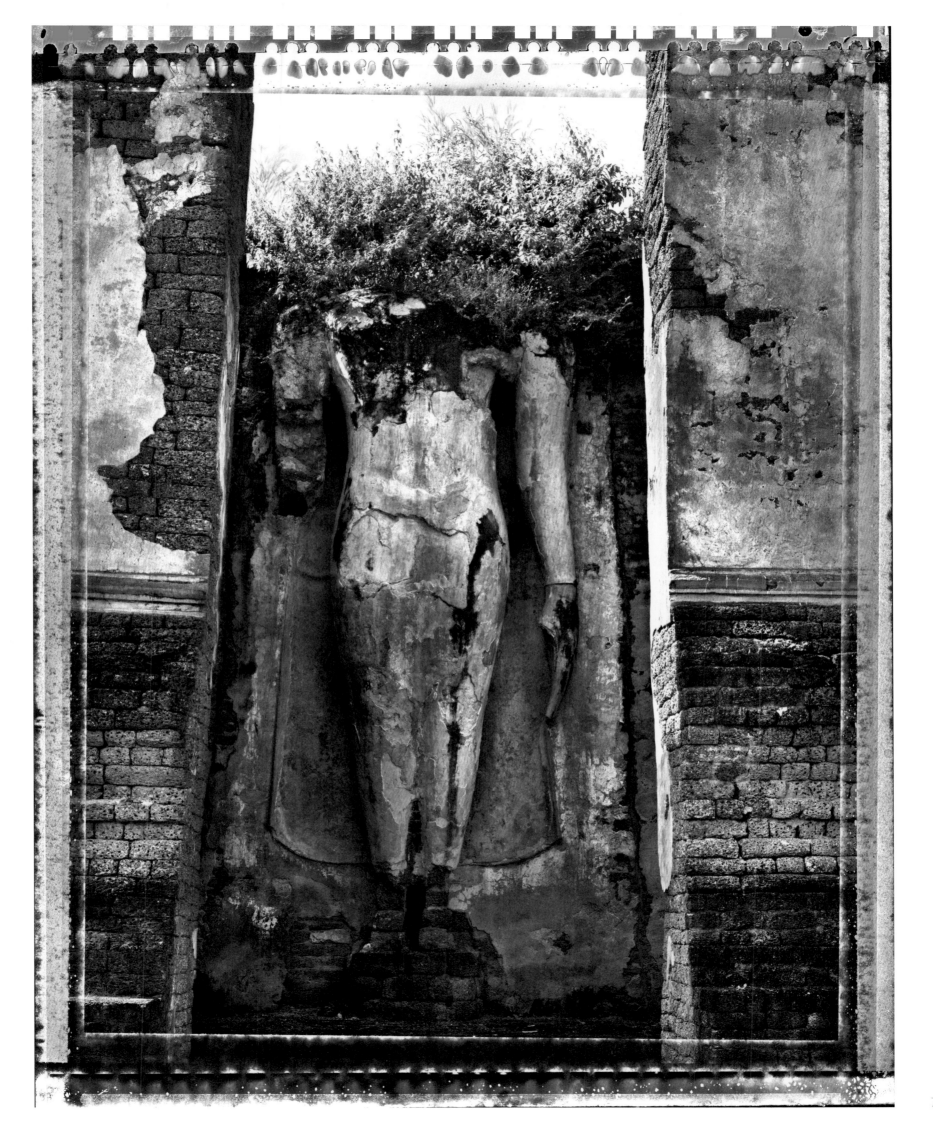

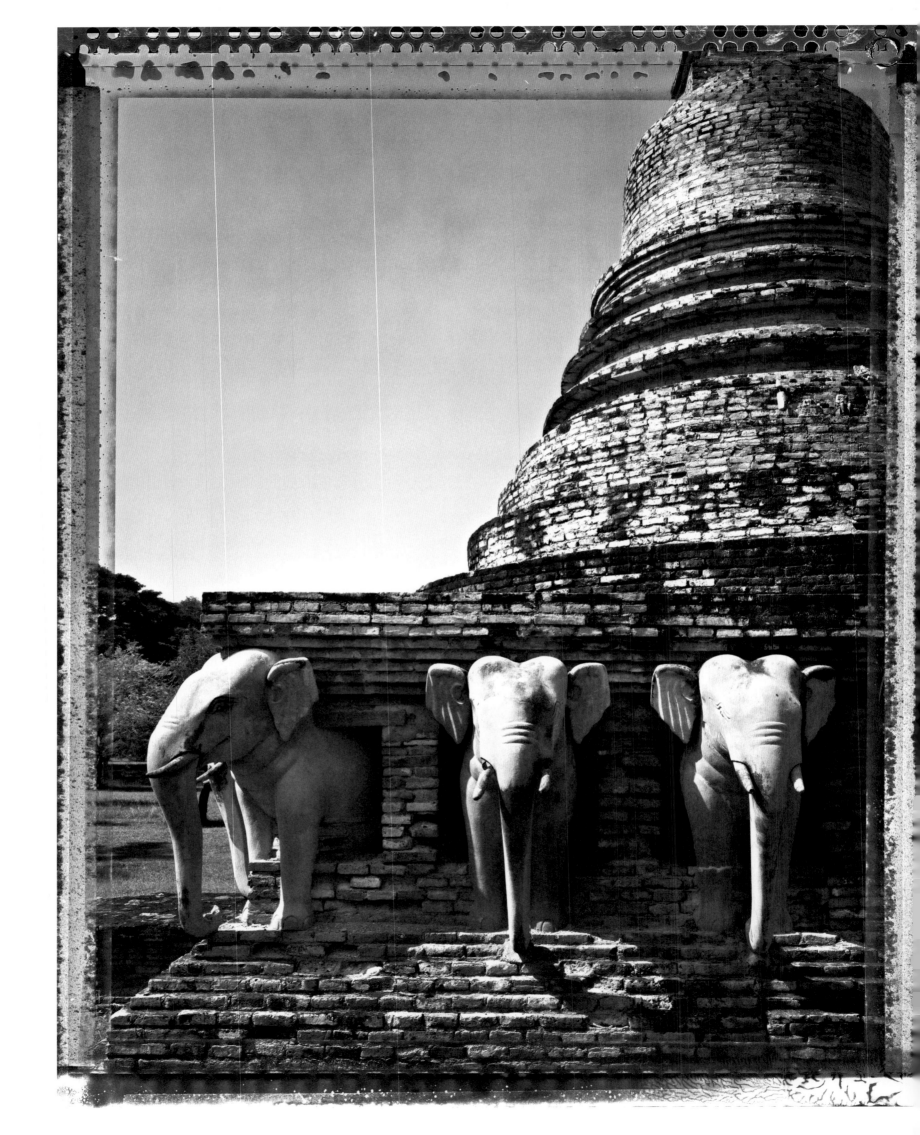

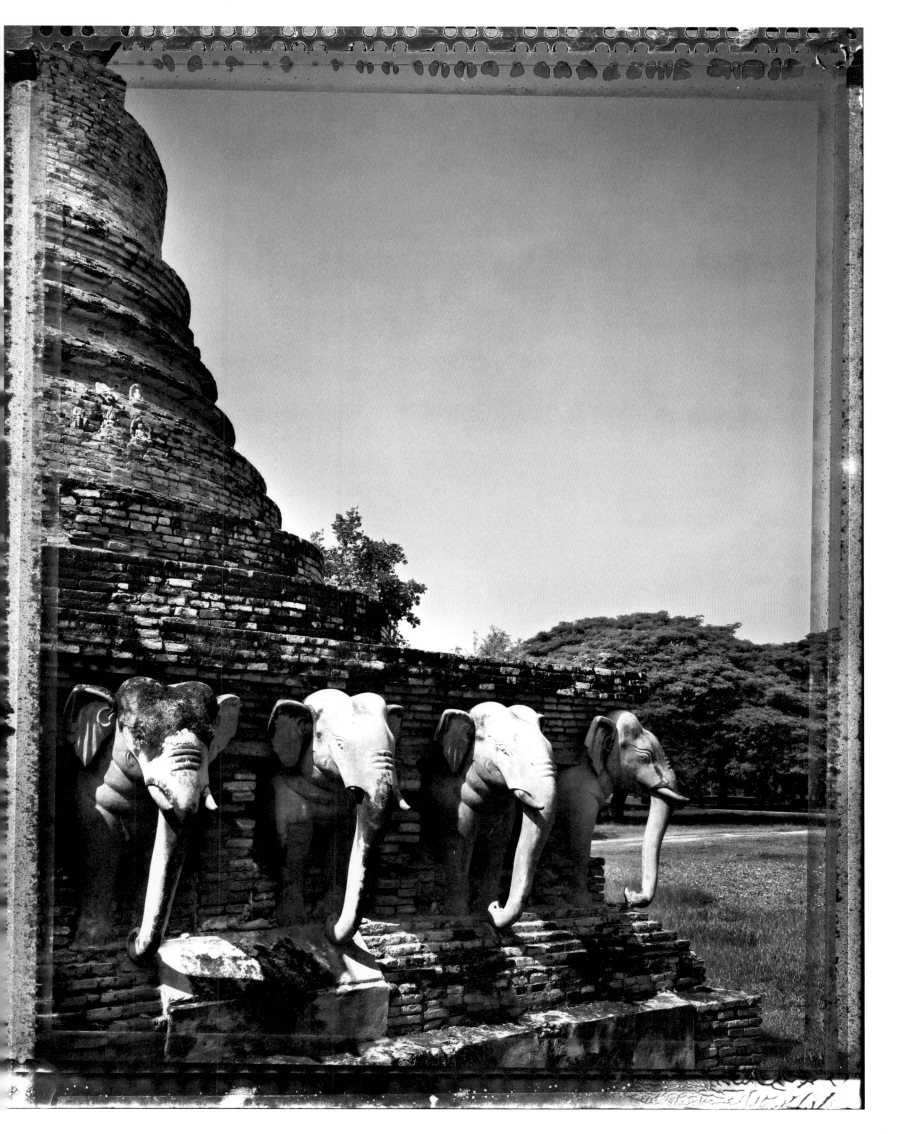

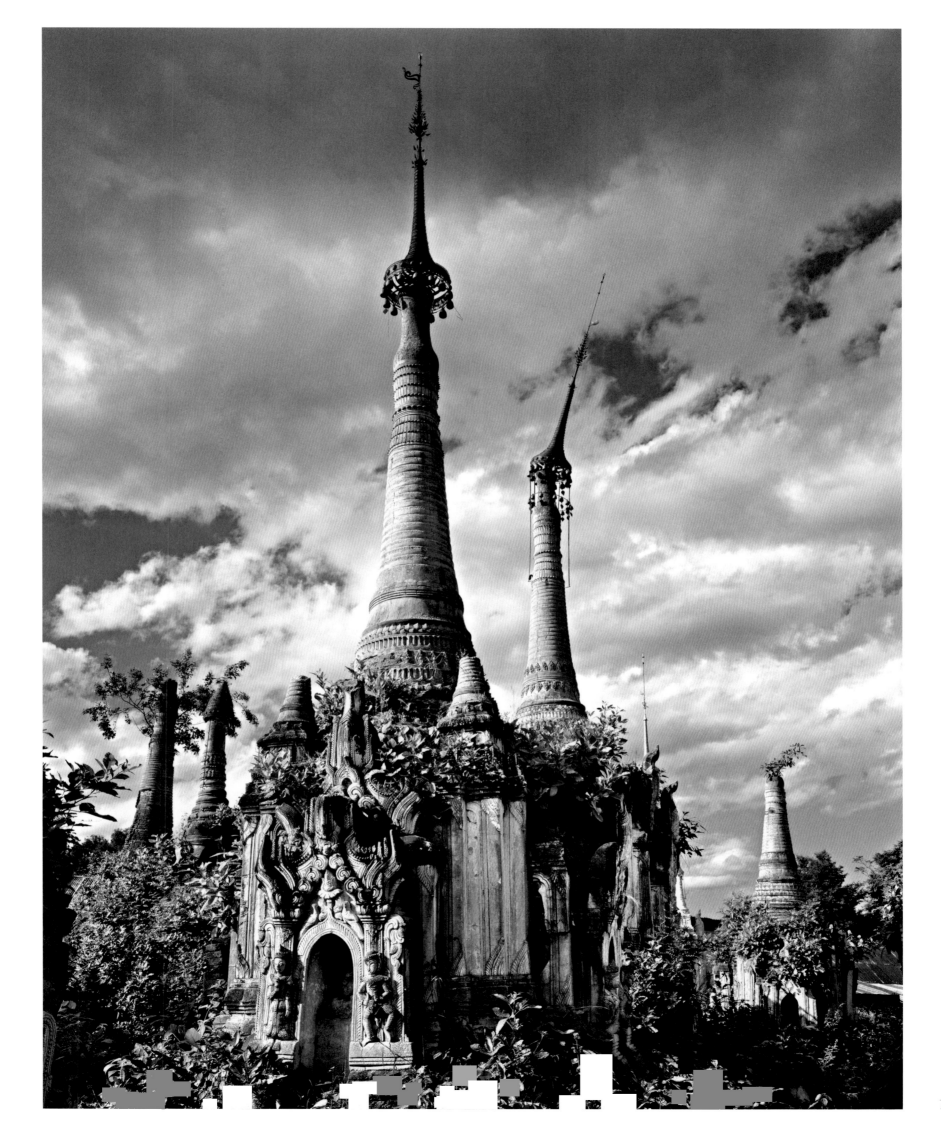

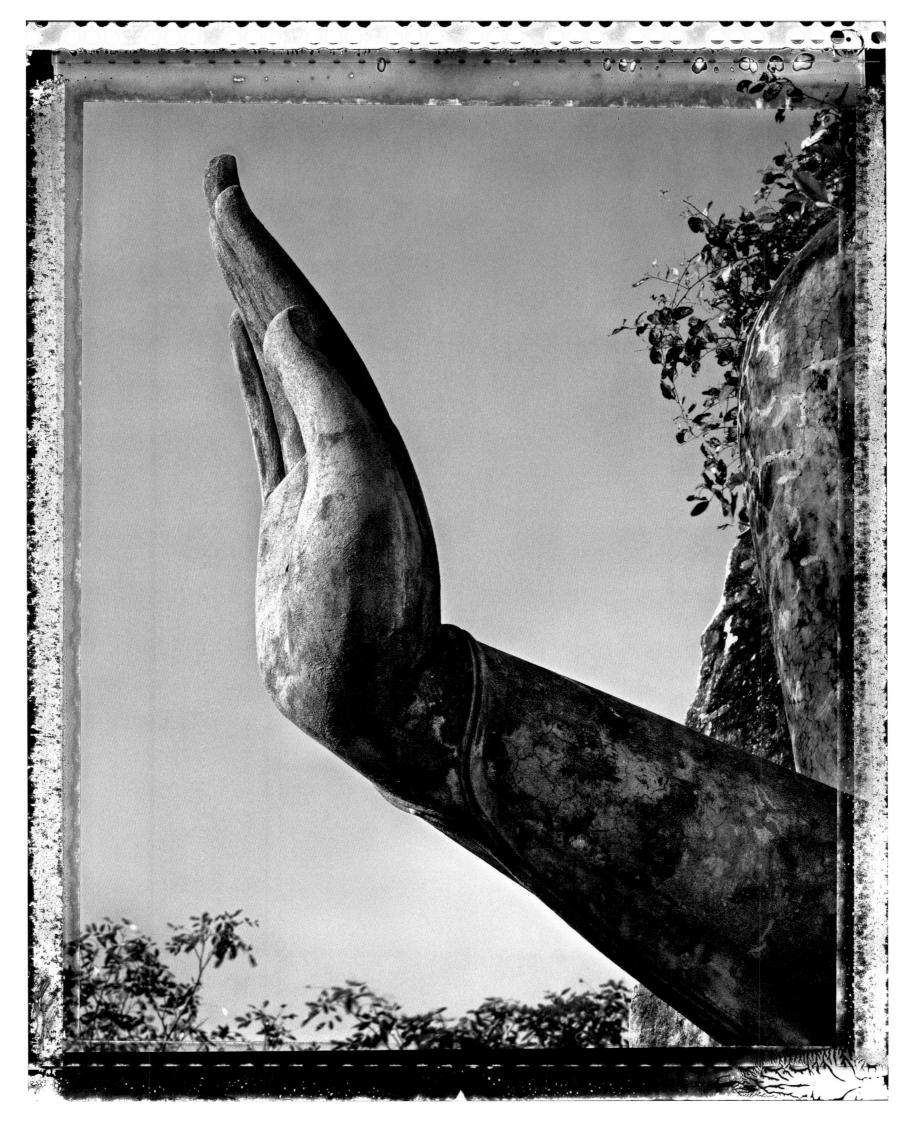

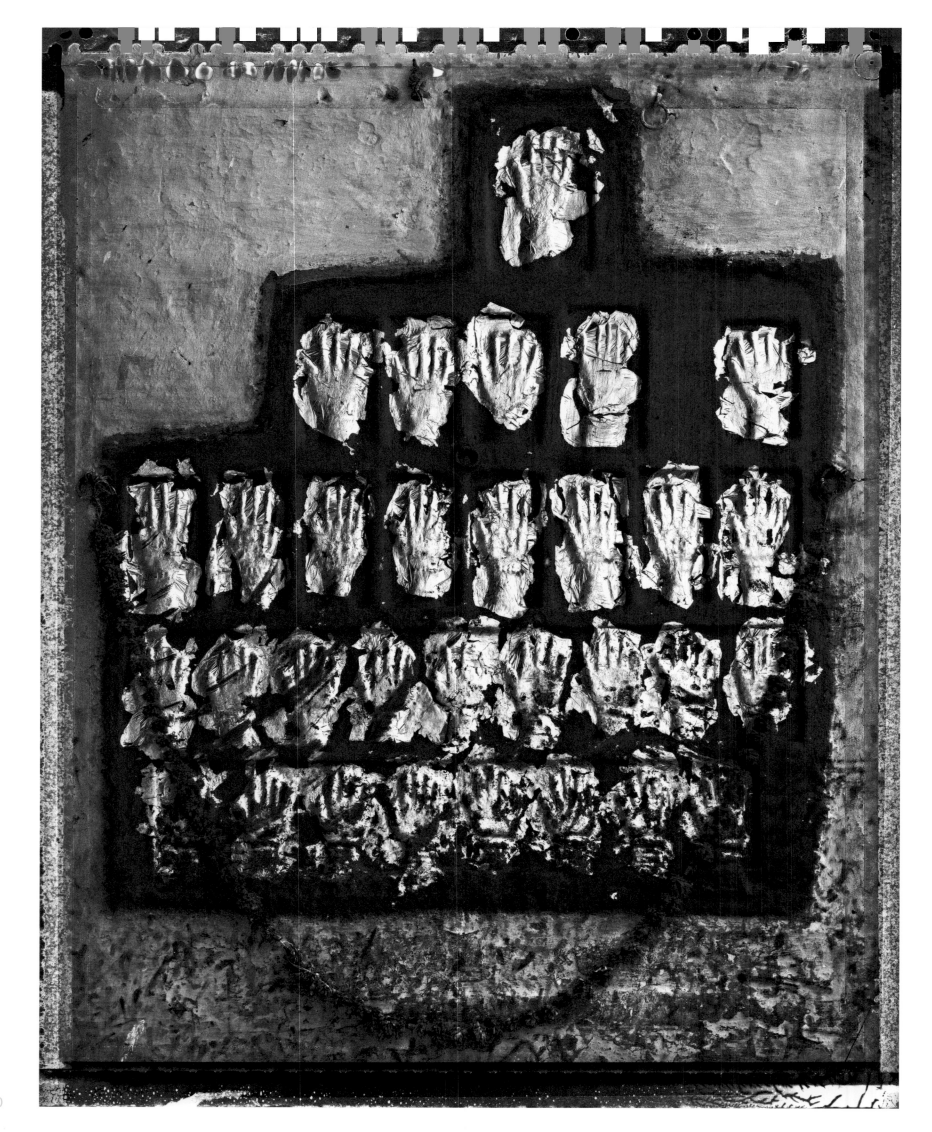

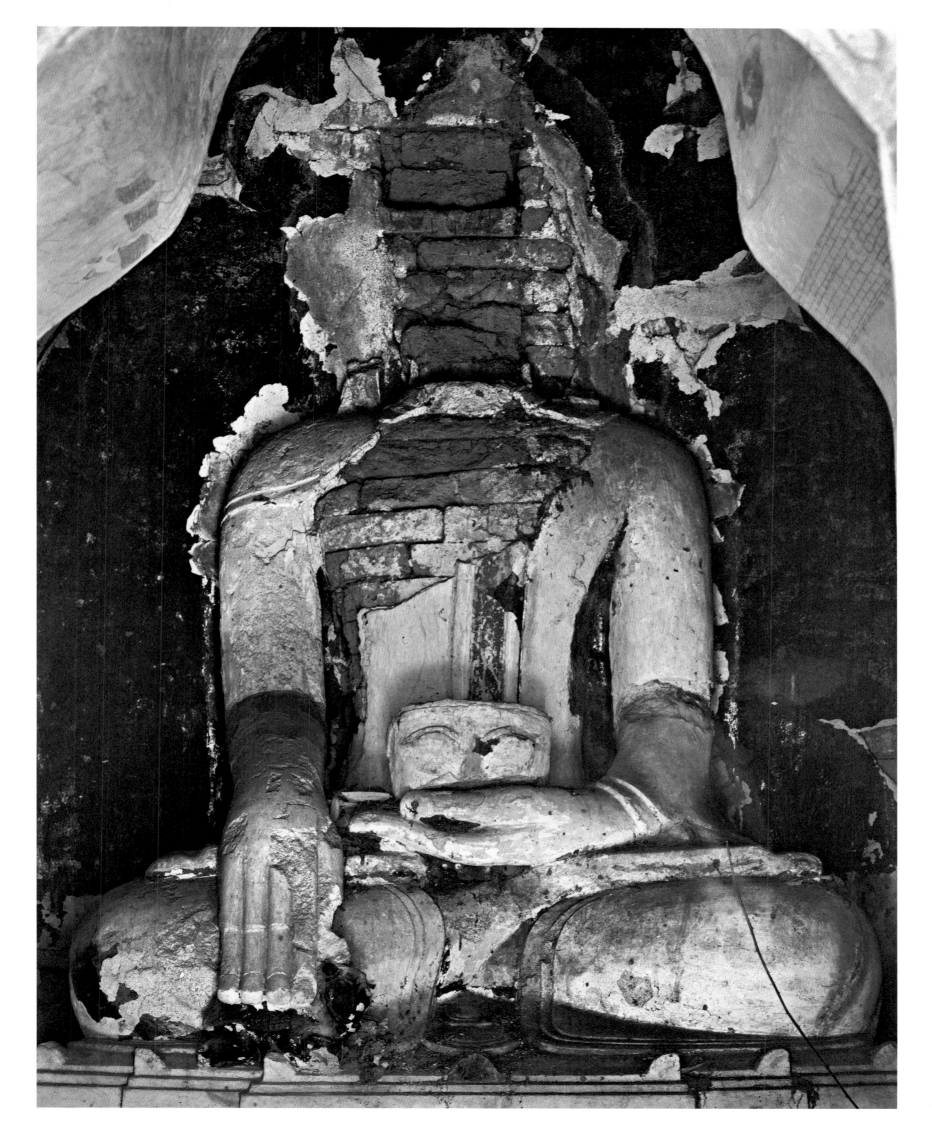

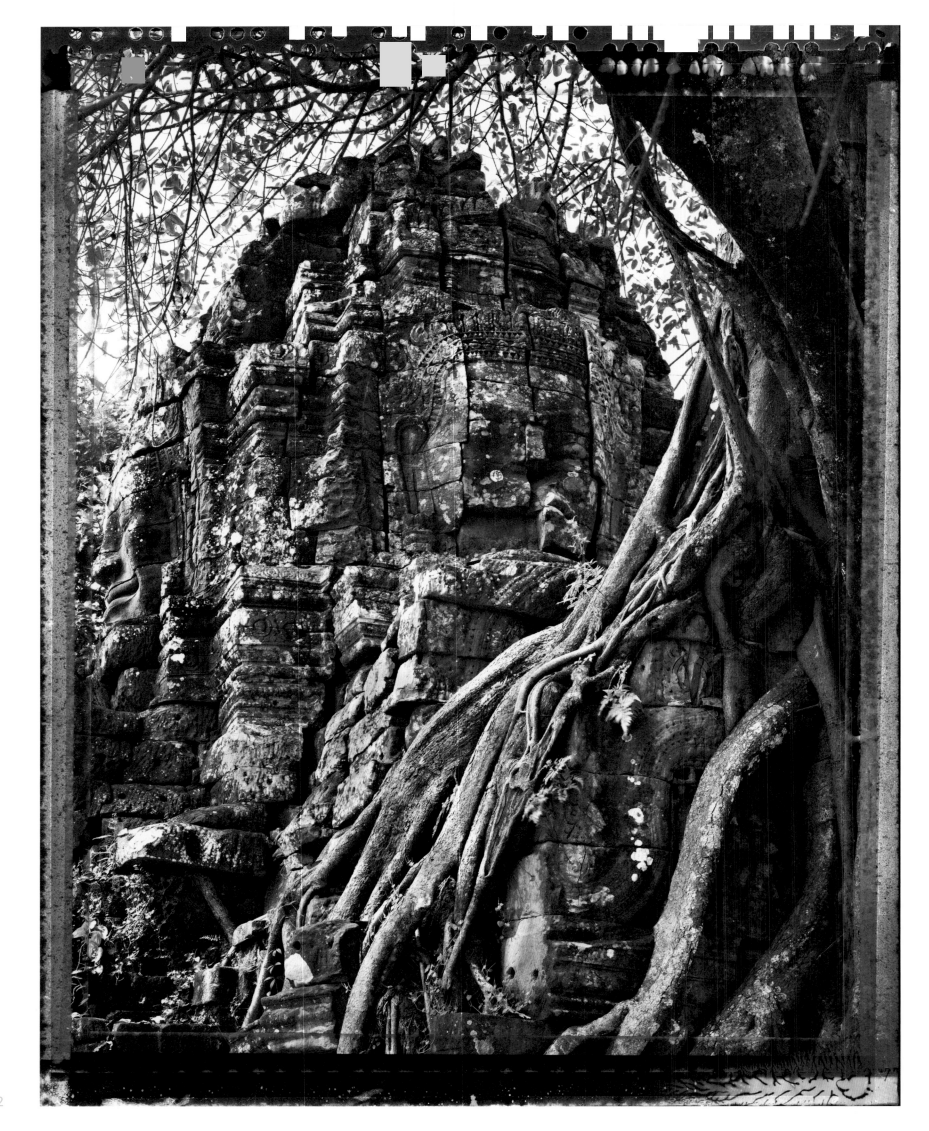

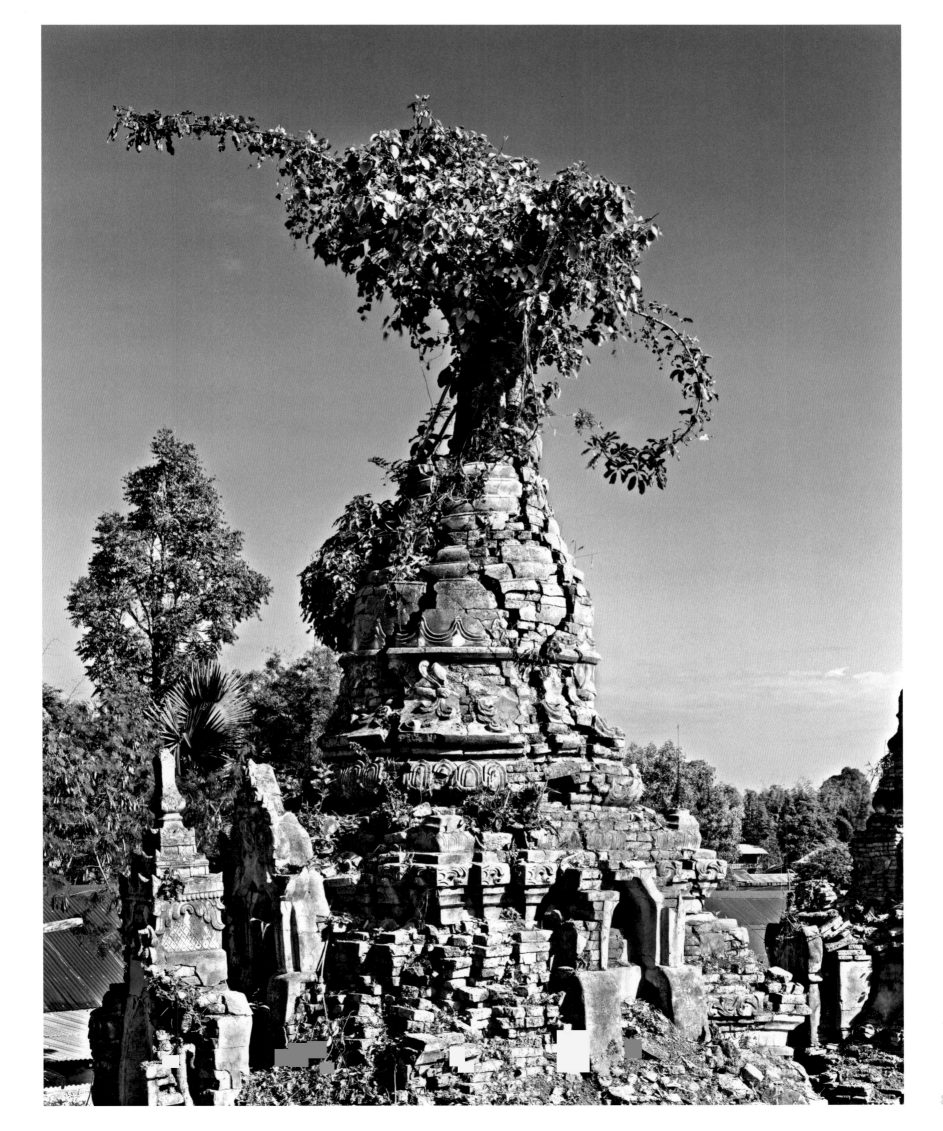

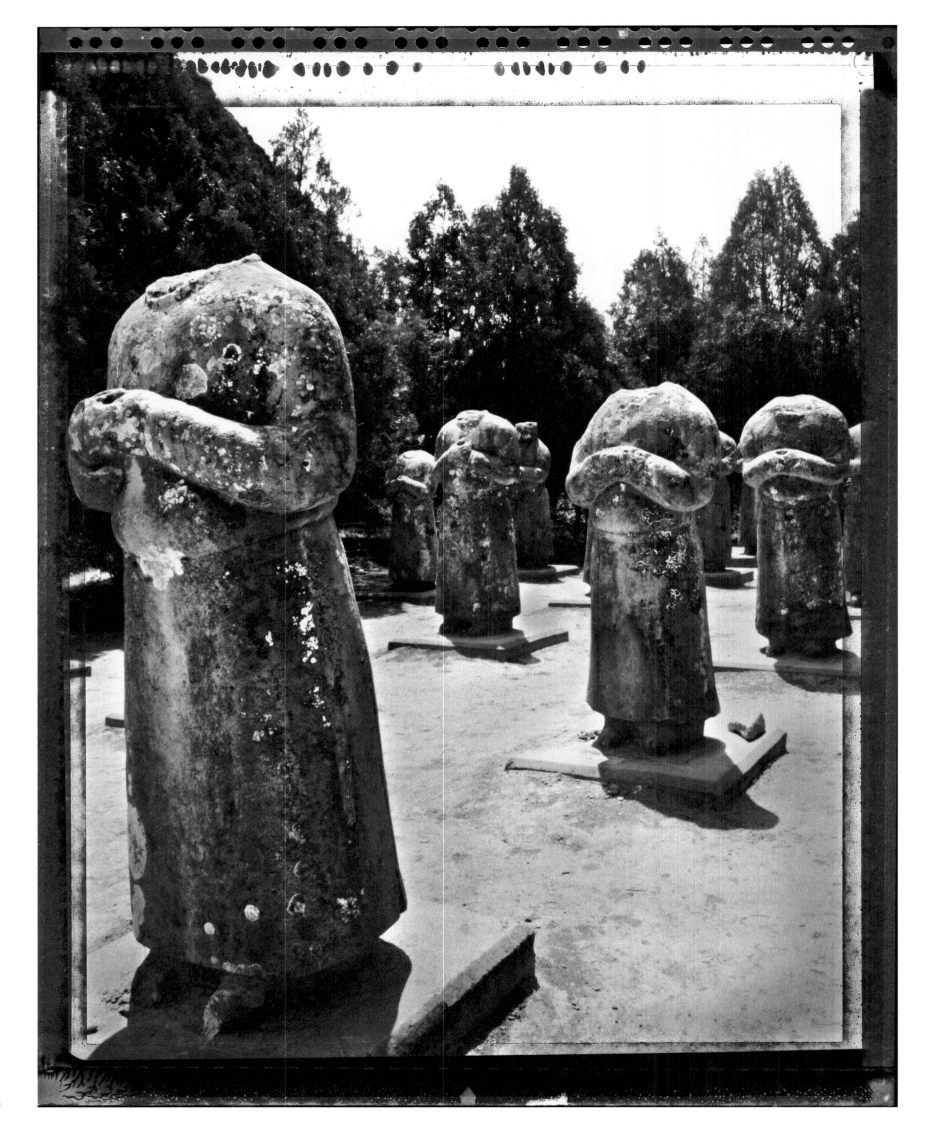

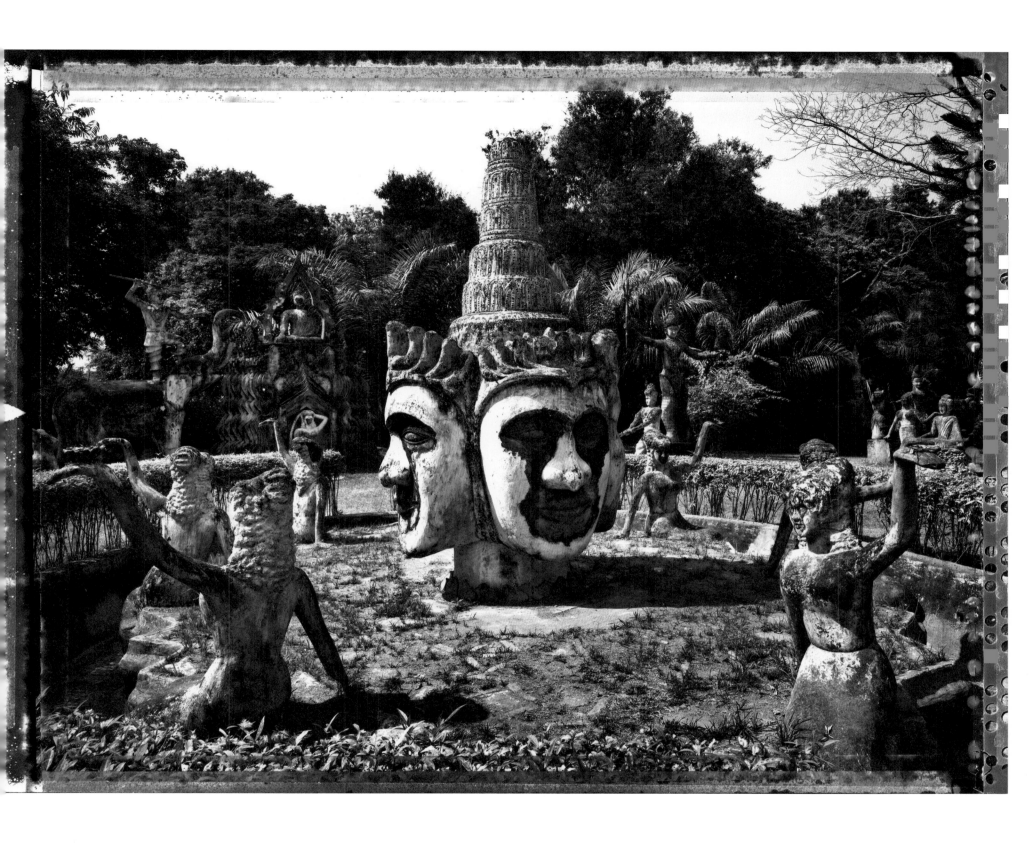

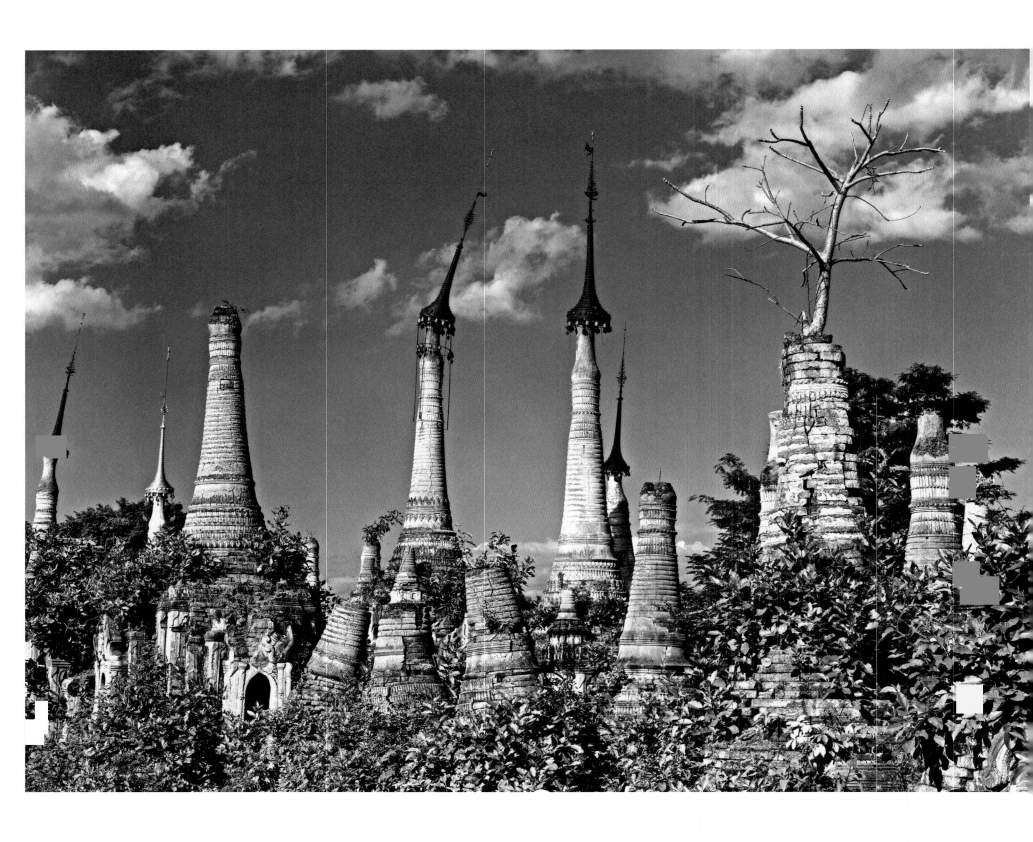

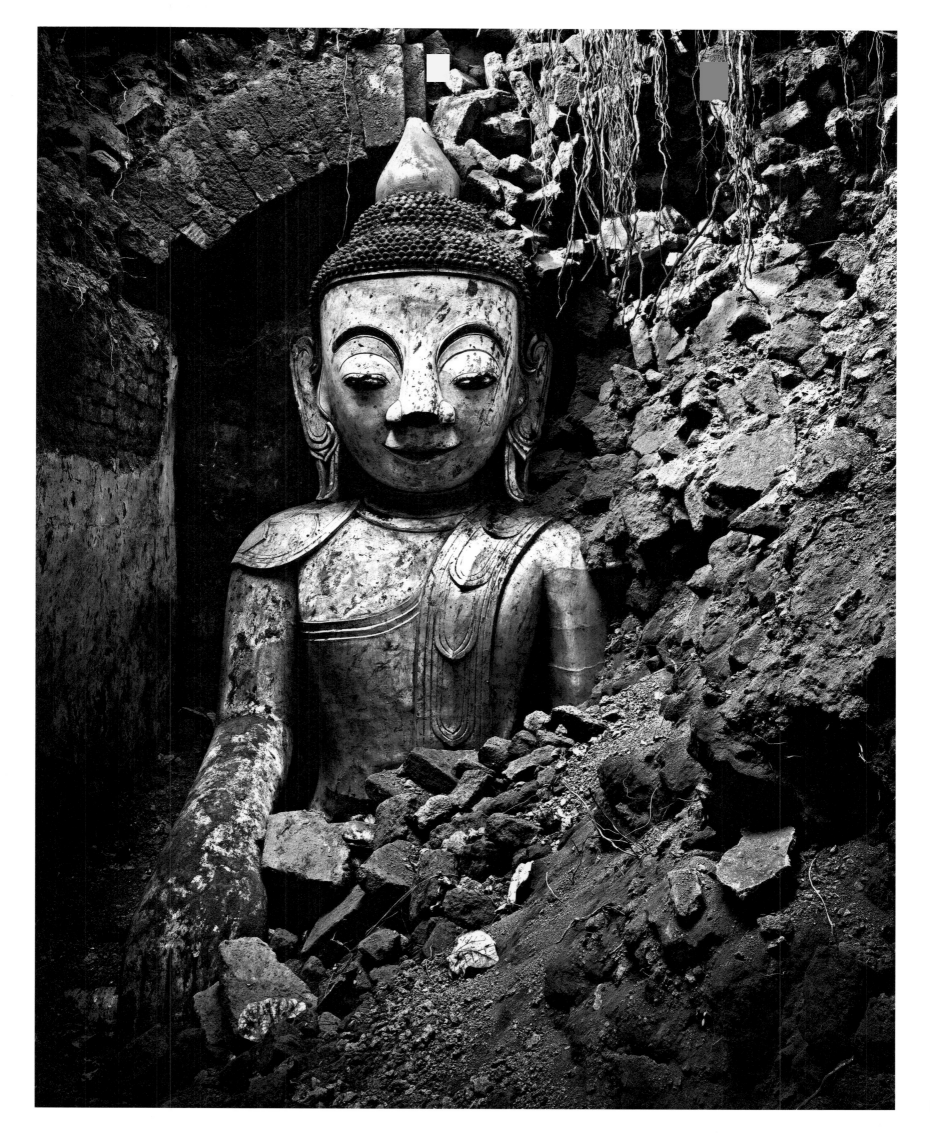

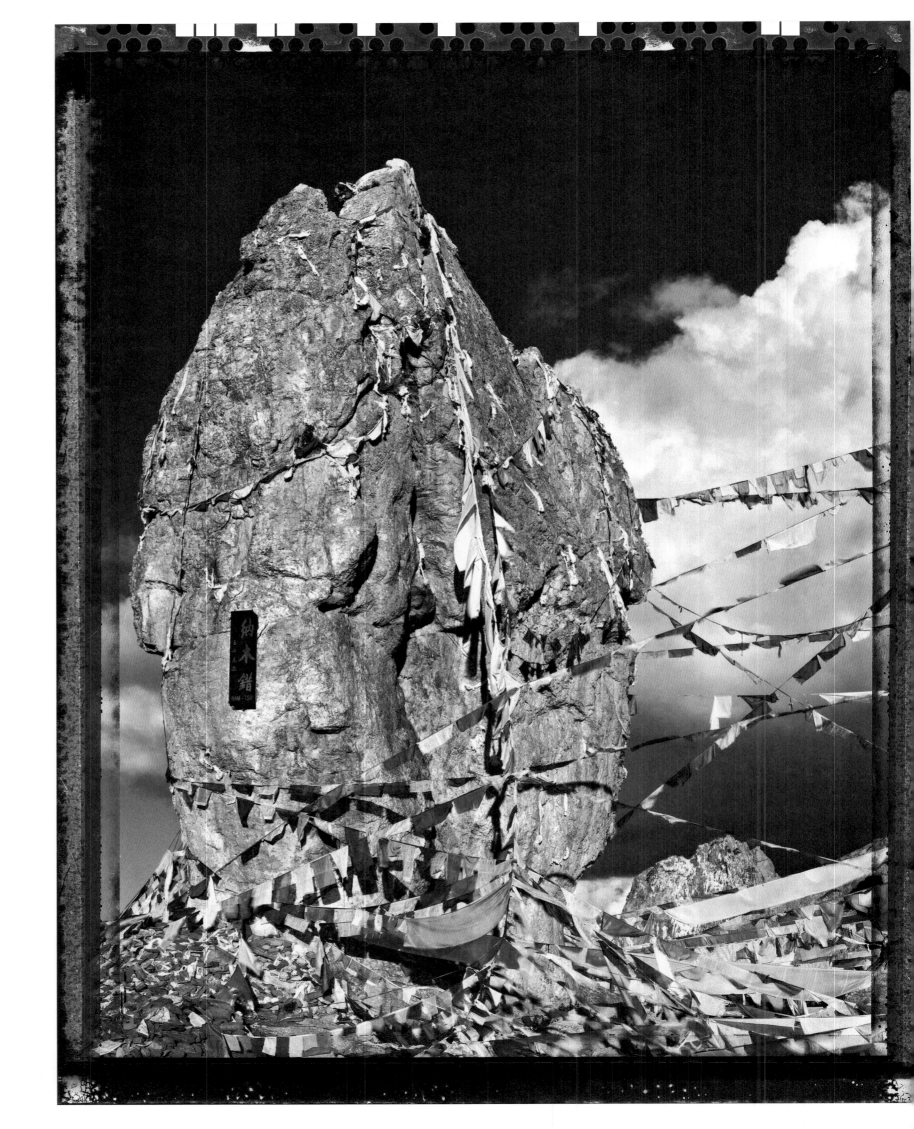

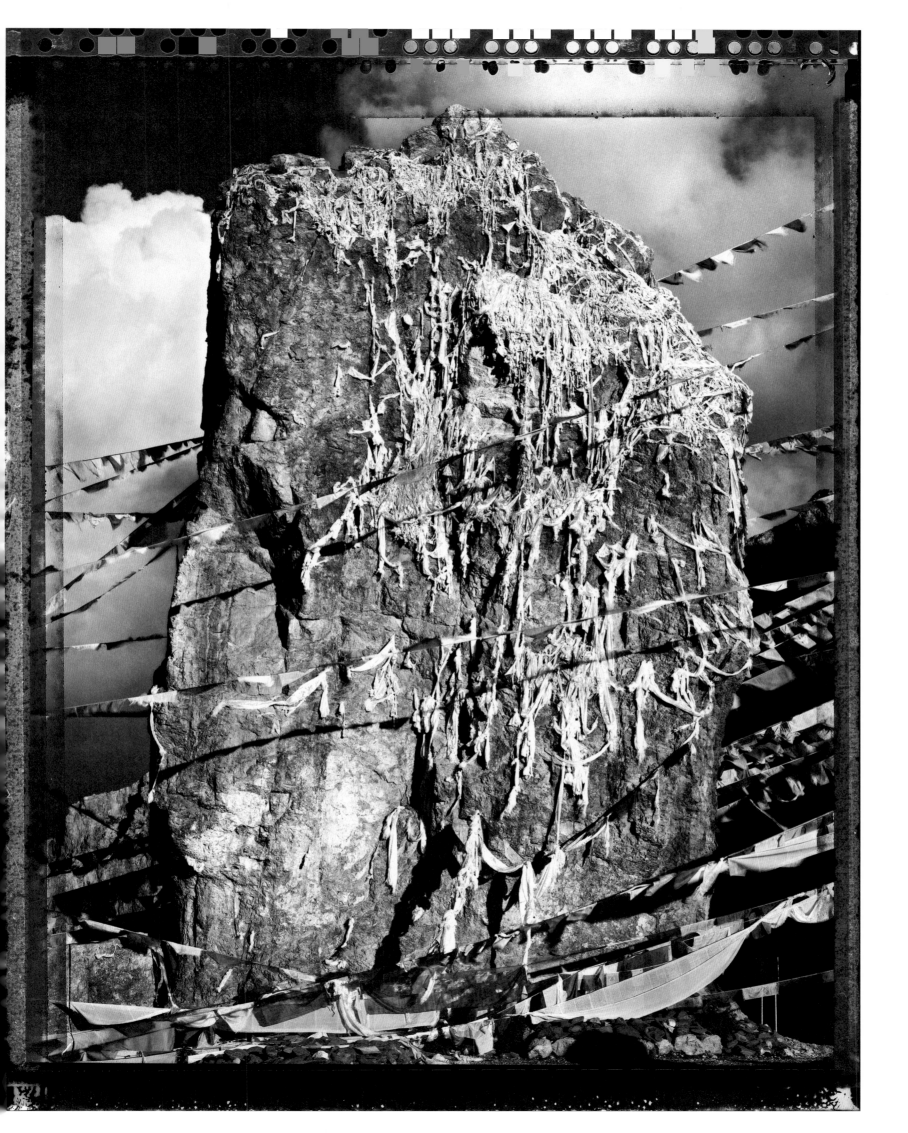

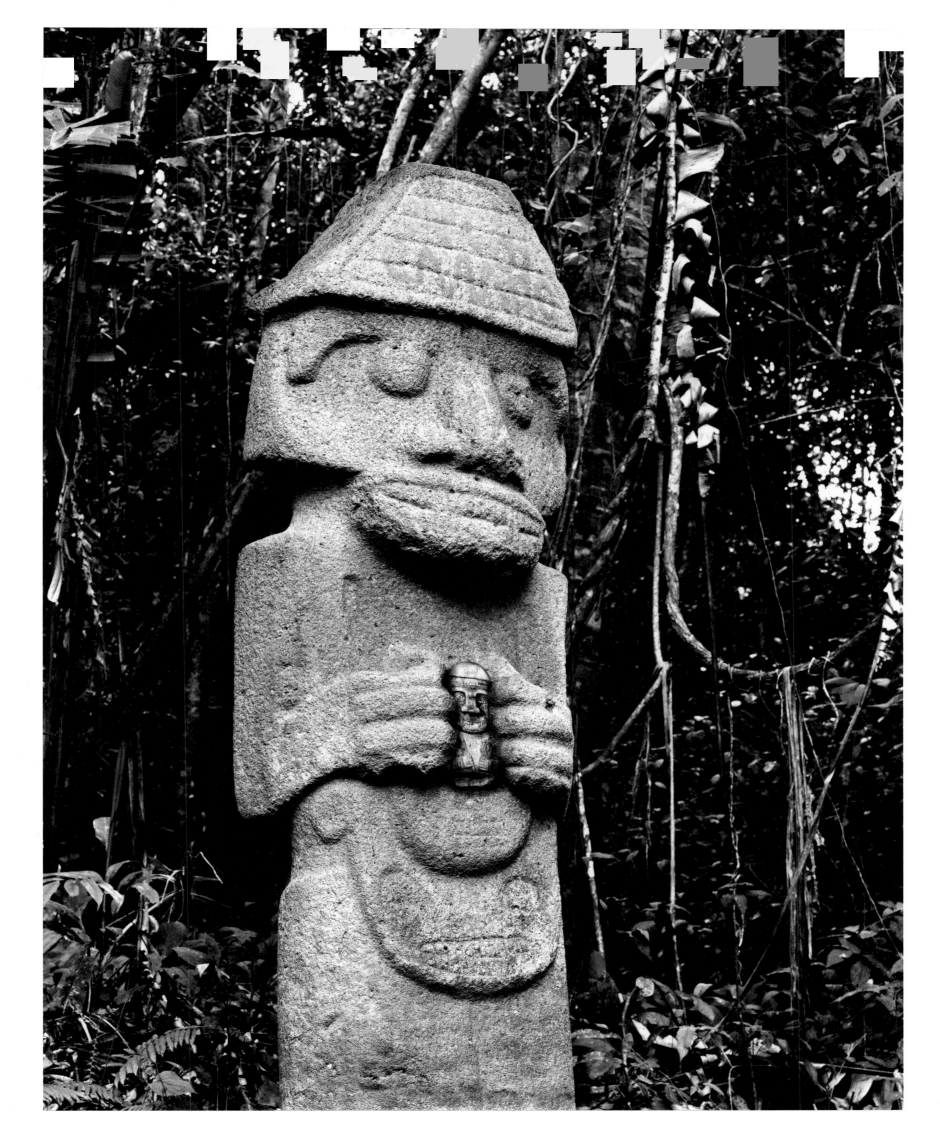

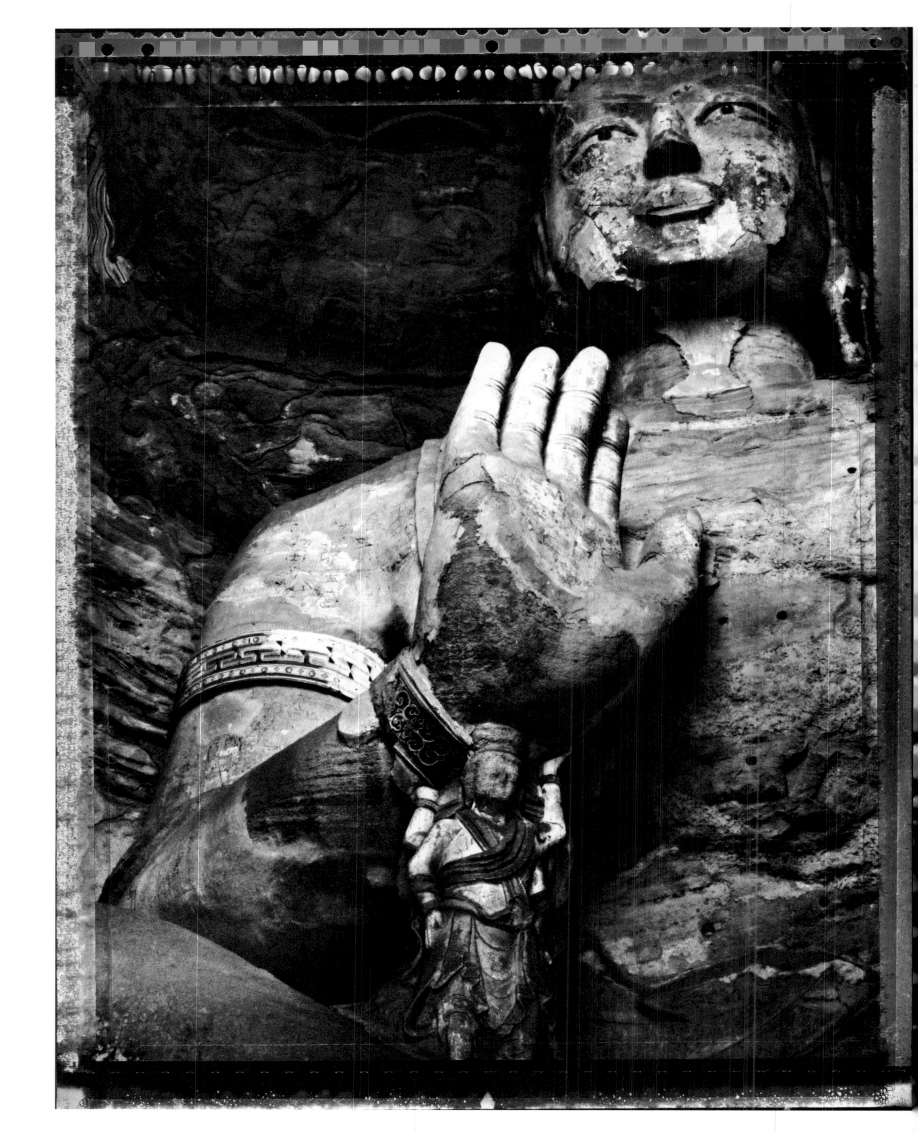

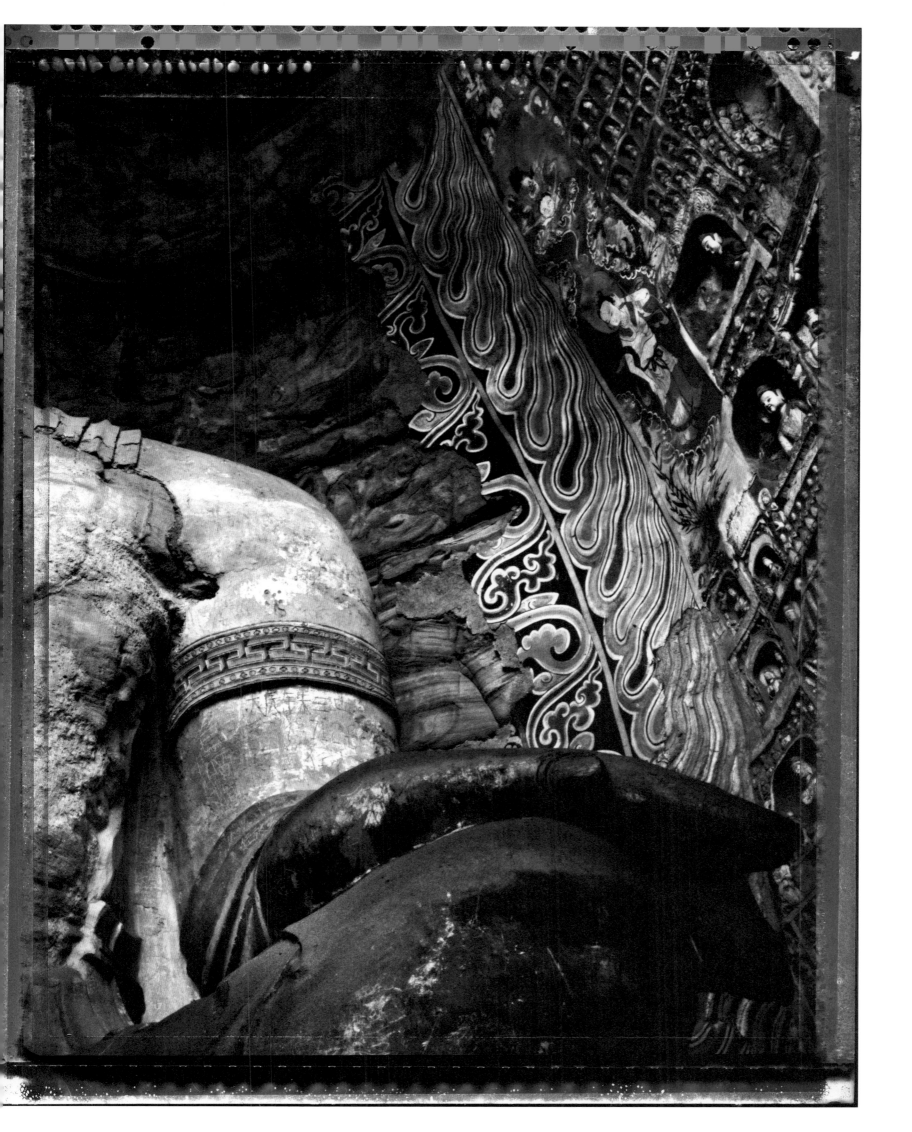

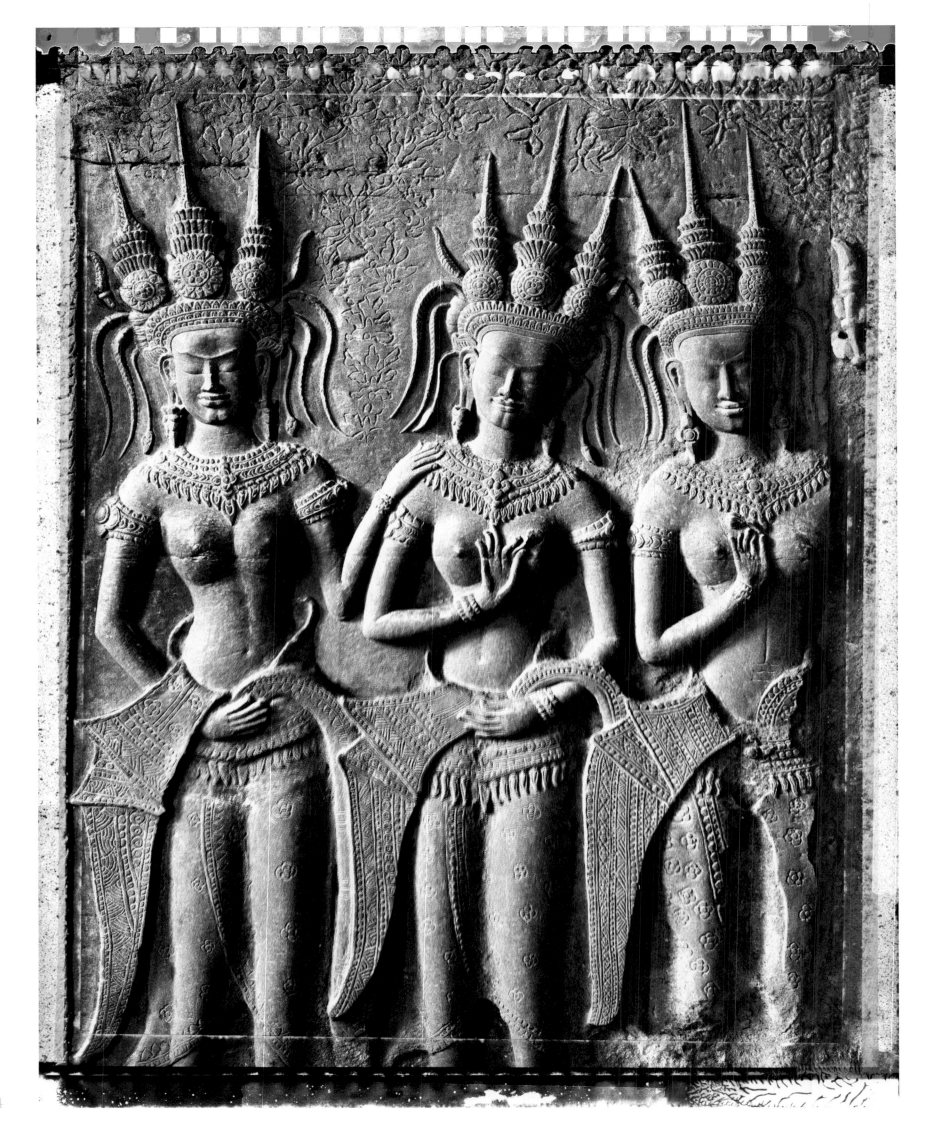

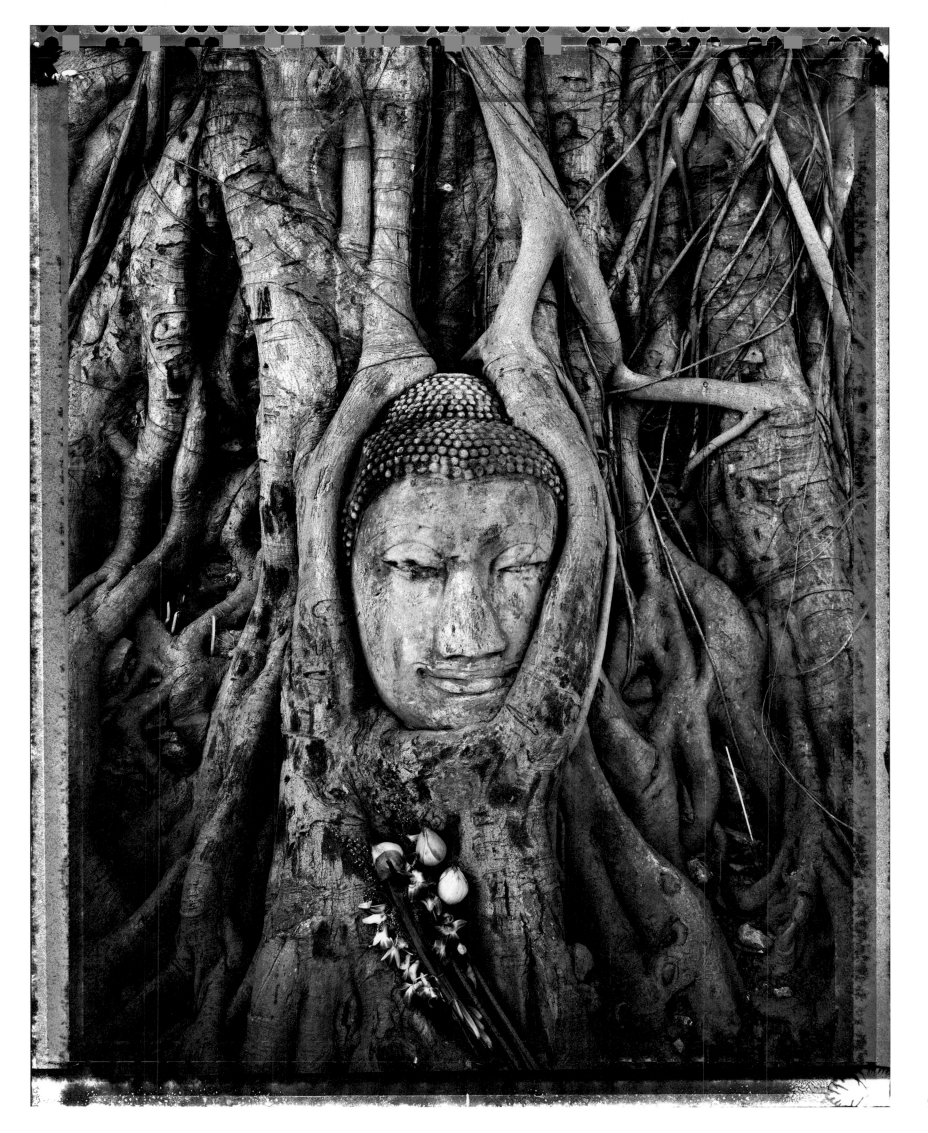

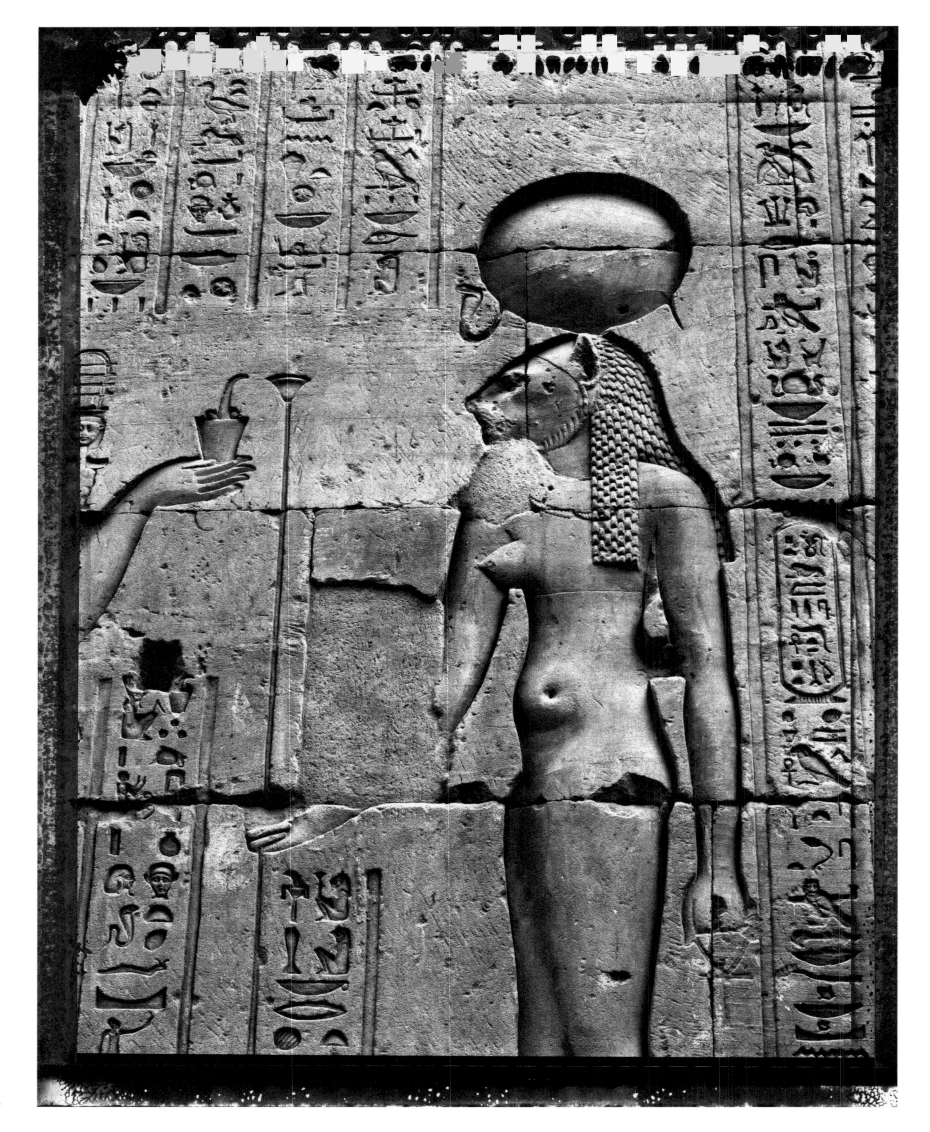

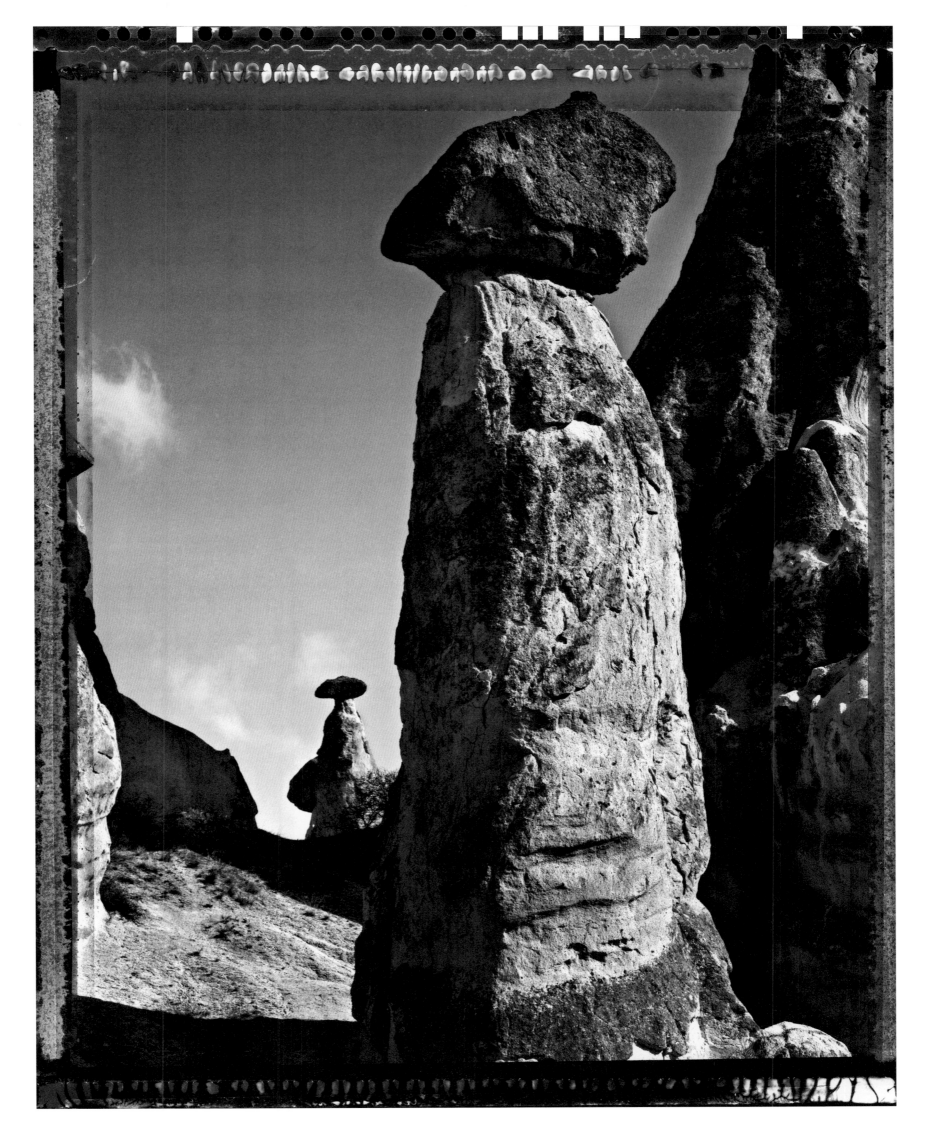

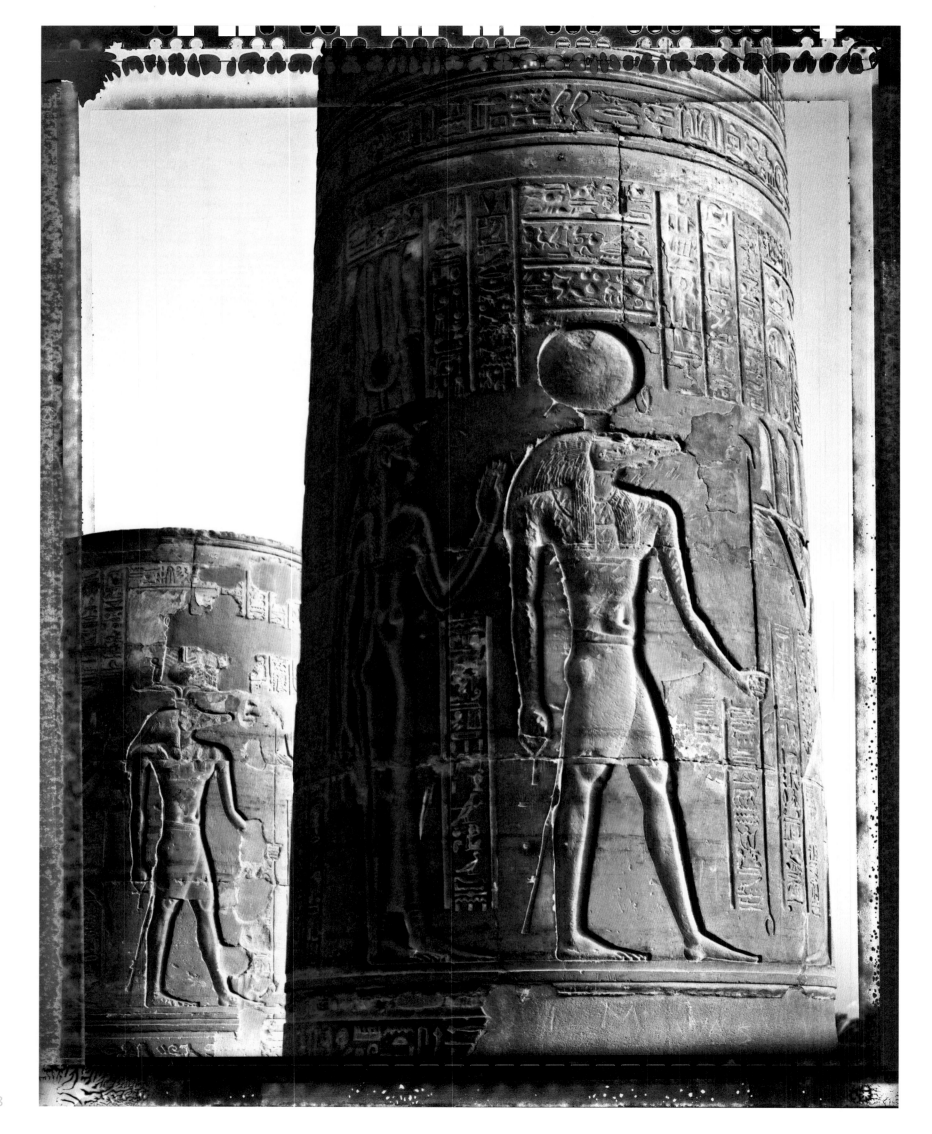

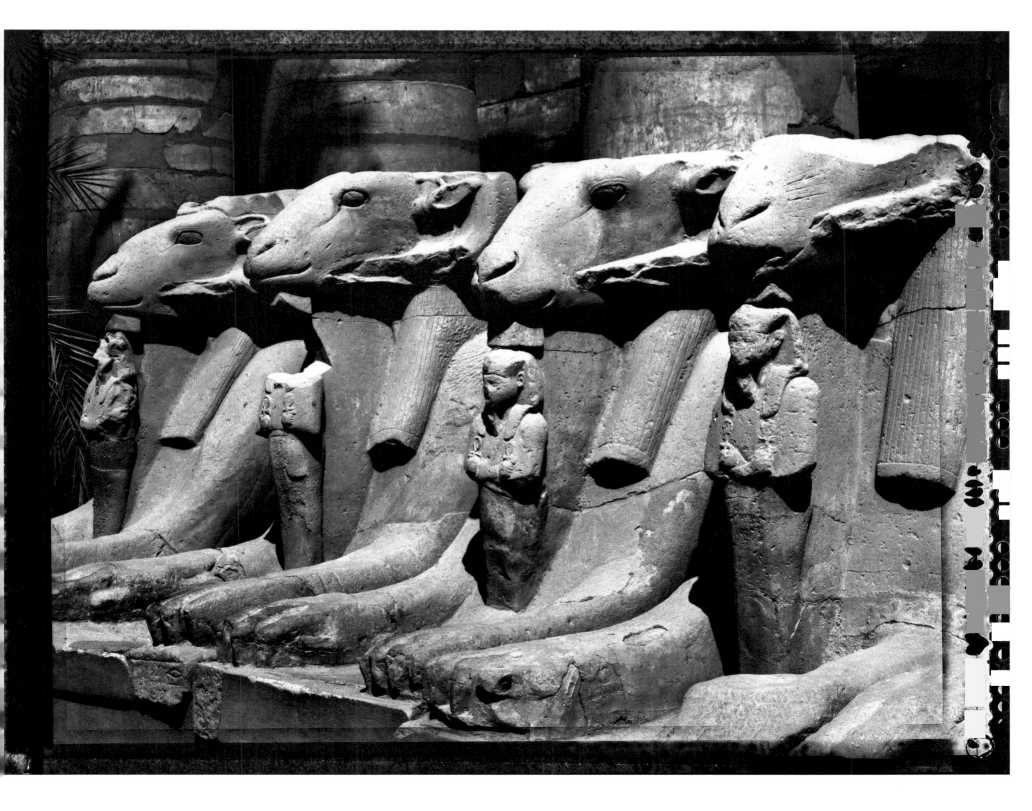

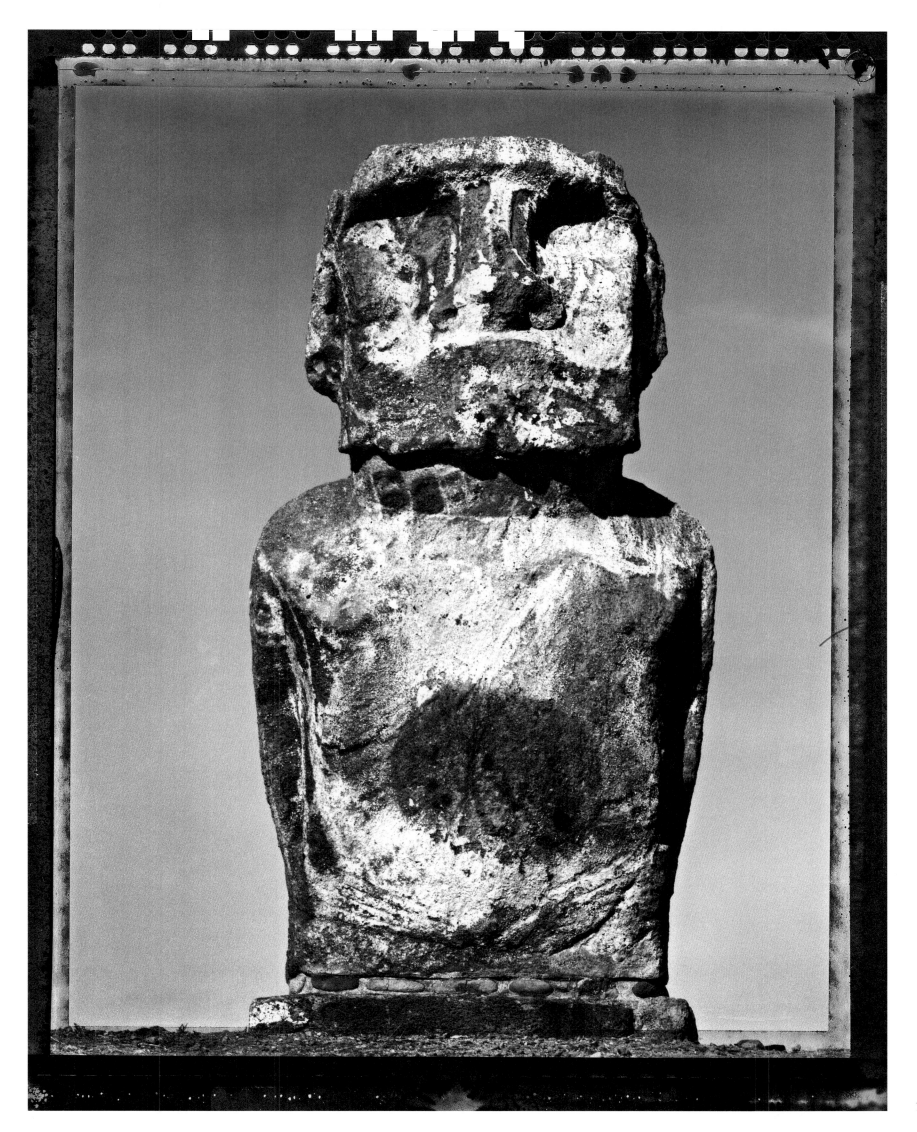

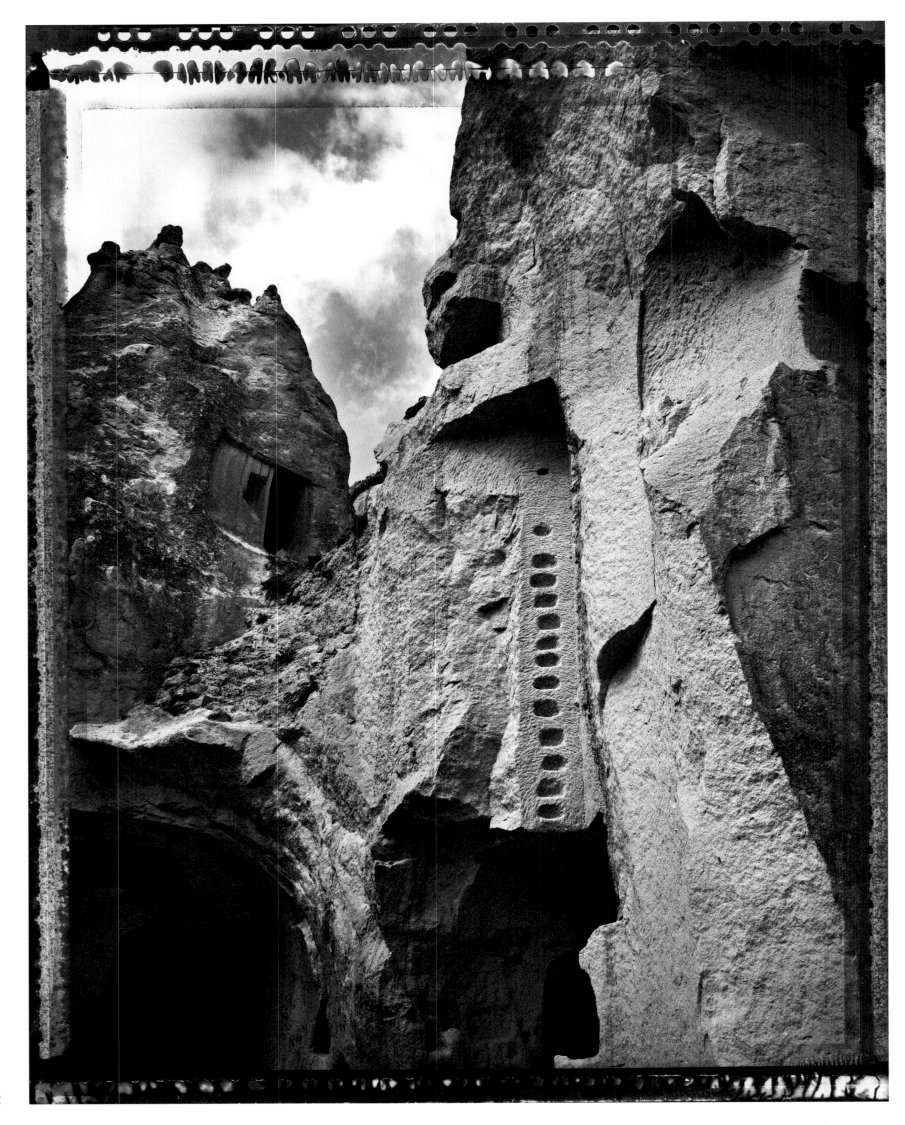

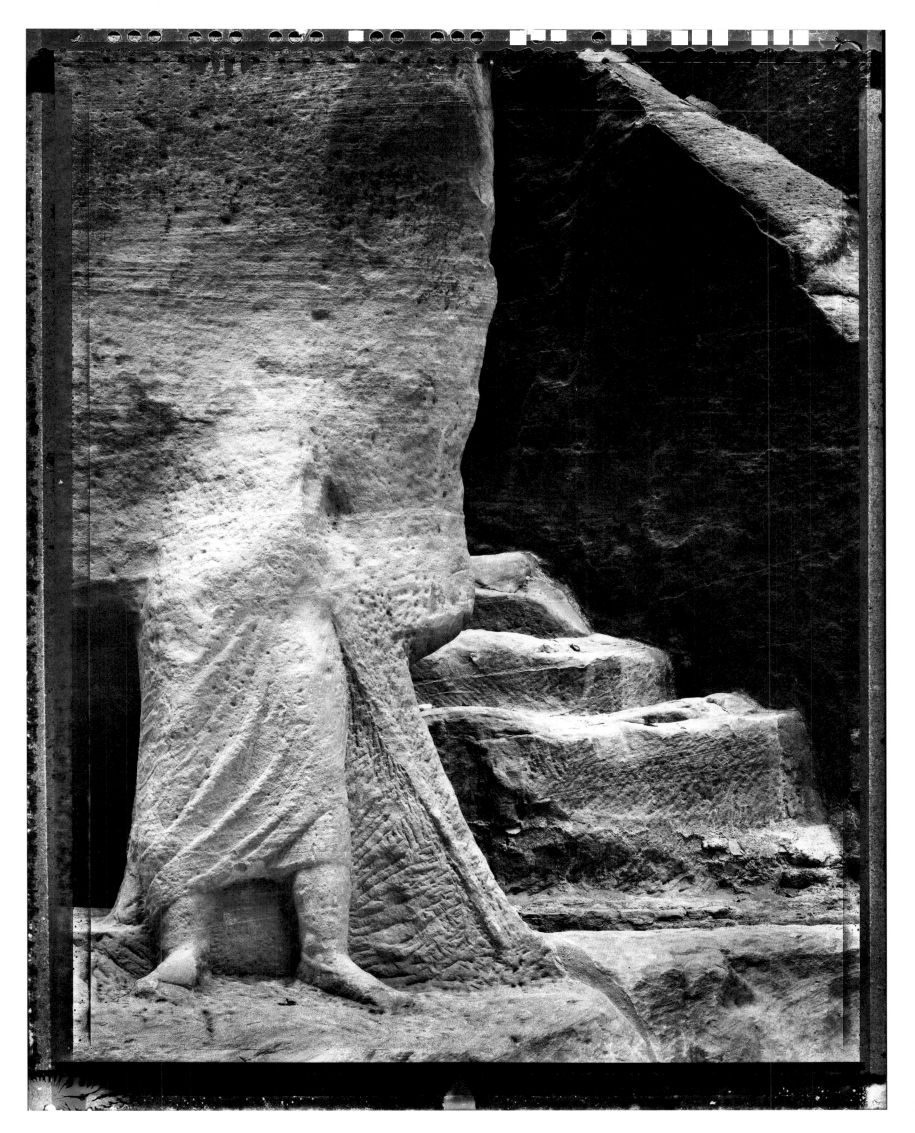

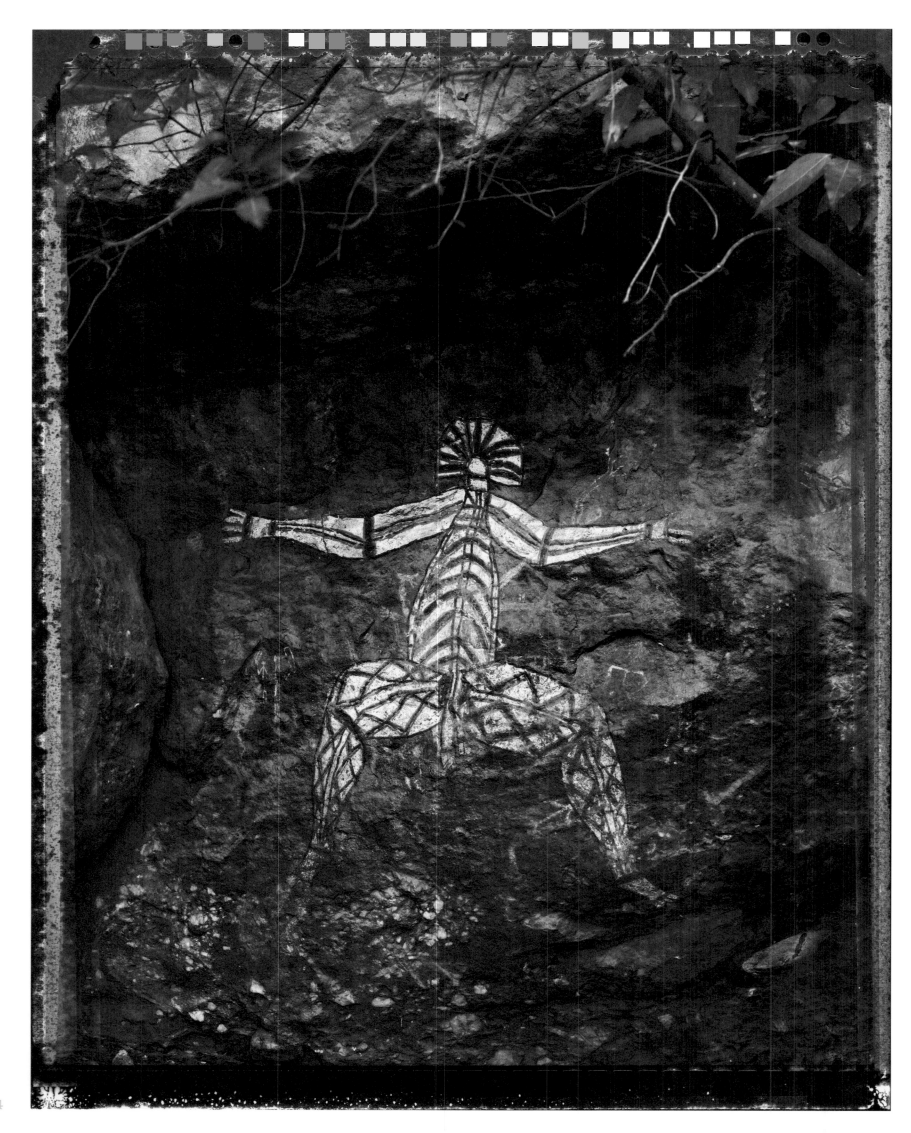

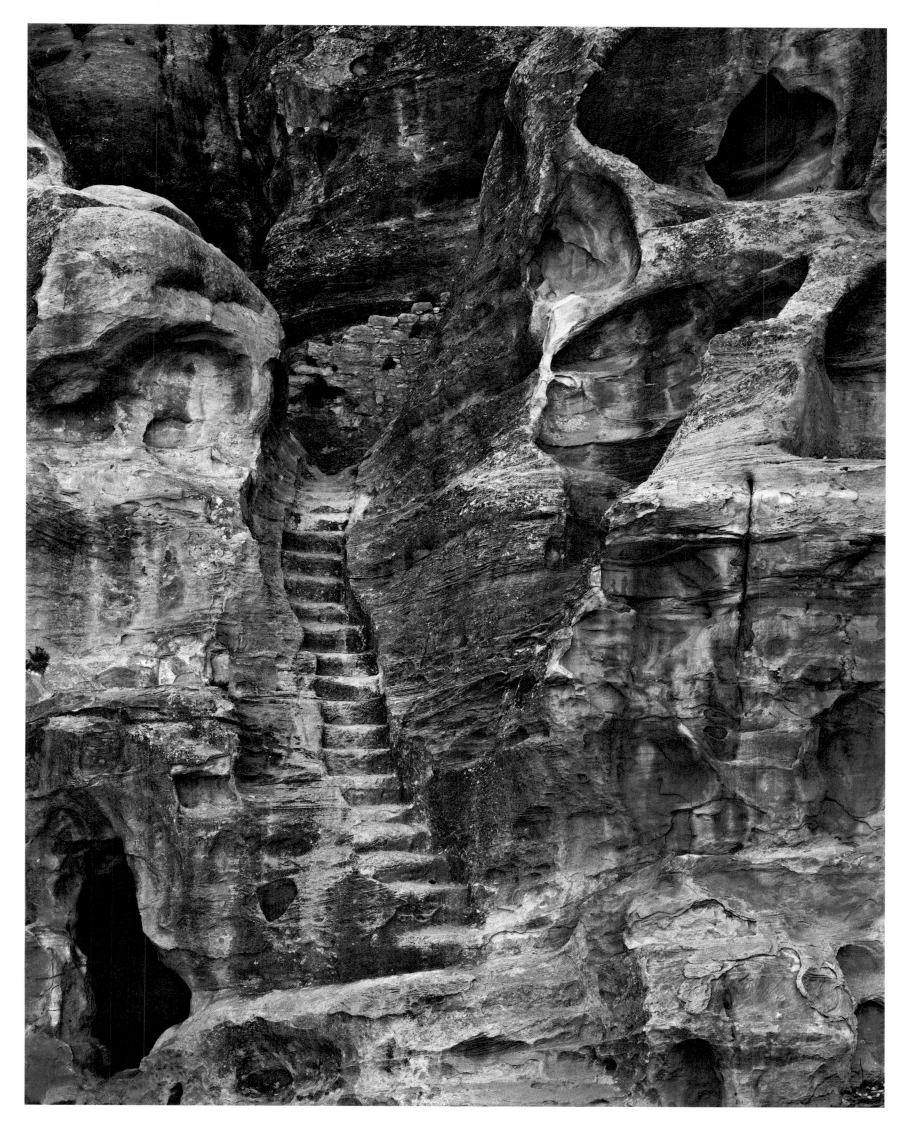

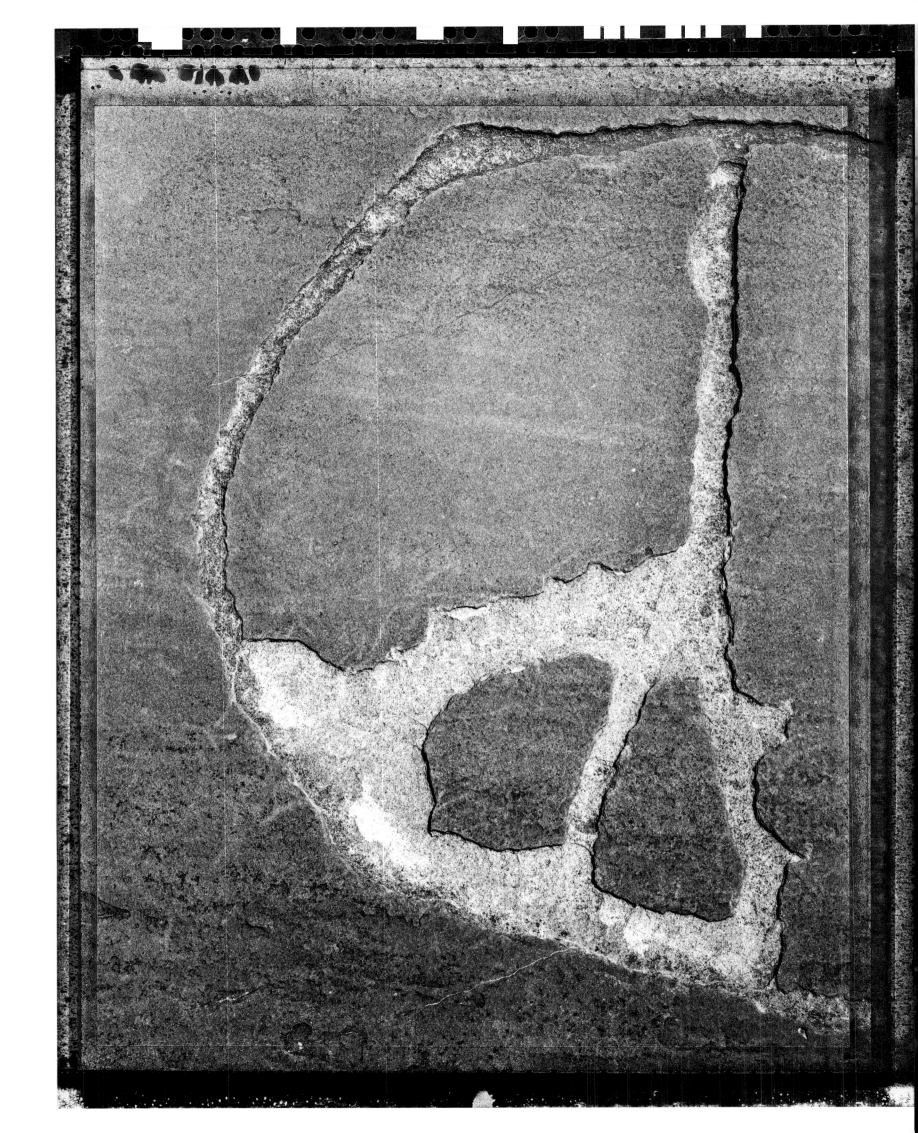

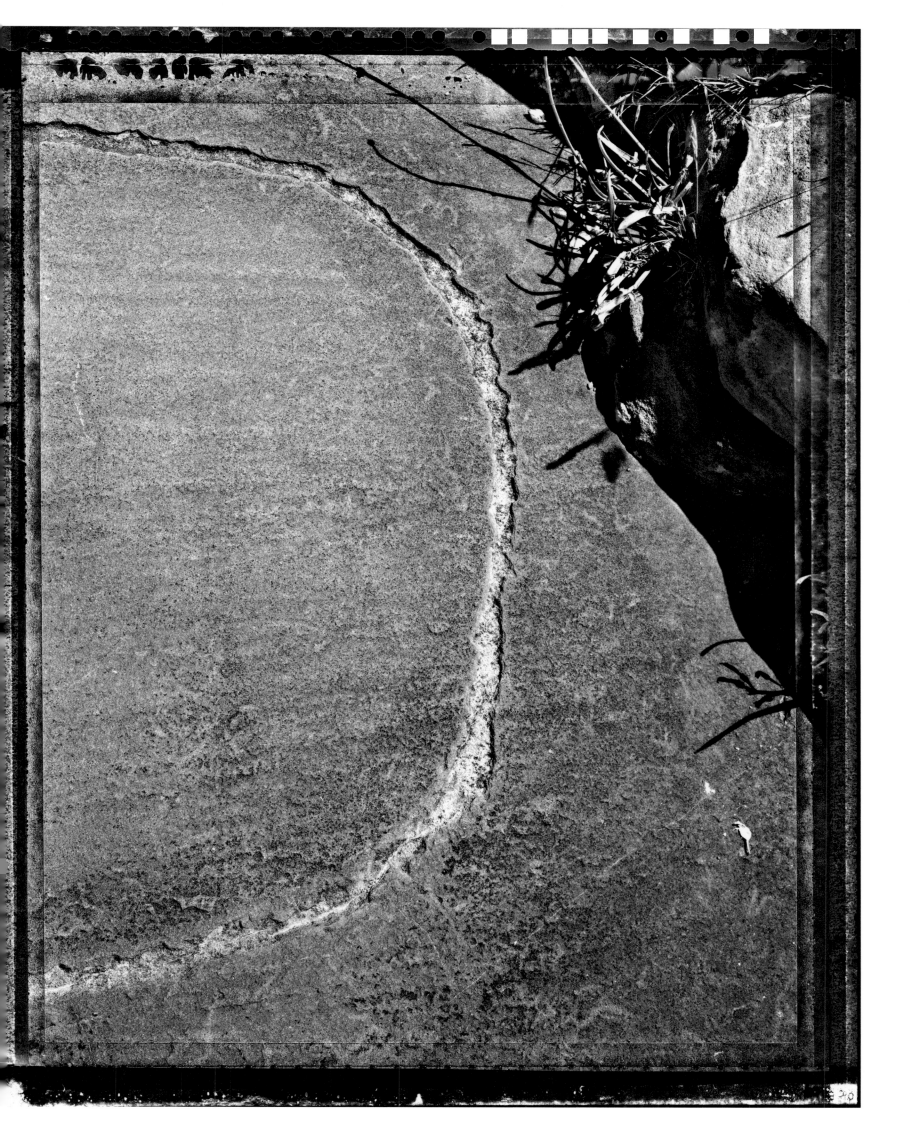

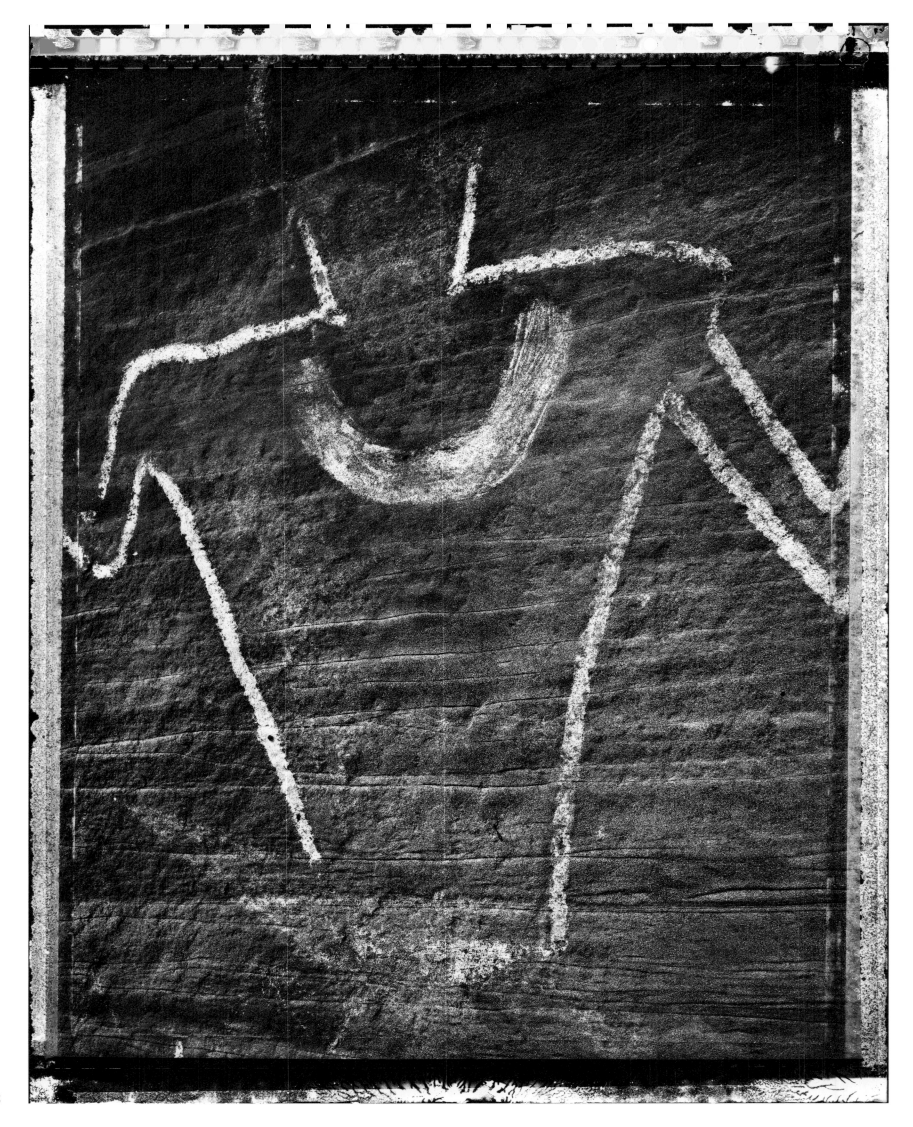

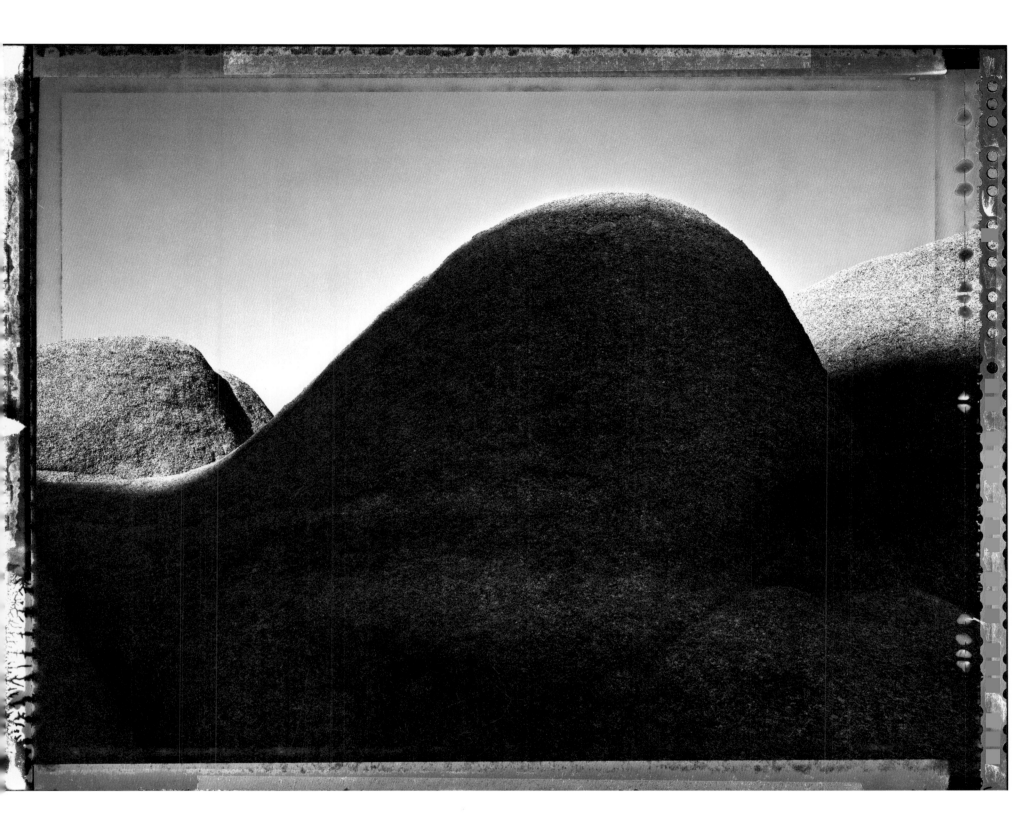

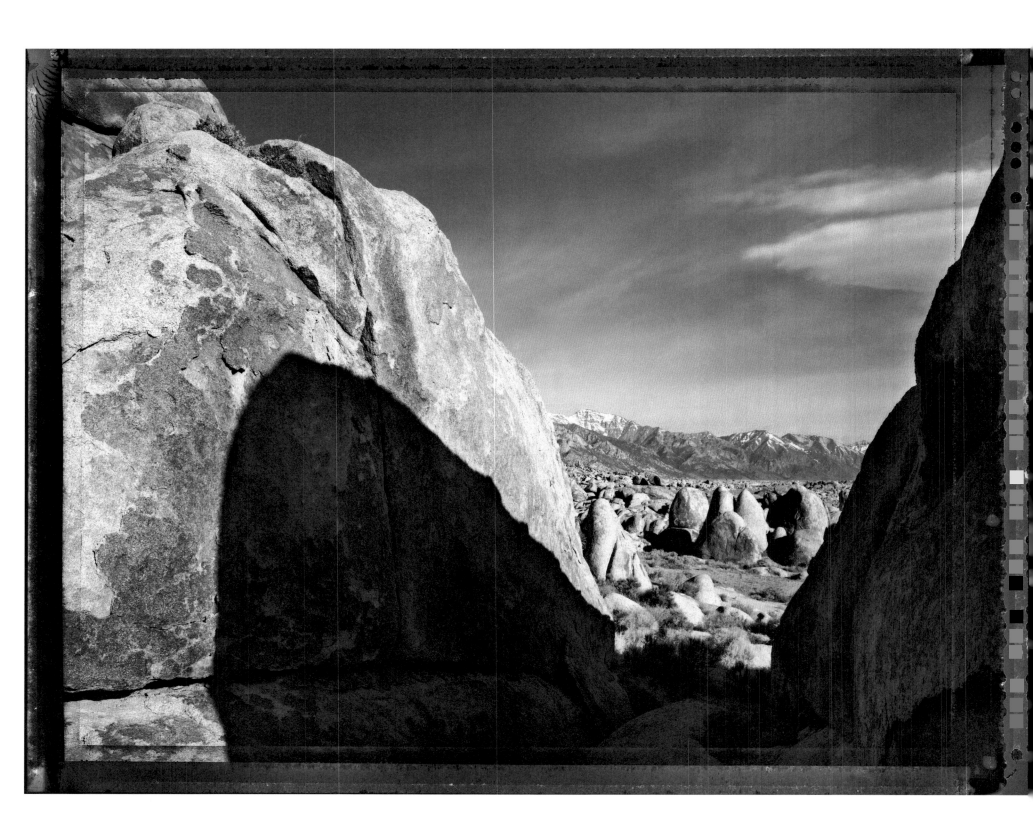

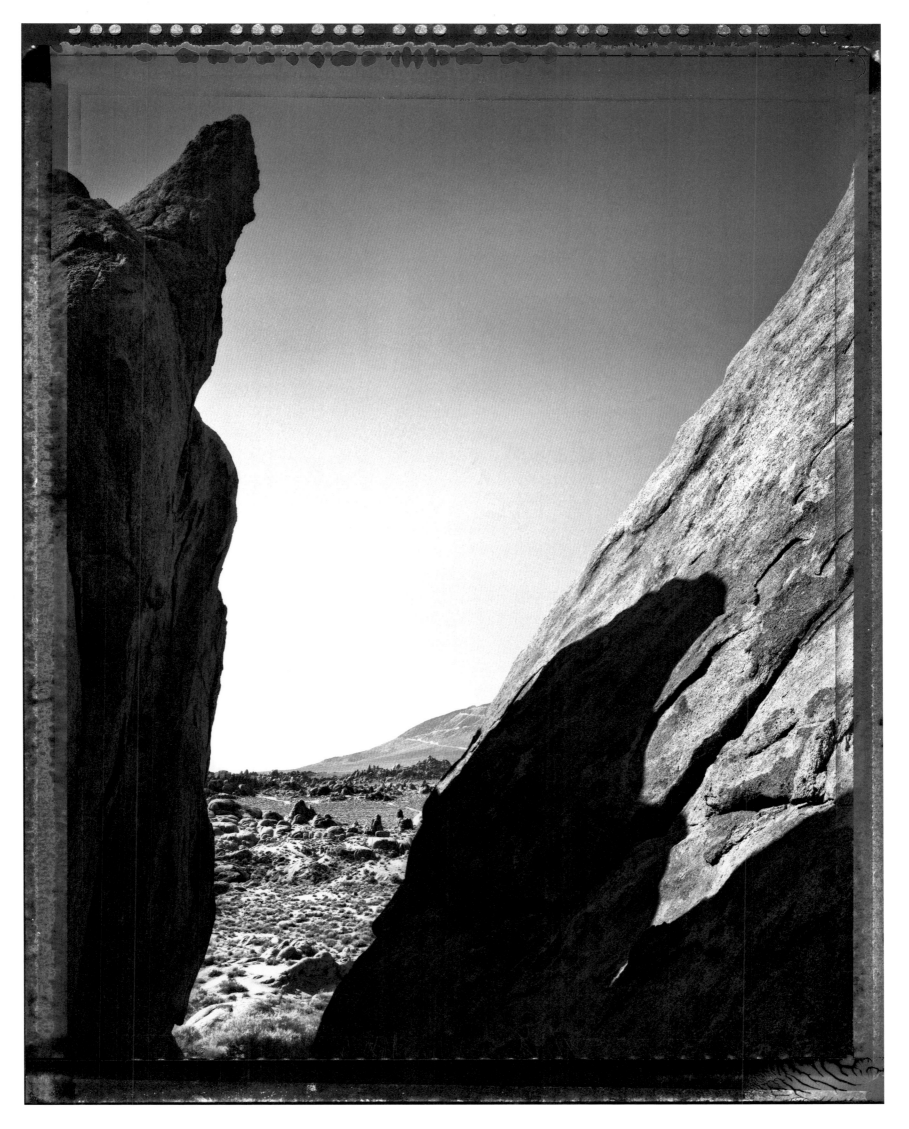

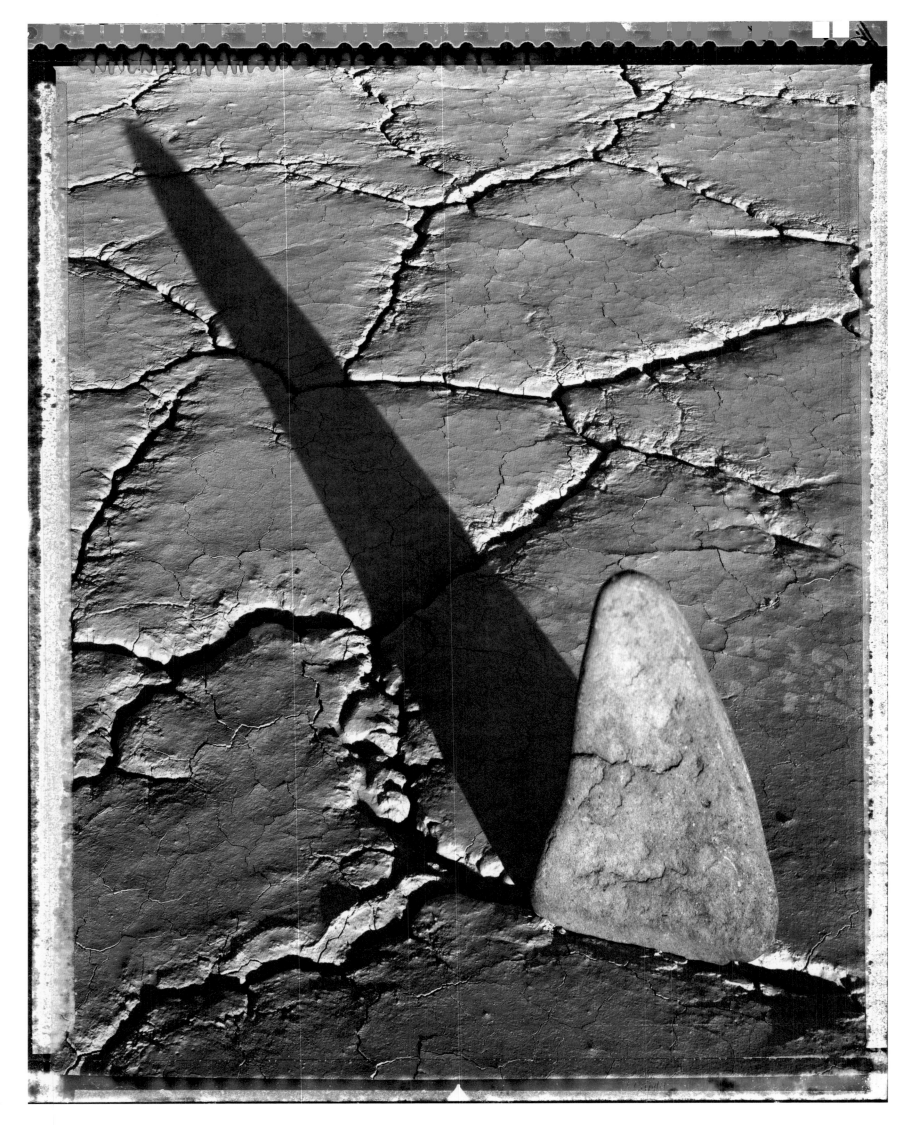

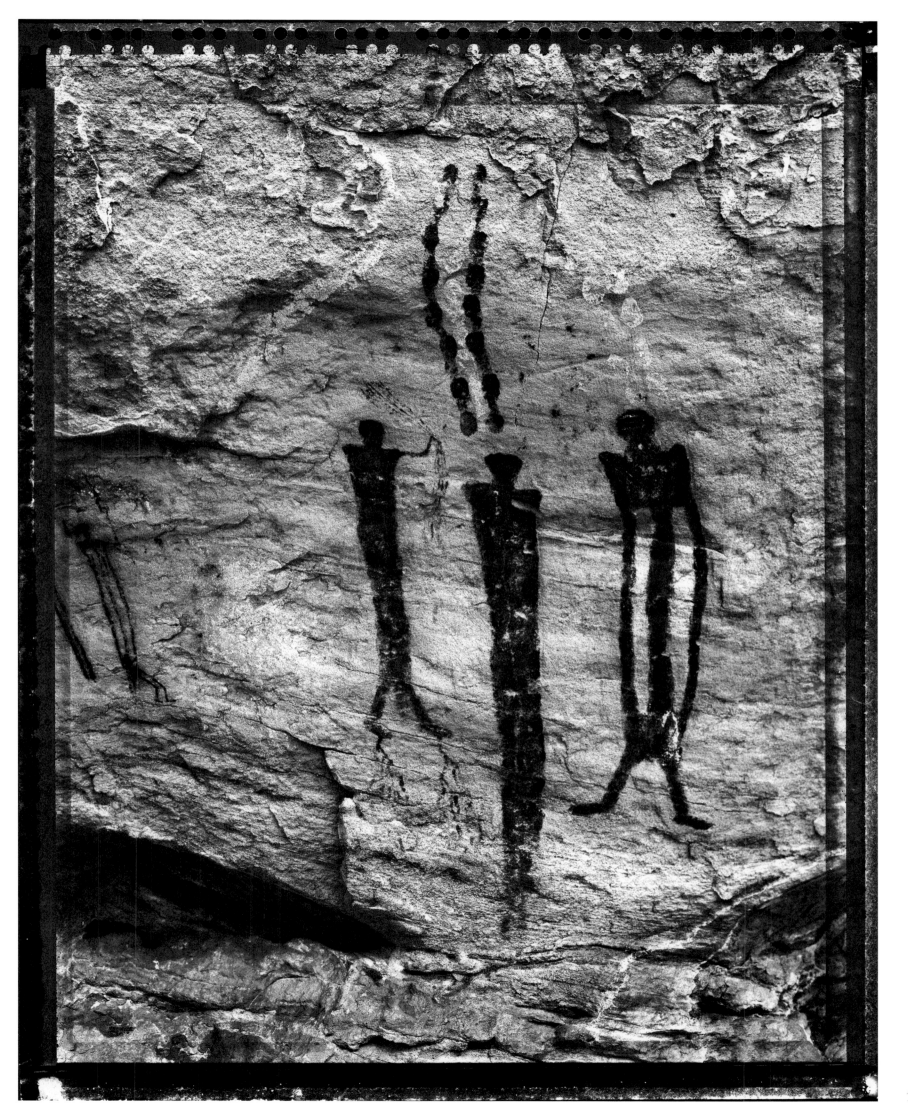

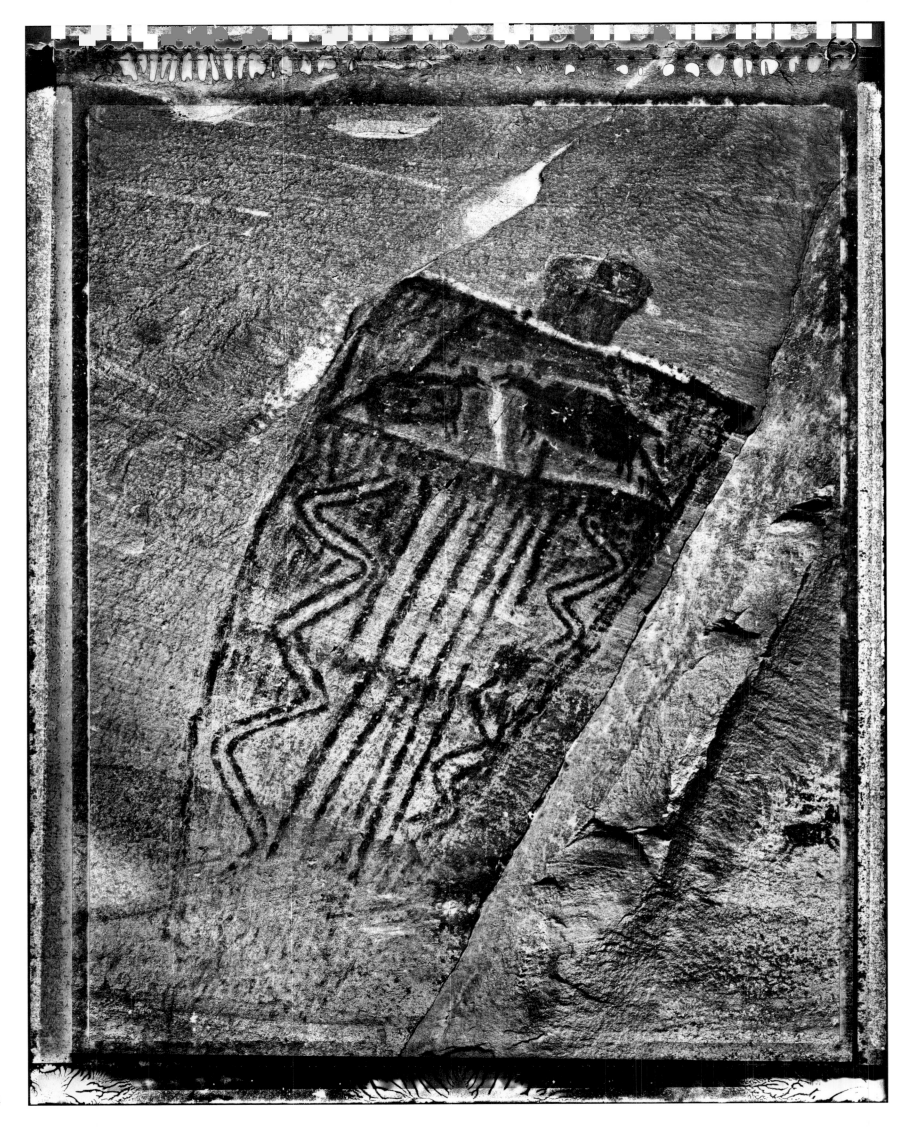

114

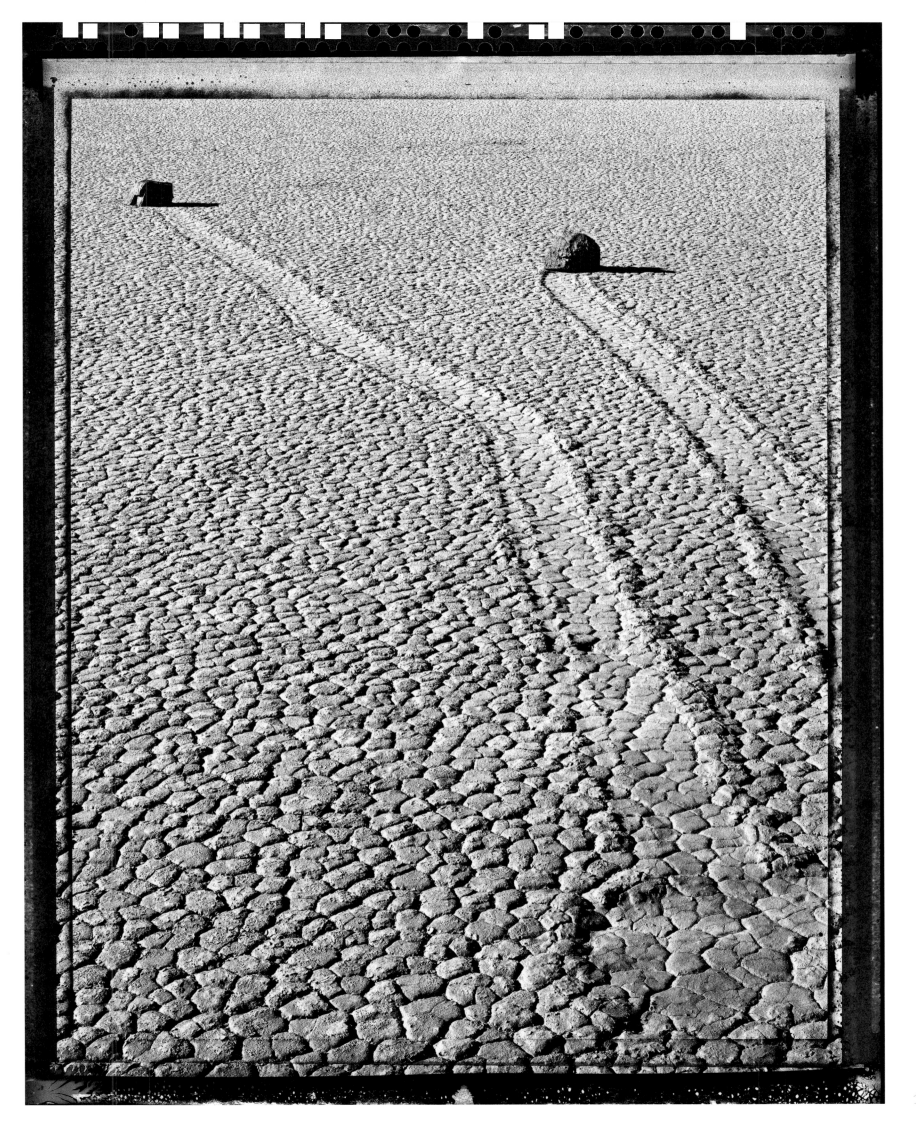

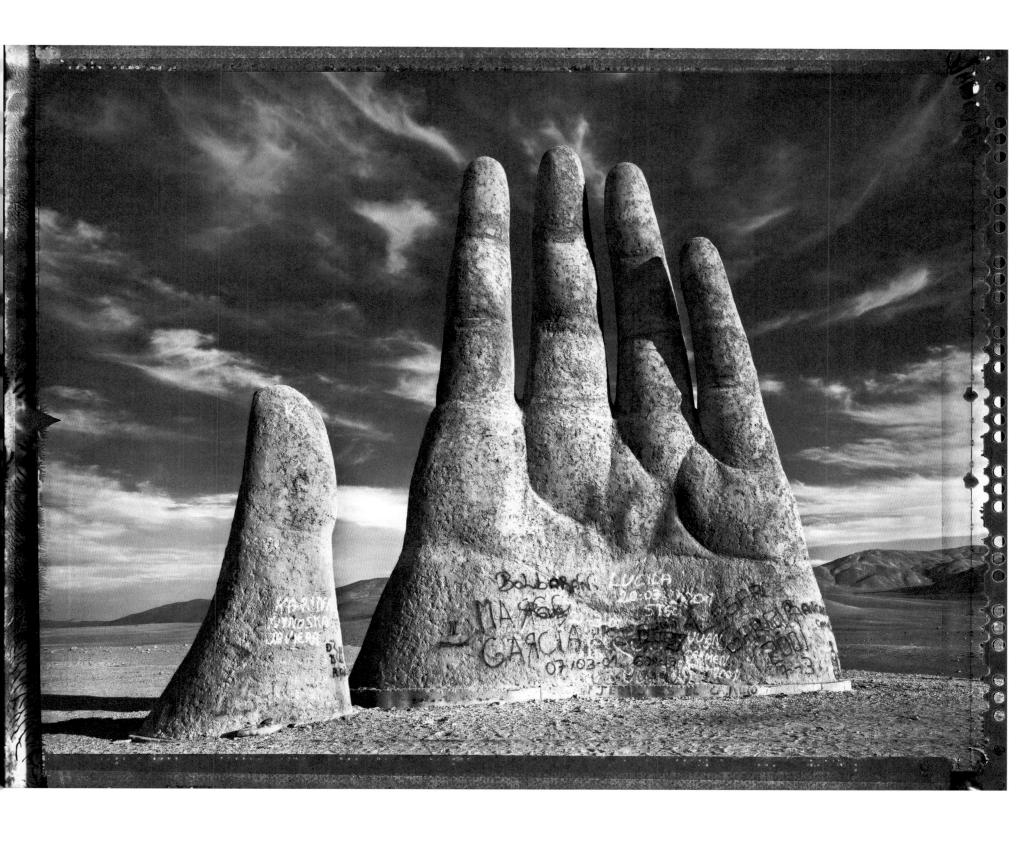

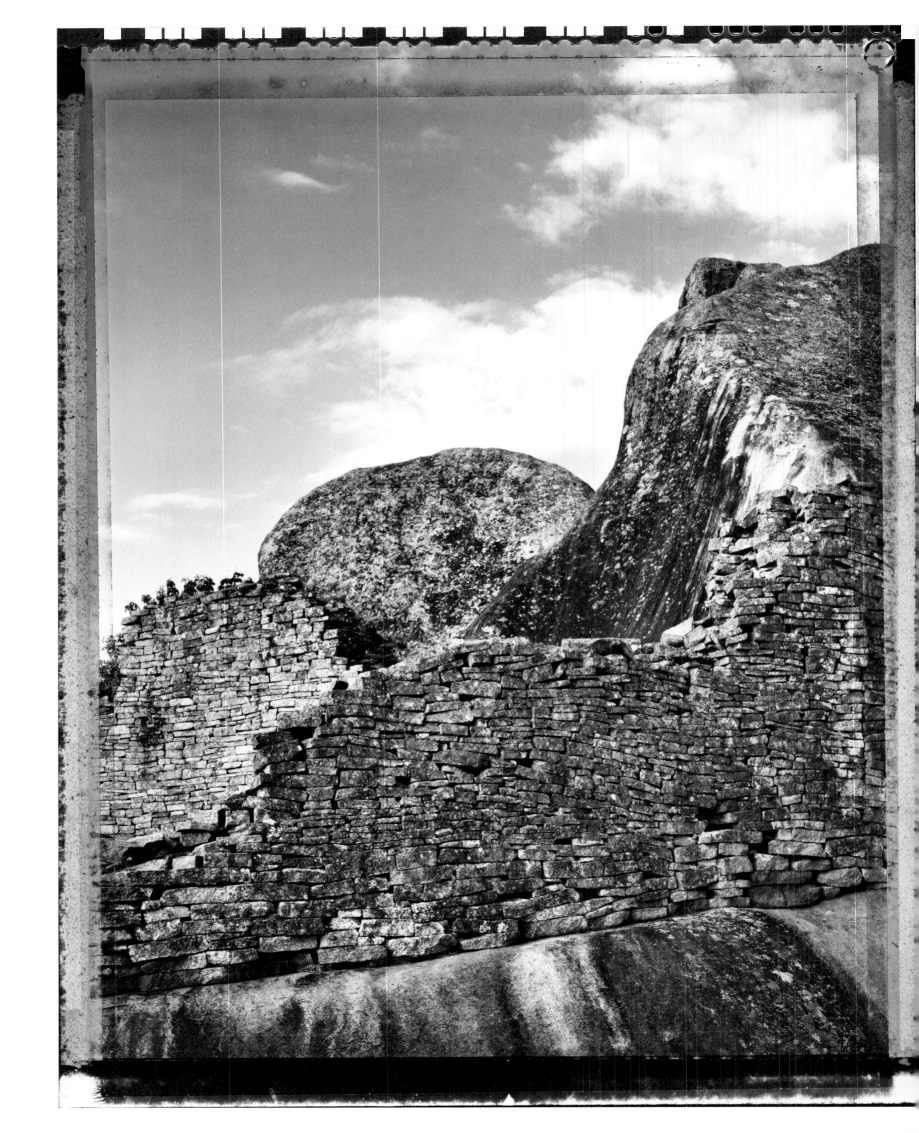

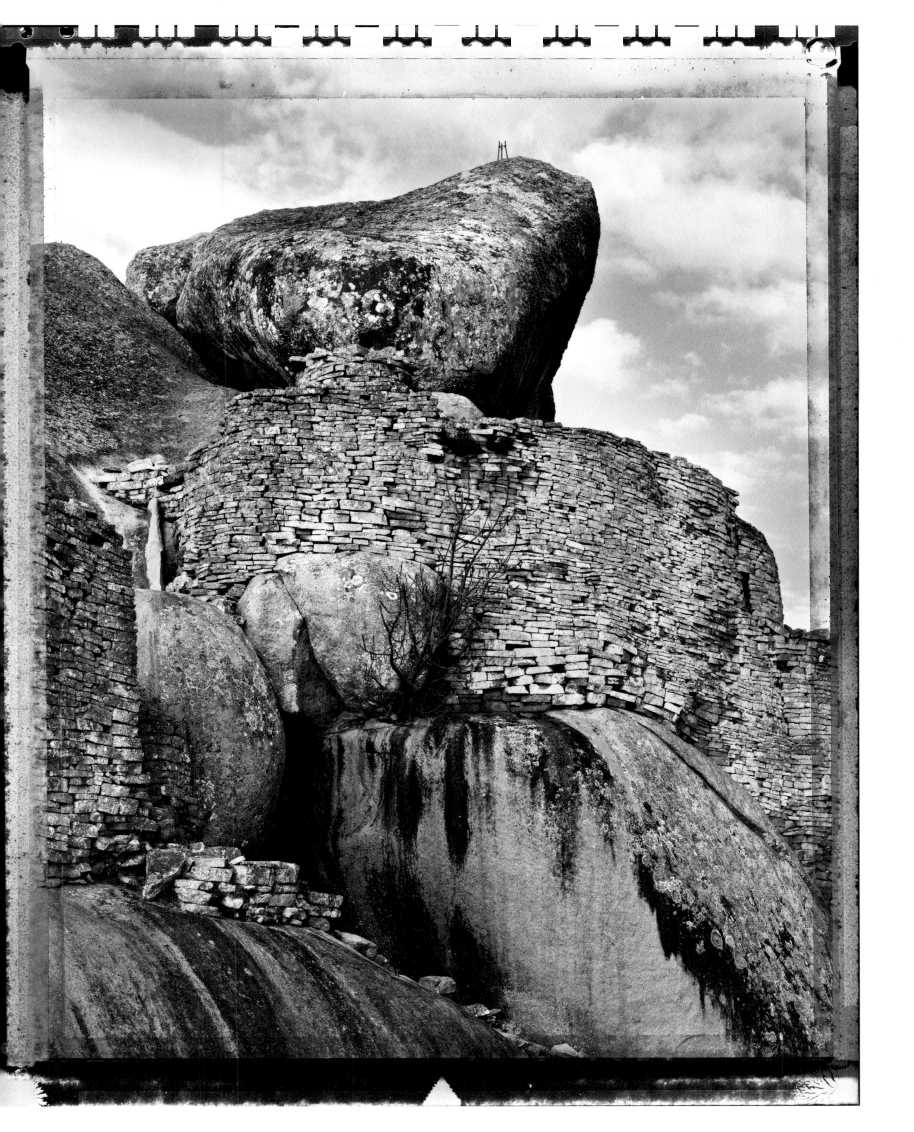

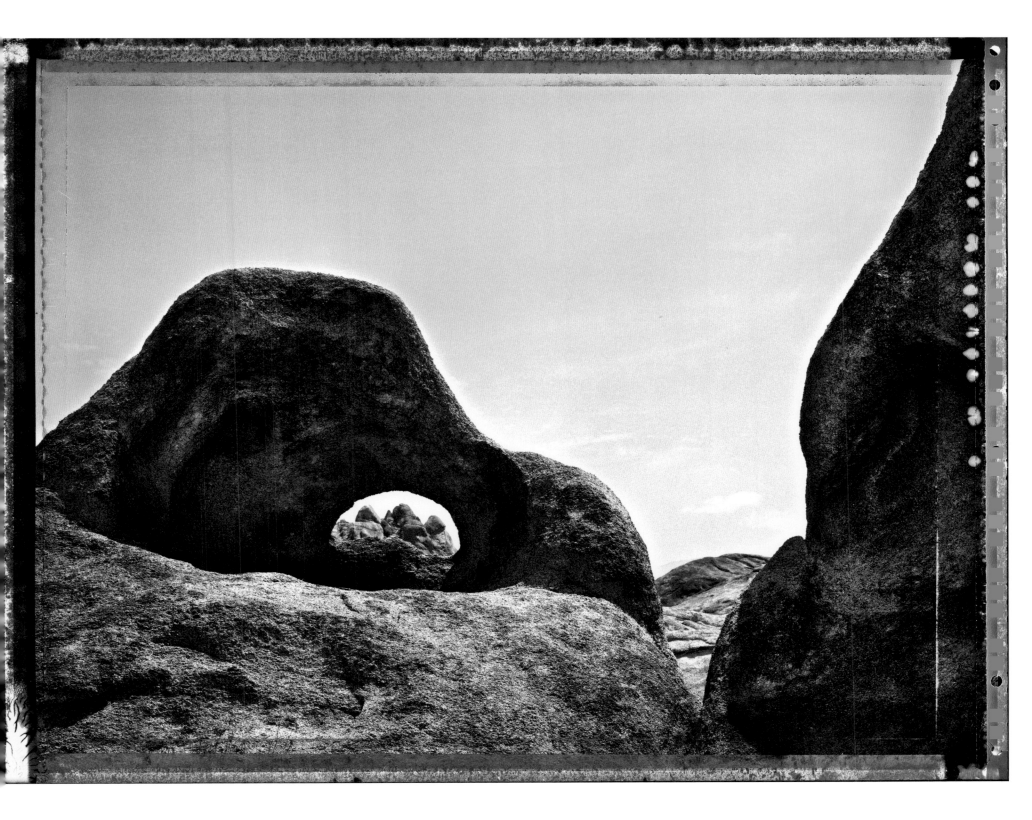

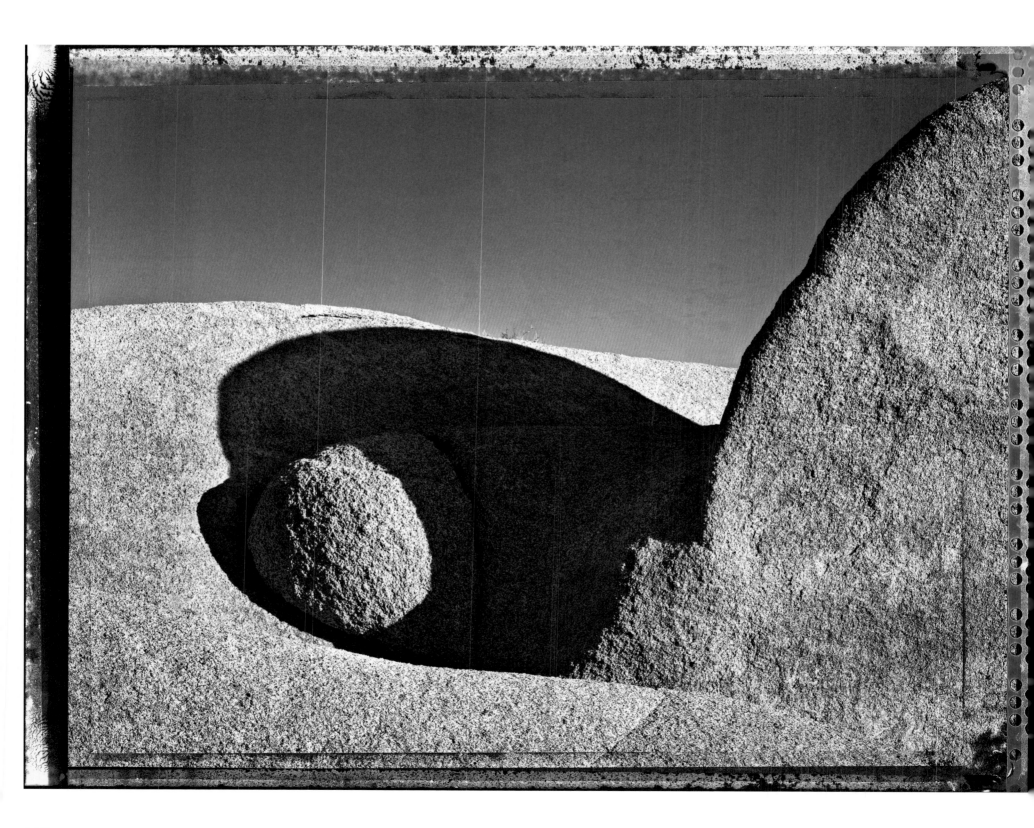

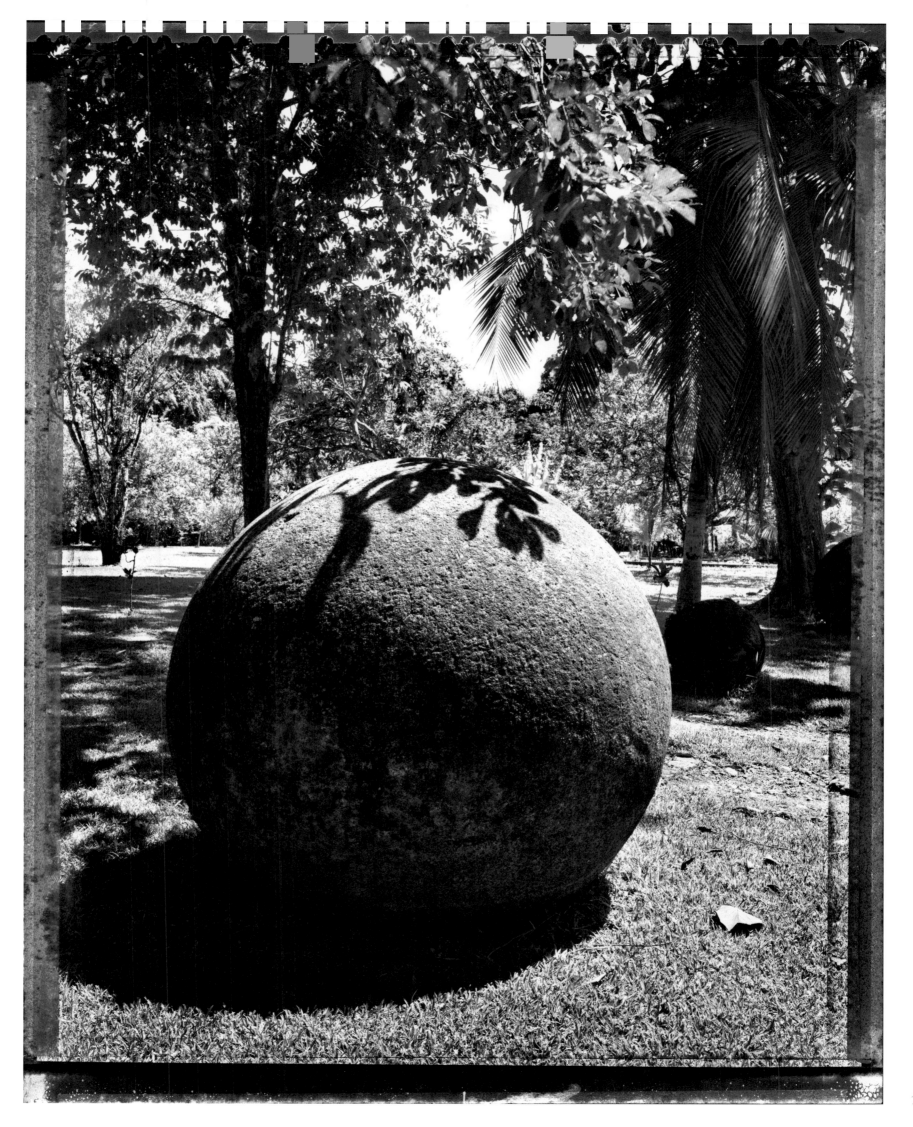

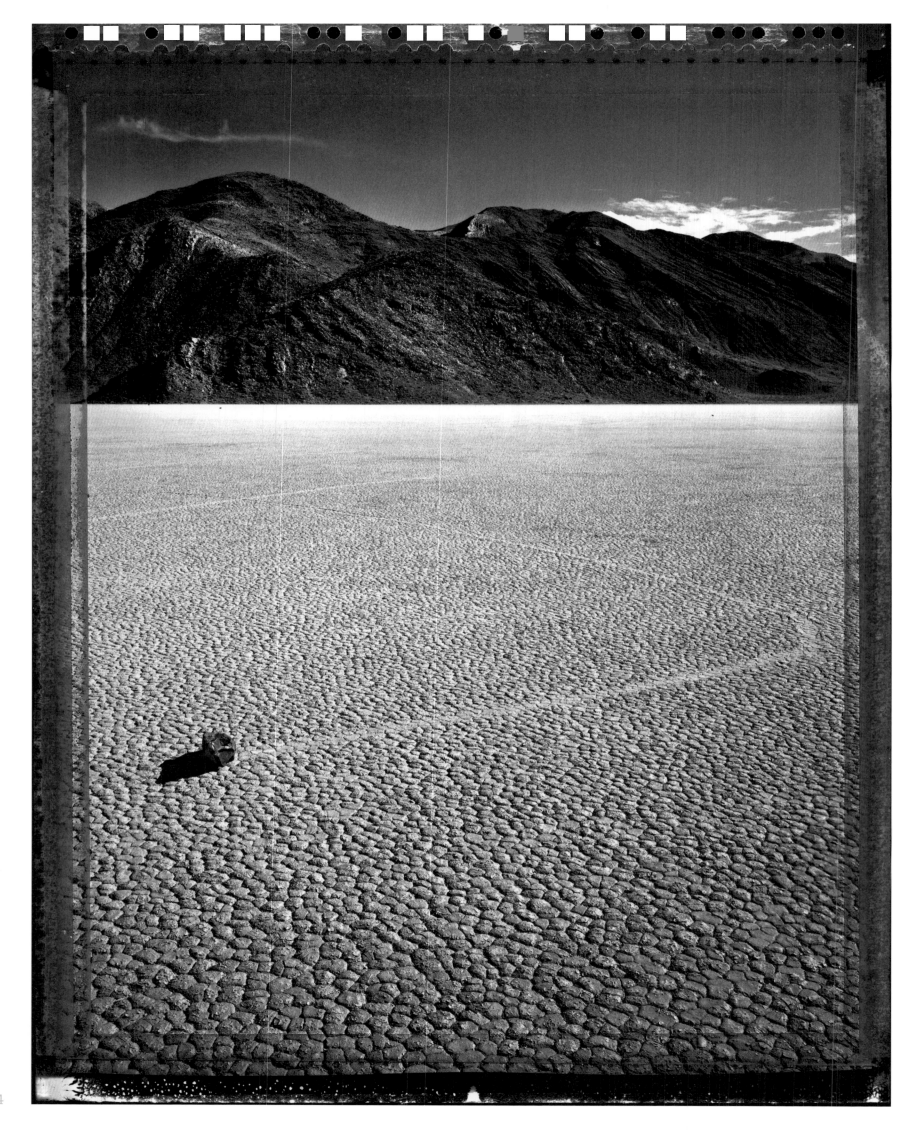

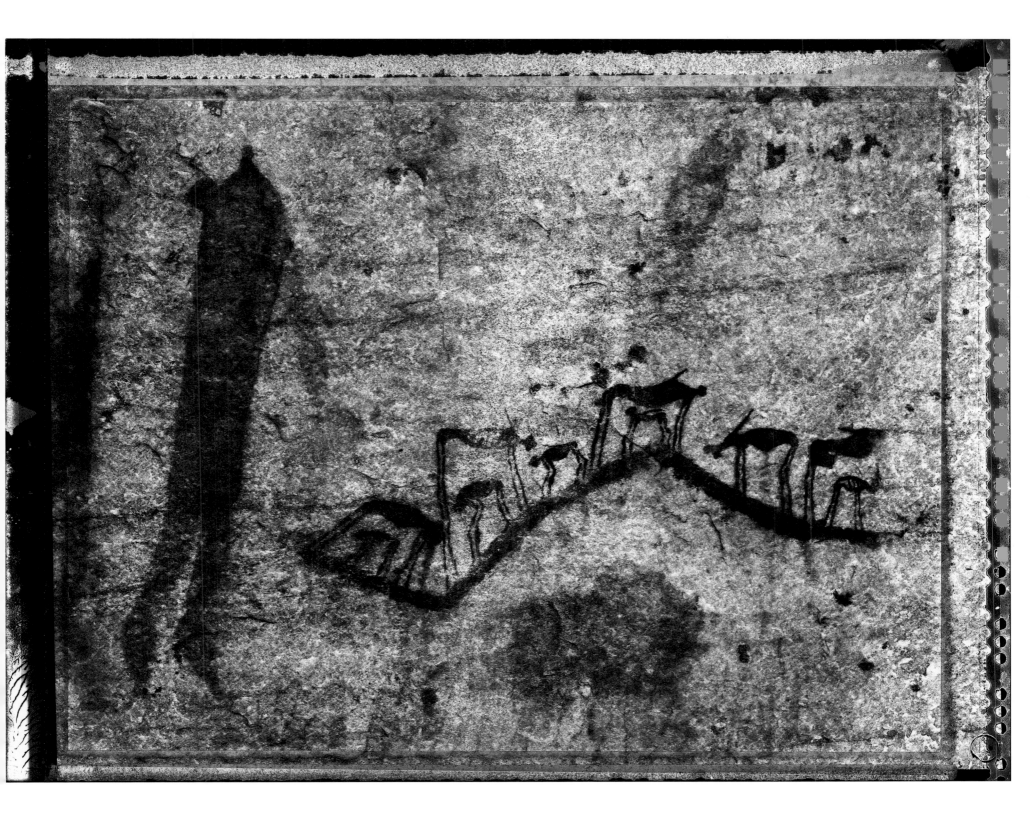

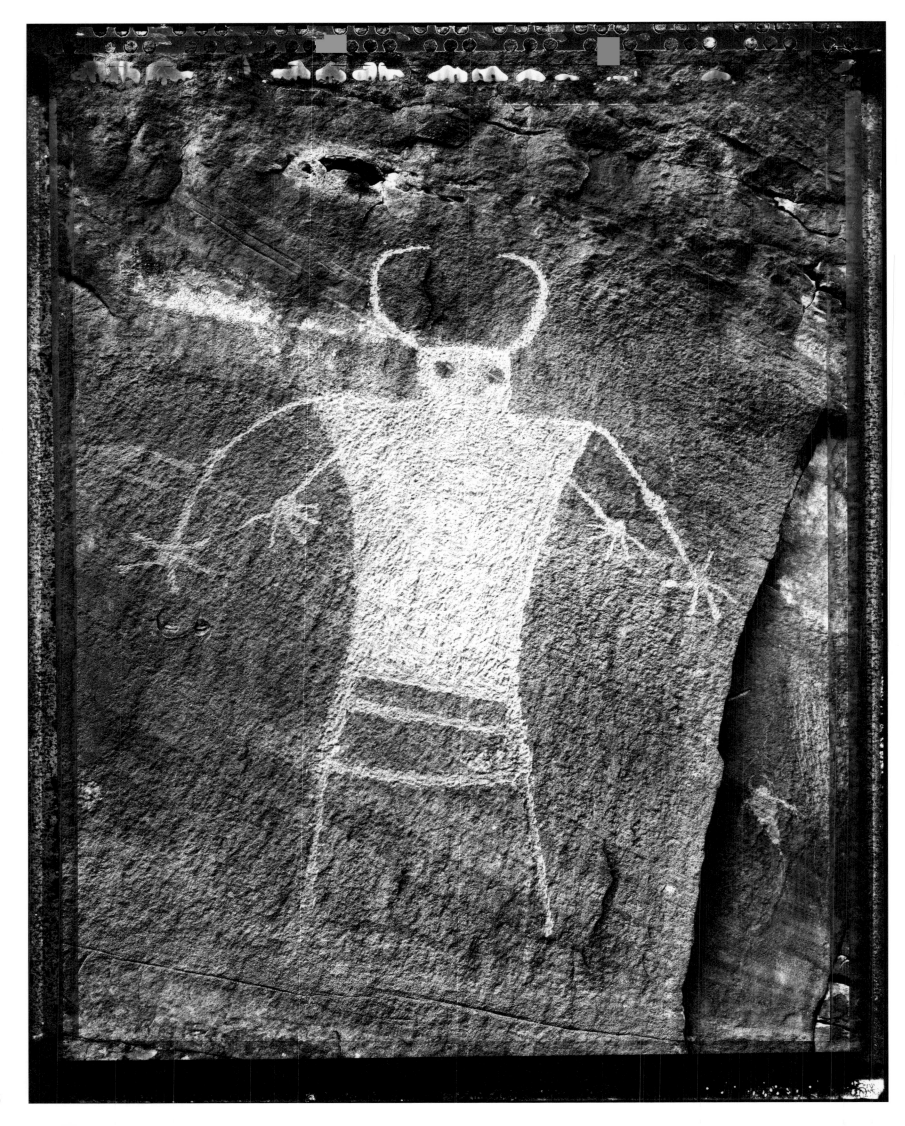

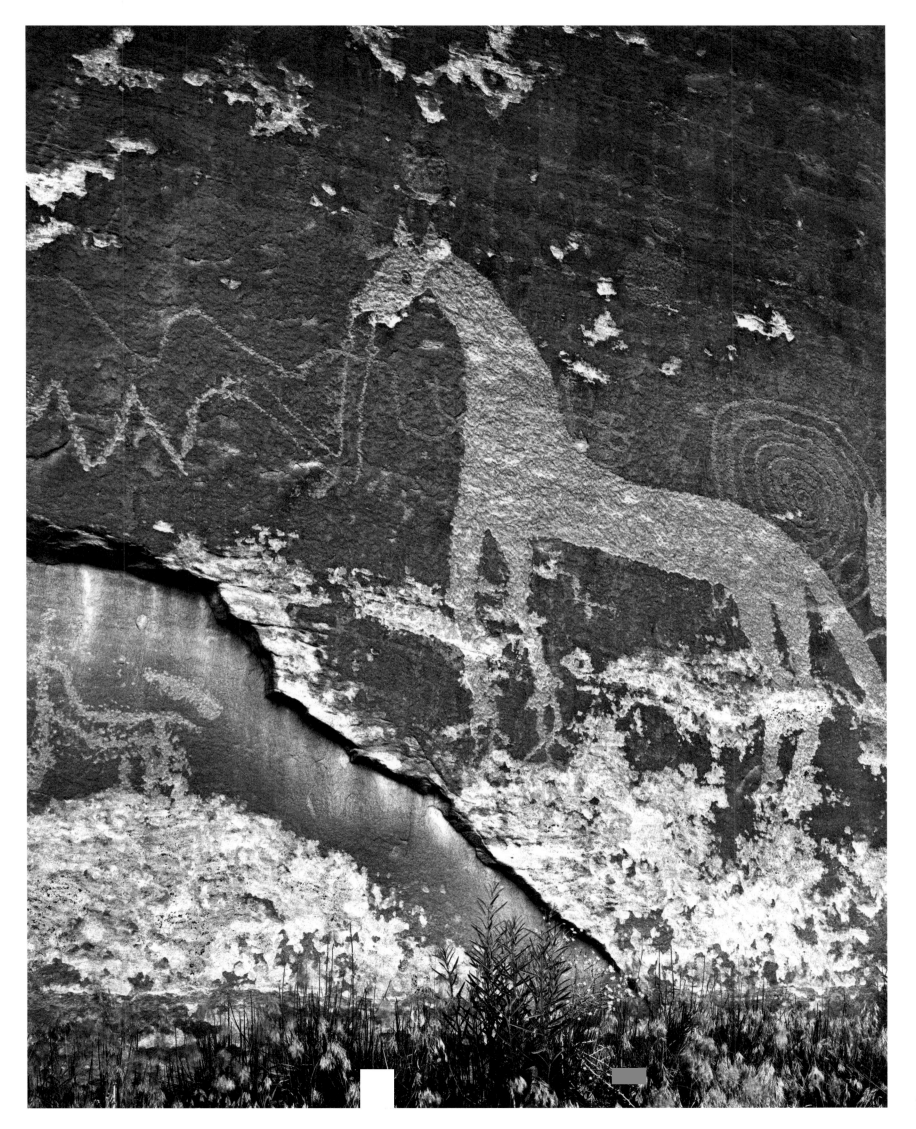

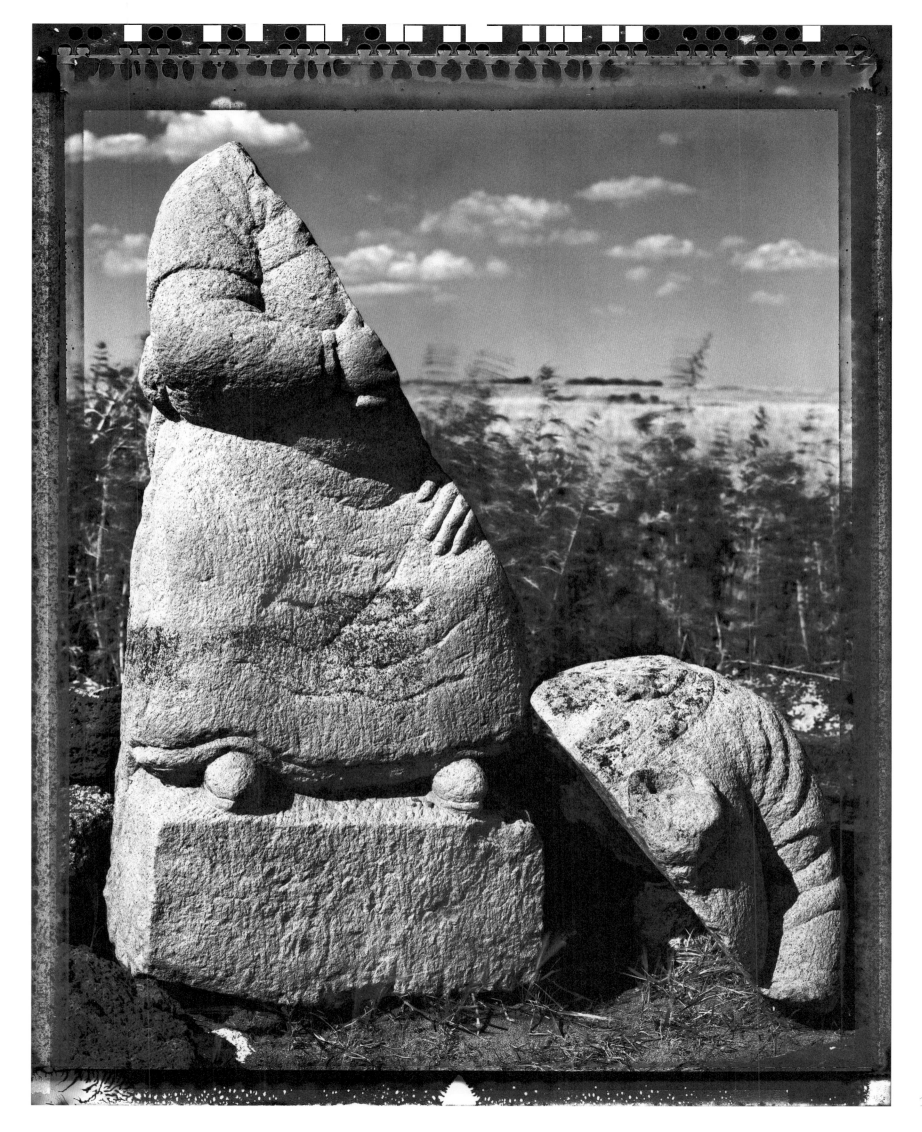

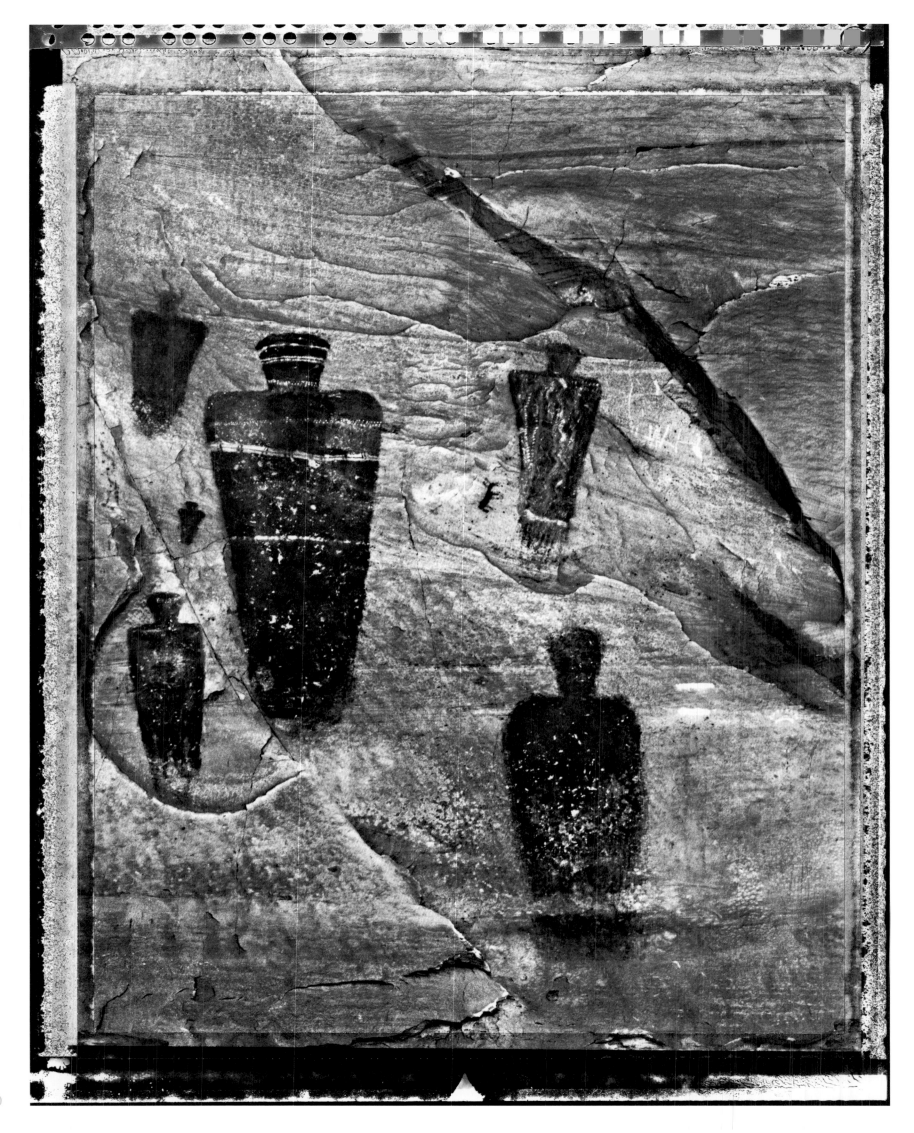

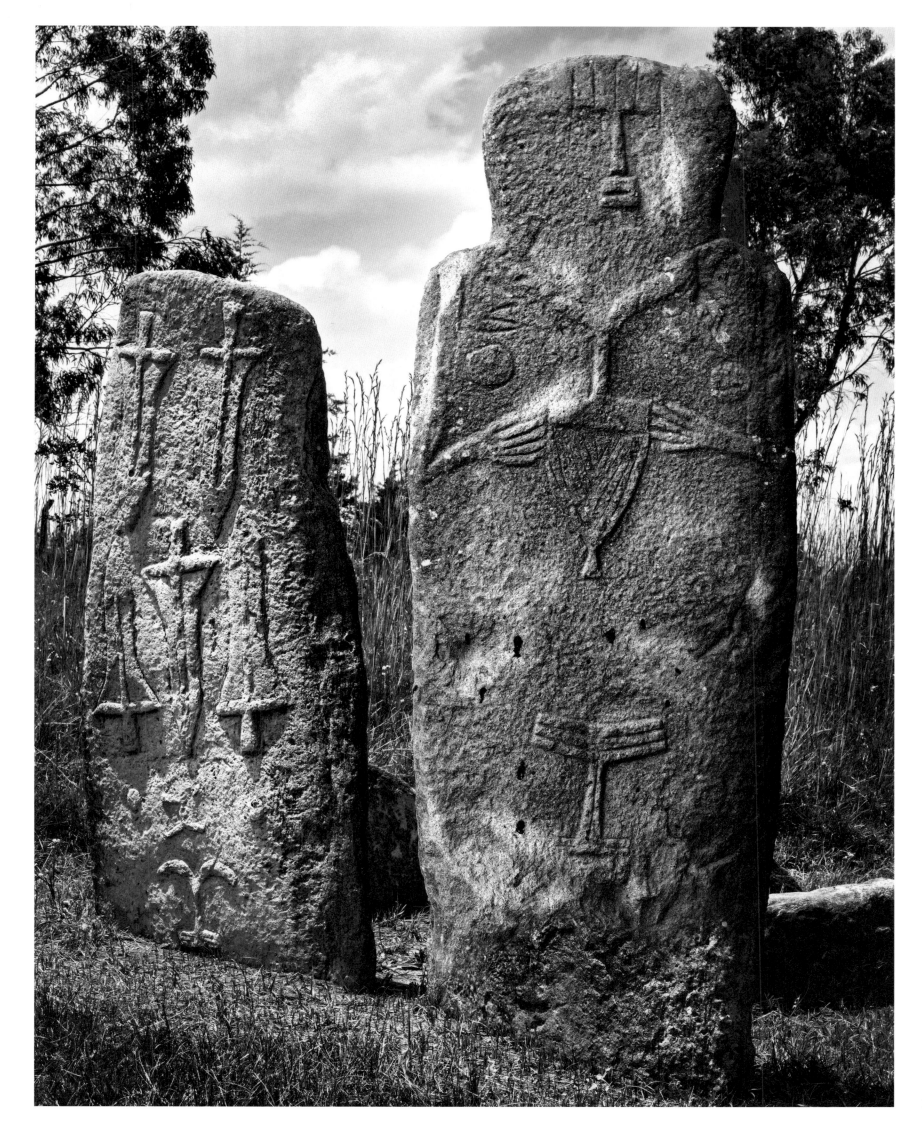

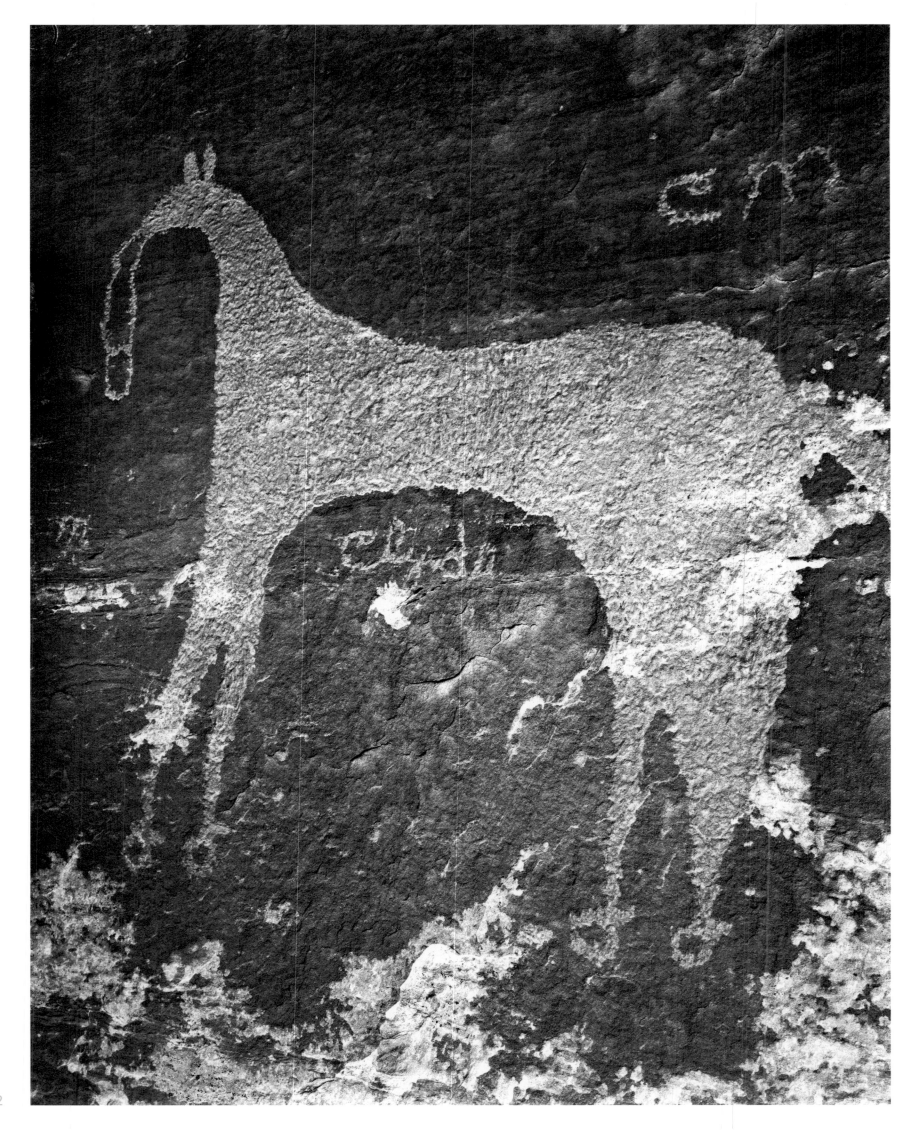

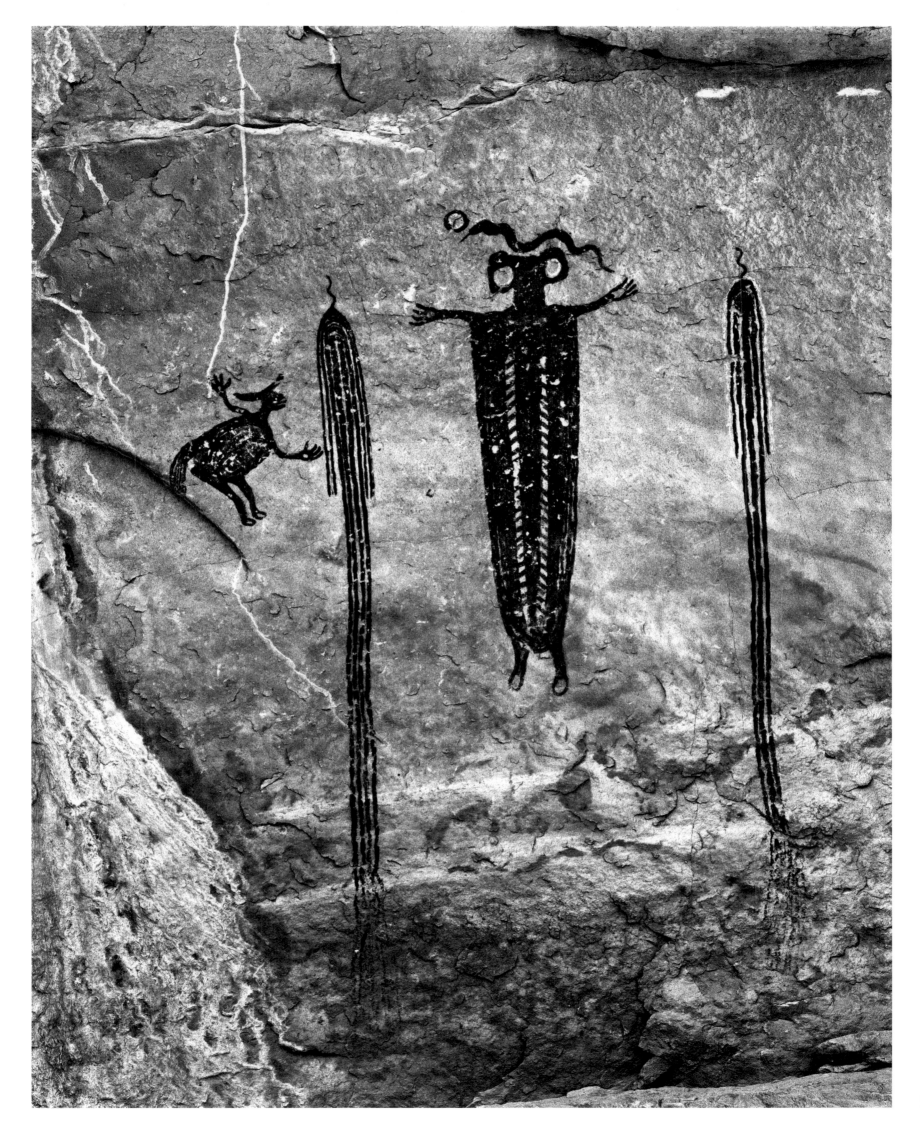

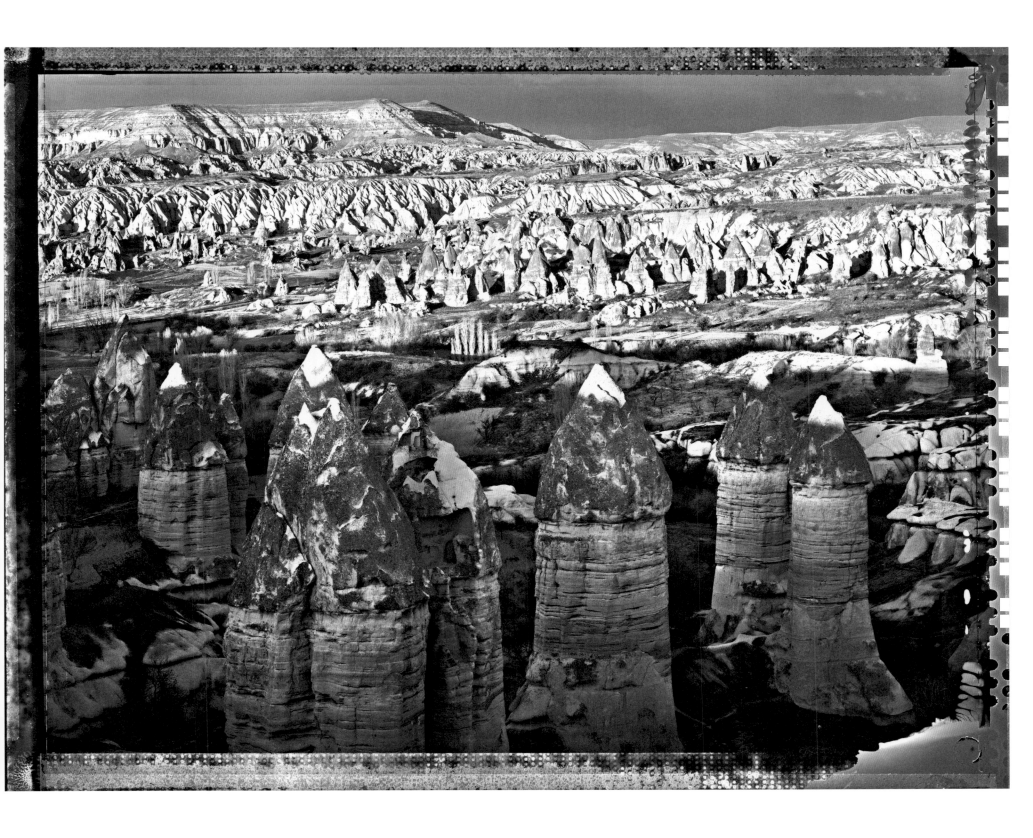

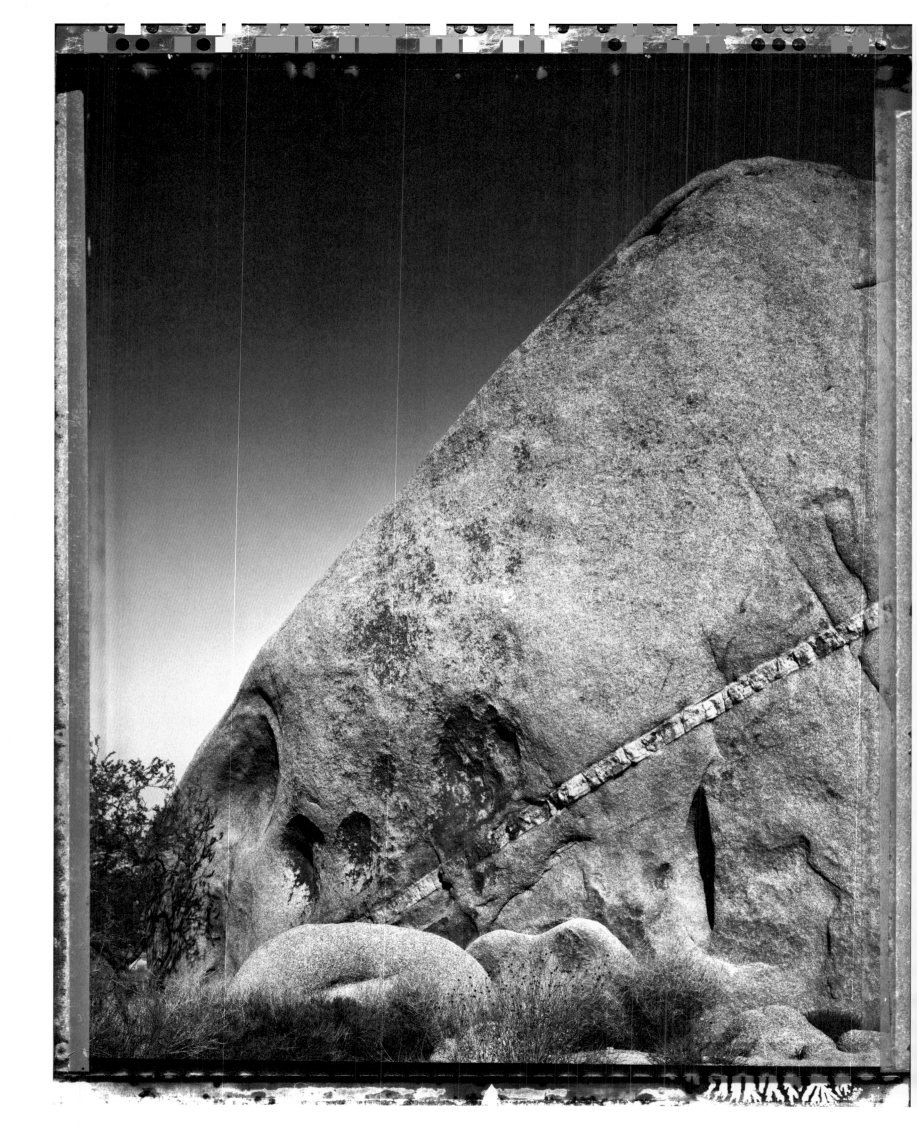

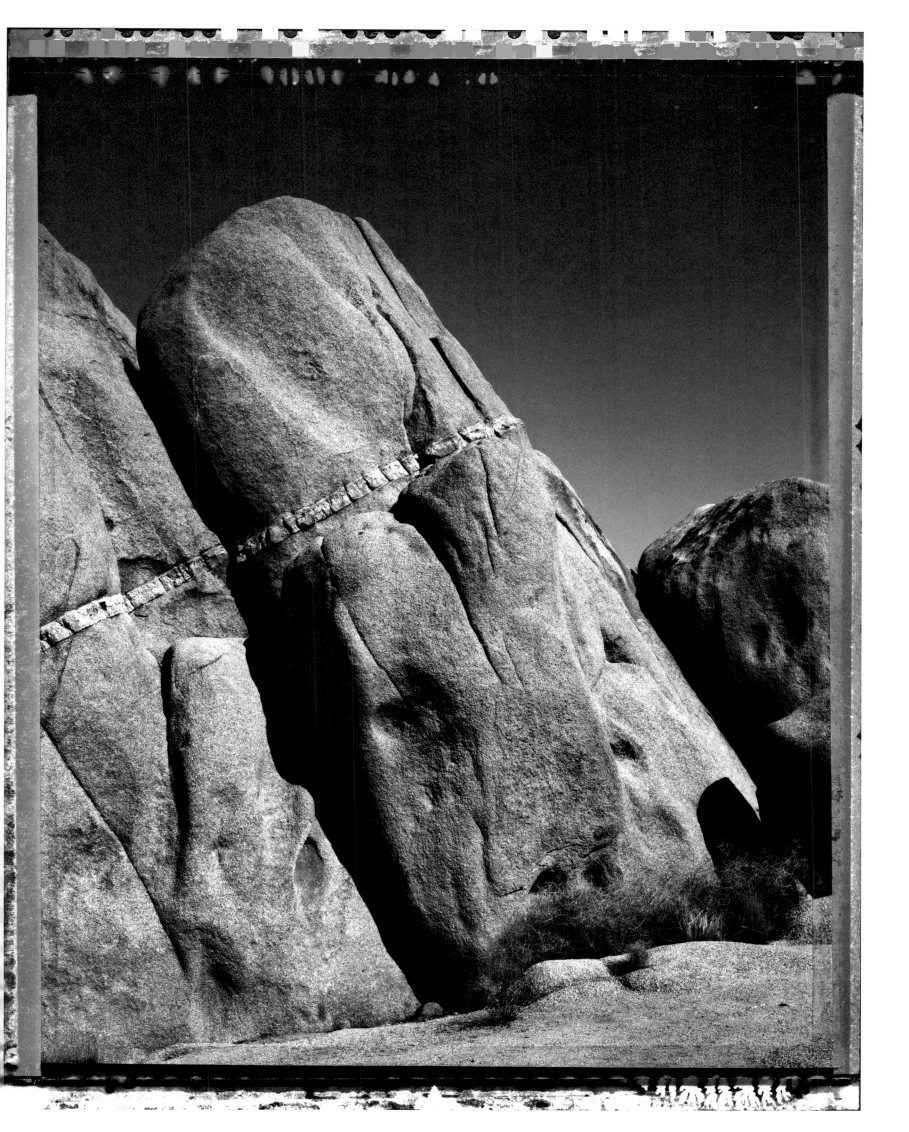

TALKING STONES STORY

Elaine Ling

Since my very beginnings as a photographer I have been captivated by ancient stones and the messages they send us from the ages. This book brings together my decades of obsessive travel and photography dedicated to recording remarkable stones, both natural and man-made. While making this selection of images I was overwhelmed by memories of the many adventures I had making them and the fabulous tales and teachings they conveyed from both ancient cultures and nature itself. There is a wisdom in these stones.

Originally most were created to be messengers for what are now long-vanished cultures. The lone man of stone staring at a Gobi Desert horizon, the beheaded nobles bearing gifts to a Chinese empress, a Buddha's face almost swallowed by a tree, were all conceived to preserve and disseminate tales of great journeys, battles won and lost, death or survival, ancient myths and powerful gods. Many of these stones are situated in harsh and remote landscapes that have added their own messages to the originals as the years have passed. They stand, massive but not mute, like powerful guardians of the earth. One of their central messages is that, ultimately, nature will prevail.

I see myself as a very small figure in the large landscape. In one image of the book, there is a doorway in the rock, an entrance for me to enter other worlds; temples hued in rock, city and spires made by hundreds of hands with stoneworking tools, canyon walls of storytelling drawings of supernatural beings. Extensively, this body of work shows the permanence of communication, that stone was the medium and I was enticed by its purity and intricate beauty. Listen to the Talking Stones.

Many thanks to the people who has given me their advice on the making of this book, Marcus Schubert, Ed Burtynsky, Michael Mitchell, John Chong, Rick Simon, Paul Roth and the troop of outfitters and guides who have taken me way beyond the boundaries of the set itinerary.

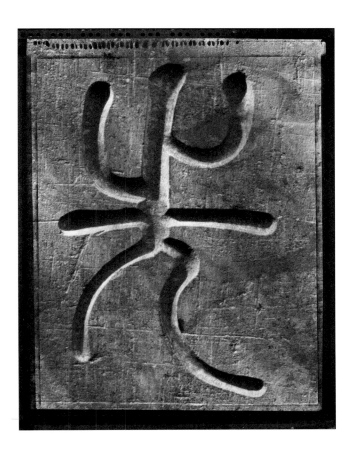

IMAGE CAPTIONS

P. 2 (detail): Escalante US, 1993
P. 9: Sacsayhuaman, Peru 2004
P. 11: Petra, Jordan 1998
P. 12: Dogon Village, Mali 2008
P. 13: *Stone Entrance*, Grand Gulch, US 1989
P. 14–15: *Monolith*, Alabama Hills, US 1994
P. 17: Tibet 2007
P. 18–19: *Oovo*, Mongolia 2003
P. 21: *Conch Shell Wishes*, Tibet 2007
P. 22: High Atlas Mountains, Morocco 1997
P. 23: Giant's Playground, Namibia 1997
P. 24: *San Pictograms*, Drakensberg Mountains, South Africa 1998
P. 25: *Sundial*, Black Rock Desert, US 2004
P. 26: Wadi Rum, Jordan 2014
P. 27: *Deer Stone*, Mongolia 2003
P. 29: *Warrior Stones*, Tiya, Ethiopia 2012
P. 30: *San Pictograms*, Drakensberg Mountains, South Africa 1998
P. 31: *Circumcision Cave*, Mali 2008
P. 32: Kalahari Desert, Namibia 1998
P. 33: *Summer Consuming Winter*, Persepolis, Iran 2000
P. 35: *San Shaman*, Drakensberg Mountains, South Africa 1998
P. 36: Persepolis, Iran 2000
P. 37: Cappadocia, Turkey 2002
P. 39: Ancient Persia, Iran 2000
P. 40–41: *Roof Sculpture*, Persepolis, Iran 2000
P. 42: Mount Nemrut, Turkey 2002
P. 43: *Pigeon Houses*, Cappadocia, Turkey 2002
P. 45: Isla de Pascua, Easter Island 2001
P. 46: *Dwelling*, Cappadocia, Turkey 2012
P. 47: *King Antiochus I Tomb*, Mount Nemrut Dagi, Turkey 2012
P. 49 and Cover (detail): Petra, Jordan 2014
P. 50: Göbekli Tepe, Turkey 2012
P. 51: Egypt 2008
P. 52: *San Agustin Gold*, San Agustin, Colombia 2013
P. 53: Kangaroo Island, Australia 2005
P. 55: Eastern Sierras, US, 1995
P. 56: Dogon Village, Mali 2008
P. 57: *Cave Museum*, Petra, Jordan 1998
P. 59: *Rock Community*, Cappadocia, Turkey 2012
P. 60: Remarkable Rocks, Kangaroo Islands, Australia 2005
P. 61: Kakadu, Australia 2005
P. 63: *Pictogram of the Sea*, Kakadu, Australia 2005
P. 64: *Jungle Temple*, Myanmar 2006
P. 65: Petra, Jordan 1998
P. 66: *Rock Drawings*, Baja California, Mexico 2005
P. 67: *Mano de Punta del Este*, Uruguay 2005
P. 69: *Temple of the Mythical Bird*, Myanmar 2011
P. 70: *Cave of a Thousand Buddhas*, Laos 2004
P. 71: *Buddha Blessing*, Myanmar 2011
P. 72: *Inde Temple*, Myanmar 2006
P. 73: *Buddha Metamorphosis*, Siam 1999

P. 74–75: Angkor, Cambodia 1999
P. 77: Myanmar 2011
P. 79: *Sunrise in the Palm of Buddha*, Siam 1999
P. 80: *Hand Prints of Wives*, India 2003
P. 81: Bagan, Myanmar 2011
P. 82: Angkor, Cambodia 1999
P. 83: Myanmar 2011
P. 84: Tomb of Empress Wu, China 1995
P. 85: Buddha Park, Laos 2004
P. 86: *Land of the Mythical Bird*, Myanmar 2011
P. 87: Myanmar 2011
P. 88–89: *Prayer Flags*, Lake Namtso, Tibet 2007
P. 91: *San Agustin Gold*, San Agustin, Colombia 2013
P. 92–93: *Wuzhousan Buddha*, Datong, China 1995
P. 94: Angkor, Cambodia 1999
P. 95: Siam 1999
P. 96: Egypt 2008
P. 97: Cappadocia, Turkey 2002
P. 98: Egypt 2008
P. 99: Egypt 2008
P. 101: Isla de Pascua, Easter Island 2001
P. 102: Petra, Jordan 2002
P. 103: Petra, Jordan 1998
P. 104: Kakadu, Australia 2005
P. 105: Little Petra, Jordan 2014
P. 106–107: High Atlas Mountains, Morocco 1997
P. 108: Escalante, US 1998
P. 109: Alabama Hills, US 1993
P. 110: Escalante, US 1997
P. 111: Escalante, US 1996
P. 112: *Nevada Desert*, US 2002
P. 113: *Anasazi Pictogram*, US 1993
P. 114: *Anasazi Pictogram*, US 1998
P. 115: Death Valley, US 1995
P. 117: *Mano del Desierto*, Atacama Desert, Chile 2001
P. 118–119: Great Zimbabwe, Zimbabwe 1997
P. 121: *Rock Family*, US 1996
P. 122: Joshua Tree, US 2000
P. 123: *Stone Spheres*, Costa Rica 2000
P. 124: Death Valley, US 1995
P. 125: *San Human Metamorphosis*, Drakensburg Mountains, South Africa 1998
P. 126: *Anasazi*, US 1997
P. 127: *Horse Panel*, Bluff, US 1993
P. 129: *Half Man Stone*, Mongolia 2004
P. 130: *Figures of the Harvest*, Anasazi, US 1998
P. 131: *Warrior Stone*, Ethiopia 2012
P. 132: *Horse Panel*, Bluff, US, 1993
P. 133: Escalante US, 1993
P. 135: *Last Light*, CappadocIa, Turkey 2002
P. 136–137: Joshua Tree, US 1993
P. 139: *Light*, Stone Dictionary, China 2001
P. 144: *San Agustin Gold*, San Agustin, Colombia 2013
Front cover (detail): Petra, Jordan 2014
Back Cover: *Selfportrait*, Atacama Desert, Chile 2001

P. 17: The interior roads of Tibet are interrupted by many checkpoints manned by Chinese soldiers. We were stopped at one and ordered to remove all luggage from our truck. It turned out that our vehicle was licensed only for Lhasa, not the interior, so our drivers were accused of illegally soliciting our business in Lhasa. Then my traveling companion remembered that after booking this trip with the China Travel Service in Toronto we were given a welcome package that included a little red button bearing the initials CTS (China Travel Service). We'd joked then about which one of us would wear it but when we now produced it claiming that it authenticated both our guides and our trip it actually worked! We were allowed to reload our truck and carry on with our explorations and photography.

P. 22: When I, along with a group of French artists, in search of these stone engravings, were driven up into Morocco's High Atlas Mountains one August, it began to snow. Upon reaching the livestock stalls to pick up the mule team that would carry us to our goal—some stone warrior engravings, our driver announced that he would now leave us. He would return to collect our group after snowmelt the following spring. It didn't take us long to collectively decide to return with him immediately and try again another year.

P. 23: While riding in a tiny two-cylinder Citroën across the Kalahari Desert in Namibia, I saw a small hand-lettered sign pointing to something called the Giant's Playground. We followed it and were suddenly confronted by gigantic natural megaliths resembling human figures and strange animals. At a nearby family farm we found a large cage holding a pair of baby cheetahs. They were cared for by a local boy who hunted daily for their food before going to school. When I returned a couple of years later the cubs that I had petted were now fully grown and fearsome.

P. 42: When I journeyed to Turkey's high mountain, Nemrut Dagi, one May to get there before the tourists, I discovered that my subjects, the fallen heads of Hercules and the goddess Commagene, were still buried in ice. Only the tips of their headdresses poked above the snow.

P. 50: When I travelled to Turkey's Gōbekli Tepe I was greeted by the son and grandson of the farmer whose plow had first unearthed one of the site's sculptures after 9000 years of burial. Initially they saw my tripod as evil. It was only after two days of visiting them bearing watermelon and cakes that they relented and allowed me to set it up and start making pictures.

P. 52: In 2003 while exhibiting at the Museo Antioquia In Medellin, Columbia, I came across a book by Luis Duque Gomez about a site called San Agustin. Its striking cover image, an owl with a snake in its beak, spurred me to request permission to visit the phenomenal Bosque de Las Estatuas, a site dating back to 3300 B.C. in the Northern Andes. I was told this was impossible—too dangerous. However I persisted, and when finally granted permission in 2012, I rode there accompanied by my view camera and an anthropologist and student. It took many miles on horseback to explore the site La Chiquira where massive divinities had been carved into the mountain face overlooking the stunning Rio Magdalena Gorge. We also examined the Alto de las Piedras of the famous Doble Yo and the seven-metre tall figure located at the Altos de los Idolos.

P. 65: In one of the cave museums in Petra, in a dark corner on the ground, quietly poised this most delicate sculpture. I had to kneel and contort my tripod to a very low spread-out position. This operation took a while. The guard left for a moment and returned with a cup of tea for me.

P. 123: In Costa Rica, carrying a torn-out page from an airline magazine that subtly showed small images of perfectly round rocks, I set out to the Osa Peninsula on the west coast. I showed the picture to a lady in the immediate area and she waved down the next person on a motorbike and asked him about the location. He signalled us to follow him and took us to his home, and the round rocks were there, scattered on his property.

P. 129: When I went searching for Deer and Turkic stones in Mongolia I had to rely on a series of lucky breaks. An initial inquiry got a general direction from a passing nomad. The next nomad suggested a slight change of course, and so on, until finally we met one who said, "Yes, I know where the stone man stands." He leaped into our jeep with his jug of fermented mare's milk and guided us to the very spot. While I busied myself with photography my crew and guide sat in a circle loudly enjoying a mare's milk party.

BIOGRAPHIES

Elaine Ling is an exuberant adventurer, traveler, and photographer who is most at home while backpacking her view camera across the great deserts of the world, sleeping under the stars. Ling's photographs, widely exhibited and published, are in the permanent collections of numerous museum and private collections including the Bibliothèque Nationale de France, Paris; Museet for Fotokunst, Odense, Denmark; Centro Portugues de Fotografia, Porto, Portugal; Musée de la Photographie, Charleroi, Belgium; Fototeca de Cuba, Havana; Lishui Museum of Photography, China; Museum of Fine Arts, Houston, Texas; Brooklyn Museum, New York; Southeast Museum of Photography, Daytona Beach, Florida; Museum of Modern Art of Rio de Janeiro Brazil. In Canada: The Royal Ontario Museum, Toronto; National Gallery of Canada, Ottawa; The Ryerson Image Centre, Toronto; and the Art Gallery of Ontario, Toronto. Her international publications include work in View Camera, Photo Technique International, The Polaroid Book, Italian ZOOM Magazine, Orion Magazine, Viktor Magazine, BMJ, New Scientist and Aperture. Born in Hong Kong, Elaine Ling has lived in Canada since the age of nine. Since receiving her medical degree from the University of Toronto, she has practiced family medicine among First Nations peoples in Canada's North and Pacific Northwest as well as among indigenous people in other parts of the world, in Abu Dhabi and Nepal. She is a fellow of the Royal Canadian Geographical Society. When not pursuing photographic projects, Dr. Ling practices family medicine in Toronto and plays cello in Orchestra Toronto, a community orchestra. Her photographic publications include: *Mongolia, Land of the Deer Stone,* Lodima Press, USA 2009, which won a Nautilus Silver Book Award.

Wade Davis is Professor of Anthropology and the BC Leadership Chair in Cultures and Ecosystems at Risk at the University of British Columbia. Between 1999 and 2013 he served as Explorer-in-Residence at the National Geographic Society and is currently a member of the NGS Explorers Council. Author of 17 books, including *The Serpent and the Rainbow, One River, The Wayfinders* and *The Sacred Headwaters,* Davis holds degrees in anthropology and biology and received his Ph.D. in ethnobotany, all from Harvard University. His many film credits include *Light at the Edge of the World,* an eight-hour documentary series written and produced for the National Geographic Channel. Davis is the recipient of 11 honorary degrees, as well as the 2009 Gold Medal from the Royal Canadian Geographical Society for his contributions to anthropology and conservation, the 2011 Explorers Medal (the highest award of the Explorers Club), the 2012 David Fairchild Medal for botanical exploration, and the 2013 Ness Medal for geography education from the Royal Geographical Society. His latest book, *Into the Silence,* received the 2012 Samuel Johnson Prize for Non-Fiction, the top award for literary nonfiction in the English language.

William L. Fox, Director of the Center for Art + Environment at the Nevada Museum of Art in Reno, Nevada, has variously been called an art critic, science writer, and cultural geographer. He has published fifteen books on cognition and landscape, numerous essays in art monographs, magazines and journals, and fifteen collections of poetry. Fox has researched and written books set in the Antarctic, the Arctic, and the deserts of Chile, Australia, and the United States. He is a fellow of both the Royal Geographical Society and The Explorers Club, and is a recipient of fellowships from the Soloman R. Guggenheim Foundation, the National Endowment for the Humanities, and the National Science Foundation. He has been a visiting scholar at the Getty Research Institute, the Clark Art Institute, the Australian National University, and the National Museum of Australia, and twice has been a Lannan Writer-in-Residence at the Lannan Center for Poetics and Social Practice, Georgetown University, Washington D.C. He is currently a guest researcher in Norway at the Oslo School of Architecture and Design.

Proofreading: Kate Pocock
Image Processing: Kehrer Design (Jürgen Hofmann)
Design: Kehrer Design (Anja Aronska)
Production: Kehrer Design Heidelberg (Andreas Schubert)

Bibliographic information published by the
Deutsche Nationalbibliothek
The Deutsche Nationalbibliothek lists this publication in
the Deutsche Nationalbibliografie; detailed bibliographic
data is available on the Internet at http://dnb.dnb.de.

www.elaineling.com

Printed and bound in Germany
ISBN 978-3-86828-623-6

Kehrer Heidelberg Berlin
www.kehrerverlag.com

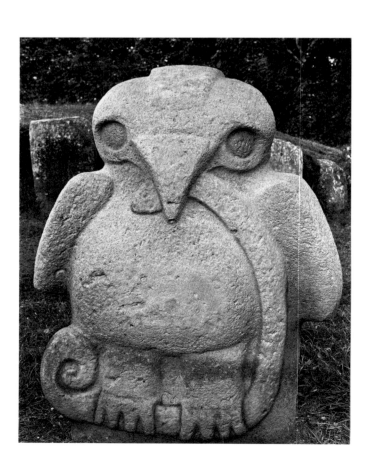

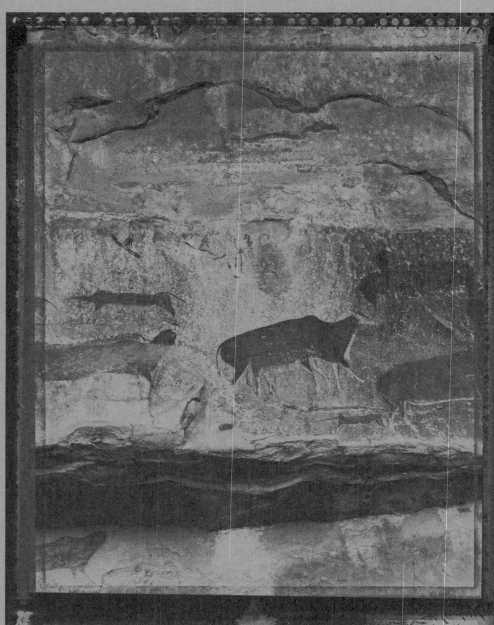